D1595110

A SHOEMAKER'S STORY

ANTHONY W. LEE

A SHOEMAKER'S STORY

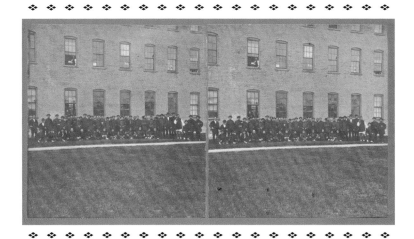

Being Chiefly *about* French Canadian Immigrants,

Enterprising Photographers,

Rascal Yankees, *and* Chinese Cobblers

in a Nineteenth-Century Factory Town

PRINCETON UNIVERSITY PRESS
Princeton & Oxford

Published by Princeton University Press, 41 William Street, Princeton,
New Jersey 08540
In the United Kingdom: Princeton University Press, 6 Oxford Street, Woodstock,
Oxfordshire OX20 1TW
All Rights Reserved

FRONTISPIECE
Unknown photographer, untitled photograph, 1870. (Courtesy of the North
Adams Public Library.)

LIBRARY OF CONGRESS CATALOGING-IN-PUBLICATION DATA
Lee, Anthony W., 1960-
 A shoemaker's story : being chiefly about French Canadian immigrants,
enterprising photographers, rascal Yankees, and Chinese cobblers in a
nineteenth-century factory town / Anthony W. Lee.
 p. cm.
 Includes bibliographical references and index.
 ISBN 978-0-691-13325-6 (hardcover : alk. paper) 1. North Adams (Mass.)—
History—19th century. 2. North Adams (Mass.)—History—19th century—
Pictorial works. 3. North Adams (Mass.)—Economic conditions—19th
century. 4. French Canadians—Massachusetts—North Adams—History—
19th century. 5. Immigrants—Massachusetts—North Adams—History—19th
century. 6. Chinese—Massachusetts—North Adams—History—19th century.
7. Shoemakers—Massachusetts—North Adams—History—19th century.
8. Working class—Massachusetts—North Adams—History—19th century.
9. Photographers—Massachusetts—North Adams—History—19th century.
10. Photography—Social aspects—Massachusetts—North Adams—History—
19th century. I. Title.
 F74.N8L43 2008
 974.4'1—dc22 2007034642

British Library Cataloging-in-Publication Data is available

This book has been composed in Bembo and Bernhard Tango

Printed on acid-free paper. ∞

press.princeton.edu

Printed in Canada

10 9 8 7 6 5 4 3 2 1

For

CATHERINE,

COLIN,

RACHEL,

AND CAROLINE

CONTENTS

A SHOEMAKER'S STORY

Introduction

How fitting it was that hail came thundering down that June. Instead of the soft, early summer breeze that normally flows over the Taconic and Hoosac ranges, caressing the slopes of Mount Greylock, big ice balls flew this way and that, thudding seemingly everywhere. Some were so unusually large—measuring a foot in circumference—that the landscape throughout the Berkshires and the Pioneer Valley seemed invaded by a foreign matter. The Knowlton brothers, two photographers from nearby Northampton, rode up and down the hills looking for especially large and photogenic stones, the enormous white balls easy to spot on the dark green fields. The brothers had to work with speed. Almost as suddenly as it came on, the storm passed, the sky cleared, the stones began melting, and the day returned to a typically warm June morning. But all the same, a ferocious summer hailstorm was a phenomenon never before seen in town. For some townsfolk it must have seemed a fitting conclusion to a week of anomalies.

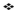

On the morning of June 13, 1870, an enormous crowd began assembling at the local train station. Reports tell us that men and women were elbow-to-elbow, lined the railroad tracks, and overflowed onto the streets outside the station. The people massed northward from the station for a quarter mile, on either side of Marshall Street, one of the main north-south thoroughfares of town. Thousands had turned out. Given that the census for that year counted about twelve thousand residents in and around town, at least a fifth of the locals, possibly a quarter, had gathered. Many were angry and primed for confrontation. All the region's papers

put reporters on site; even the Boston papers, normally uninterested in the western half of the state, sent men to cover the events. A local shoe manufacturer, Calvin T. Sampson, was importing seventy-five strikebreakers to fill the workstations left empty by the local shoemakers' union, the Order of the Knights of St. Crispin. Although able-bodied men were available throughout New England, including many who were not formally associated with the Crispins and possessed considerable skills at shoemaking, strikebreakers were being brought on a two-week train journey from San Francisco and scheduled to arrive that day. What's more, they were Chinese.

Sampson later described being notified by the Crispins that "if the Chinamen stepped their feet into North Adams they would be shot, and that if I showed my head I should meet the same fate."[1] Some in the crowd had brought rifles, others stones and clubs. A few were drunk, "spirited with whiskey" in anticipation of a brawl.[2] Sampson prepared by meeting the train ahead of time at Eagle Bridge north of Troy, just the other side of the state line, and personally riding with the Chinese on the last brief leg. He armed himself with six pistols, summoned the state police, and arranged to have seven of his own men deputized and armed. He planned a quick march, military style, from the station to his factory but also knew how much resistance he might face, given that the entire route was clogged with ornery townspeople and the road nearly impassable. As the doors to the emigrant cars opened and the Chinese emerged, the hoots and hollers began. Pugnacious, arrogant, and in no mood for delay, Sampson "thrust open his coat, shoved his hand threateningly toward the pistol inside, clapped his free hand on the shoulder of the nearest man, and looking him squarely in the eye, growled, 'Make way there. Stand aside!' "[3] Two former workers at the shoemaker's factory threw stones and were quickly handcuffed and led away. But that only diminished the number of guards to make the dash to the factory. Blood was about to be spilled.

But then events took a most remarkable turn. As the Chinese men, two by two, shoulder to shoulder, set foot on the planks, a general paralysis seemed to descend on the enormous crowd. Perhaps it

was brought on by Sampson's bravado, perhaps by the appearance of armed guards. But more likely, it was the result of a simple curiosity that took hold of those assembled. The men and women gawked as the young men spilled out of the train. Most in the crowd had probably never seen a Chinese man before. "I was disappointed in their appearance," a reporter for the *Berkshire County Eagle* wrote, "for as they marched along they looked neat, smart and intelligent. Most of them are young, and had a merry twinkle with their eyes."[4] It must have come as some surprise that, in contrast to the image of degraded, dull-witted, heathen coolies, to which the caricaturists gave shape and against which the labor unions so fulminated, these Chinese in the flesh seemed so compellingly strange, so tidy, alert, and lively. The townspeople were rapt in their attention. A local preacher-turned–social activist, Washington Gladden, declared that "the curiosity of the crowd was so acute that its brutality was held in check. These pig-tailed, calico-frocked, wooden-shod invaders made a spectacle which nobody wanted to miss even long enough to stoop for a brickbat."[5] With pistol in hand, Sampson was dumbstruck. "There was every chance for the execution of threats," he recalled with wonder at his good fortune (and perhaps with a bit of lament that he did not have a chance to shoot someone).[6]

The crowd parted like the proverbial Red Sea, and the Chinese, with Sampson and his top assistant, George Chase, at their lead, made their way to the factory.[7] If anyone cared to recall the images that had appeared in the national magazines in the previous months, they might have been struck by the irony of the situation. As the last spike was being driven at Promontory Point, Utah, just a year earlier, connecting the Union Pacific and Central Pacific railroads, and at last providing a transcontinental rail route, the illustrators began portending the huge influx of Chinese heading east (fig. I.1). They were most often pictured as a long line of men, single file or, as in North Adams, two by two, snaking through river and valley, unperturbed by obstacles, even miraculously walking across water where bridges had not yet been built. In their relentless length, they were like the winding new rail system itself. Where the Chinese had previously been arranged primarily in California, the new cross-country connection meant they would

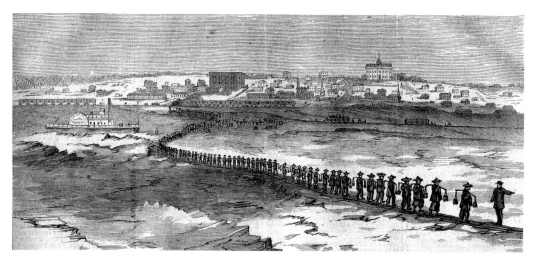

FIGURE I.1

Leavitt Burnham,
*Chinese Coolies Crossing
the Missouri River,* 1870

spread quickly across the land.[8] Or take a cartoon by Thomas Nast, where the Chinese assume the shape of a comet dashing across the sky (fig. I.2). Although picketers have come ready to agitate, the crowd can do nothing but point and look. The ladies bring their toddlers out in strollers, men in top hats are out for an evening's air, ready to witness the astral phenomenon. Cheap labor, like comets or hailstones, flies past, with hardly a demonstration by the crowd. And so it was in North Adams, Massachusetts.[9]

With the men safely in the factory and the crowd stunned and slowly dispersing, events took yet another remarkable, unpredictable turn. Before the men had a chance to change out of those frocks and shoes or settle into their new environs, Sampson ordered them back outside, spread them across the south wall of his factory, and ordered a picture of them (see frontispiece). In the days before the portable Kodak, taking such a photograph was no spontaneous act. A photographer had been called well ahead of time. He had lugged his big glass plate camera and heavy tripod to the south lawn, set up his viewfinder, and found just the right distance to position his lens so as to accommodate the lateral spread of so many men. He most likely brought his portable darkroom, the chemicals, trays, and plates piled into a covered wagon, and the whole thing hitched to a horse or mule. In addition, he brought a stereo camera—two plate cameras positioned on a single mount—anticipating that the scene

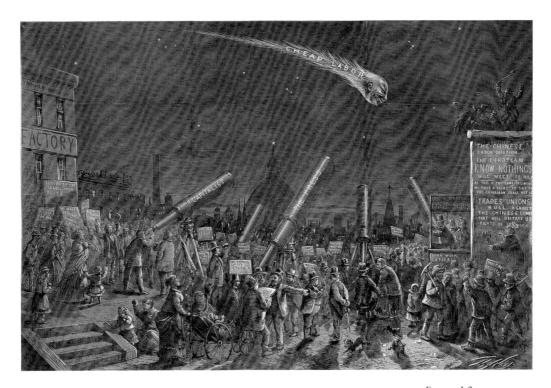

FIGURE I.2

Thomas Nast, *The New Comet—A Phenomenon Now Visible in All Parts of the United States*, 1870

would be useful as a stereoview and, in that format, find its way onto the growing lists of local views and be distributed widely. Among other things, the photograph of the Chinese was going to be a commercial venture, and it required proper orchestration.

Anticipating an angry, violent crowd, arming himself and his men like a military convoy, and almost ludicrously preparing for a bloody fight with, literally, thousands, the pugnacious shoe manufacturer had thought to arrange for a photograph. Was he mad? What could he possibly have had in mind?

❖

A closer look (fig. I.3) might give us some insight into what the local North Adams crowd found so riveting. The men are young and clean-shaven, slim and decently fed. In contrast to the unemployed Crispins, many of whom were men with families, the Chinese look like teenagers. In fact, most were. Of the seventy-five, sixty-eight of them were under twenty years old. The youngest

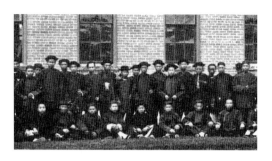

Figure I.3
Unknown
photographer,
untitled photograph,
detail, 1870.
(Courtesy of the
North Adams Public
Library.)

was fourteen, most fell between sixteen and eighteen. Their fore-
man, known as Charlie Sing, was all of twenty-two.[10] They were
disarmingly more like boys than men. "Neat, smart, and intelli-
gent," as the *Berkshire County Eagle* reporter described them, seems
plausible. "Calico-frocked" and "wood-shod," as Gladden remem-
bered the Chinese, does not. His characterizations were more like
the clichés found in guidebooks and travel accounts in China,
where such fashions were generally gleaned from the highly or-
nate decorative dress of upper-class Mandarins. As the photograph
declares, these Chinese are decidedly peasants. Most wear simple
cotton jackets with big baggy sleeves and scooped necklines; light-
weight, loose-fitting cotton trousers; and soft slippers with soft,
white soles. They are outfitted in typical traveling clothes. Some of
them have taken to wearing the flat-brimmed hat, once common
among nineteenth-century peasant Chinese travelers in America.
Others have kept the skullcap more characteristic of traditional
costume. Without exception, the men sport the cropped hair and
long queues characteristic of Chinese living under Qing rule. The
grooming that was required to maintain the crop and queue was a
weekly chore, which all Chinese men, young and old, knew well; it
is clear they have kept up the habit during the two-week journey.
Among other things, the photograph is evidence that these men
adhere to the strict social code. One is tempted to say that two of
the men in figure I.3, in the back row towards the right and left of
center, have deliberately taken off their hats to reveal their appro-
priately coifed heads, offering visible evidence of their humility
and their observance of decorum. The "merry twinkle" in their
eyes discerned by the local journalist does not seem in evidence in

the photograph. Instead, although one man, nearly at dead center and in the back row, breaks into a smile and another, at bottom left, begins to grin, the Chinese are mostly poker-faced and appear before the lens with neither anger nor malevolence but, seemingly, seriousness and solemnity. "These are the strikebreakers?" we can imagine the North Adams citizenry asking in puzzlement.

On the one hand, the men's seriousness—their tight-lipped, unyielding expressions—is typical of the conventions of early photographic portraiture. Depending on available light, the glass plate's exposure time could be long, and men and women seated before the camera learned to keep still for uncomfortable stretches if they wanted crisp images of themselves. On the other hand, the men had been boxed for two weeks in railcars, sleeping on wooden benches and eating rice and crackers day and night, the kind of journey to make men ornery.[11] Emigrant cars were decidedly the poor man's option, as passengers shared space with bags of mail and smelly farm animals. Sampson later told state officials that at the stops along the way the men were mostly kept in the cars, only a few minutes to stretch here and there and, occasionally, a quick dash to the stations to buy bologna sausages.[12] In North Adams, they had just been met with something less than a warm greeting. Tired, confused, not speaking English, perhaps a bit defensive, the men could not have viewed standing against the hot brick wall, the June sun high overhead, as a welcome respite.

Or did they? Amidst a crowd carrying clubs and rifles, what did they think the photograph was for? How should they comport themselves before the lens? What understanding—of themselves, of the shoe manufacturer whose wall they stood before, of the shoemakers they displaced, of the photographer whose gaze they met—informed their appearance?

This book is about the large forces, understandings, and personalities that brought the famous photograph of the Chinese into being. In addition, it follows the discussions, events, and images that the photograph put into motion. It is concerned, therefore, with the industrialization of a New England craft at one of its key historical

moments; the tumultuous and often violent debates about labor, race, class, and citizenship during the decade and a half after the Civil War, when such debates were on everyone's anxious lips; the rise of photography as a profession and, related to that, the enormous popularity and widespread use of the carte de visite and stereoview; and the ambitions and experiences of immigrants, of all sorts, as they tried to find places for themselves in Reconstruction America. It tells all of those stories by attending to photographs, especially the voracious imagery surrounding the picture taken that June day. Pictures are not incidental to the story but central, not merely illustrative of events but objects of key historical meanings. Telling this history would be impossible without them.

The reasons to attend so carefully to pictures are many. Apart from the fact that images, like texts, are complex carriers of meanings and provide histories and understandings that in the thickness of time would otherwise be lost, in the late 1860s and 1870s these many photographs and other related images formed a remarkable, momentarily discrete, and analyzable visual culture. From the point of view of their makers, sitters, and early viewers, they were not inert objects, tucked into albums or stuffed into drawers and soon forgotten, but instead deserved high attention and careful, sometimes urgent interpretation. The many viewers, however, never seemed to agree on what the pictures meant, especially that central photograph of the Chinese against Sampson's factory wall. The shoe manufacturer saw one thing, the photographers another, the Crispins yet another, and the Chinese still more. Perhaps because of that lack of consensus and perhaps because the many constituencies were not merely passive but astonishingly active observers, they each turned to making even more images to press their points of view. The Crispins, for example, returned Sampson's favor by assembling together and having a photograph made of themselves, too (fig. I.4). They made clear that they had a stake not only in the arrival of the strikebreaking Chinese but also in the representation of that arrival.

All of this arguing in front of the camera ended up creating a large body of photographs that was vital and plentiful but also plural, conflicting, and often incommensurate. Indeed, although all of major actors in our story looked at photographs and resorted to

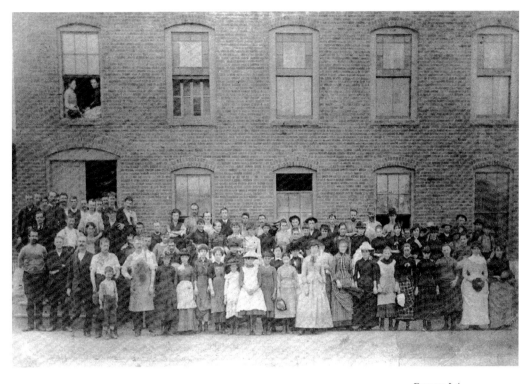

Figure I.4

Unknown
photographer, *The
Crispins of the
Co-operative*, 1870

yet more pictures as a way to express themselves and meditate on their experiences, no one ever agreed on much of anything, photographically or otherwise. In the pictures, we can sometimes still feel the heat of their disagreements. In their hands, the photographs were not merely illustrations but sites of historical struggle. That is to say, the social struggles among North Adams's constituencies became a struggle in and of representation.

Rather than see the visual culture in North Adams as single and whole, developments in that town—where immigrants and migrants came and went and individuals from far-flung places were brought suddenly together—encourage us to see it as multiple and fluid. It might be best, therefore, to understand the many pictures as bound to the complicated social relationships among the different actors in this story. Although the Chinese strikebreakers, the French Canadian Crispins, the ambitious photographers, or the Yankee shoe manufacturers did not belong to a single "culture," they had

relations with each other. In that sense, the photographs and other kinds of pictures were important deposits or briefs of those relations. The photographs, that is, were social relations momentarily hardened into images. How we untangle and understand those relations through pictures, in a remarkable place and time, is what this book is about. Or to put it another way, how we view our visual archives critically—how we value and interpret the photographs remaining from our past—is also what this book is about.

❖

Although the story is richly local—we will spend a good deal of time sniffing around Sampson's factory, inside the Crispin lodge, in the photographer's studio, in the Chinese residence—it was also national, even international, in scope. The big papers and journals certainly knew something huge was brewing. Days after the Chinese men arrived, *Scribner's Monthly*, *Harper's Weekly*, *Frank Leslie's*, the *New York Herald*, the *New York Tribune*, the *New York Globe*, *The Nation*, among many others, sent reporters. Suddenly having its authority on local matters superseded, the local paper was both dismayed and oddly pleased by so many national journalists' conspicuous presence around town. "This private business step has thus become a public event of the widest notoriety and discussion," it observed of their many reports. With so much attention, strikebreaking with foreign labor "promises to become the cause of important business and perhaps political results."[13] The national reporters were more direct. "Should he succeed in his venture," the journalist for *Frank Leslie's* wrote of Sampson, "hundreds of employers engaged in the shoe business, and the companies running spindles and looms at Lowell and elsewhere in New England, will contract for large companies of Chinamen."[14] The prognosis sent a shiver through labor's spine. The labor movement began holding national meetings, developed a political platform regarding immigration, and put candidates up for office. Ultimately, the Chinese appearance in North Adams and the anxious discussions it engendered had much to do with leading Congress in 1882 to pass the Chinese Exclusion Act, the most trenchant American policy surrounding immigration of its kind, which simply forbade further

entry of the Chinese and attempted to strangle the population already in the country.[15] The act is one of the photograph's most bitter legacies.

But for a moment, let us try to keep the wholesale exclusion at bay. In June 1870, change, not to mention hail, was in the air, and the picture of the Chinese seemed to mark it. The wondrous aspect of that early photograph was not only its unprecedented quality and its portending something new, but also its putting into relief the difficult and fraught questions about community and belonging among immigrants, migrants, and townspeople, its palpable pressure on the region's many constituencies who were affected in all kinds of ways by the large and growing presence of a post–Civil War, postslavery, factory-based industry. Complex histories lay behind these many actors, and equally complex arguments, actions, and picturings lay ahead. We would do well to understand the many important issues surrounding a country in the throes of a massive historical transformation by attending to one of its key examples, and by attending not to the sad, end result of exclusion but to the place and time when those different histories met and intertwined, and to those nerve-wracking, pregnant moments when the Chinese came.

ONE

ᴄᴗᴄ

What the Shoe Manufacturer Saw

The View: Because he had much to do with bringing the picture of the Chinese into existence, Calvin Sampson was keen on the photographer's results. There, on the south wall of his factory, stood his imported strikebreakers, brought to him at considerable cost to his wallet and reputation. He meant to recuperate both. What he saw in the photograph therefore had something to do with reestablishing himself—as a manufacturer, a man of capital, and perhaps most surprisingly, given his previous demeanor towards the working classes, a paternal figure. A self-made man and a Yankee of proud but complicated pedigree, he had observed with horror what previous pictures taken of the workingmen of North Adams had accomplished in establishing public interest for their causes; and he understood, perhaps only in very rough terms, that he needed to take pictures seriously and put them to use for his own ends. But because the older idea of the "paternal figure" and the much newer idea of "manufacturer" in Reconstruction America did not fit so easily together as they were imagined to have in the antebellum era, Sampson was also searching for a sense of himself that, if pressed, he could not easily identify. In a sense the photograph helped him formulate a reply. But he could not have guessed that his picture of the Chinese would cause him to turn to the photographers again and again, for a variety of reasons, as this chapter tells.

Only one photograph of Calvin Sampson survives (fig. 1.1), a studio portrait taken by an unknown North Adams photographer and today preserved as a photomechanical print. The overall countenance is impressive. Sampson's hair is slicked to a fine grain,

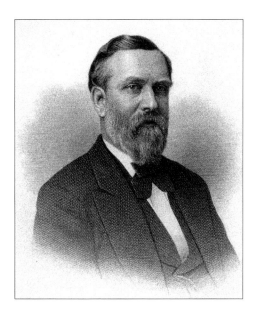

FIGURE 1.1
Unknown
photographer, *Portrait of
Calvin T. Sampson*, ca.
1880

his beard and temples are graying in just the right proportion to give him the air of being distinguished rather than simply elderly (or daft), his jowls and cheeks are slightly full from regular square meals, his brows bushy and eyes lucid, altogether offering a penetrating, serious, self-assured expression. The lone picture was taken many years after the Chinese had arrived, when Sampson, after years of bullying, had finally mellowed, put his pistols away, and settled into the role of a town patriarch. Or so the photograph would have it be. Like most villages in the Berkshires, North Adams had no native or landed aristocracy, even of the middling sort. Its rapid growth in the antebellum and Reconstruction eras was due to merchants and industrialists who, by hard work, political maneuvering, a ready embrace of new technology, unabashed scamming, and simple good luck, had attained wealth and influence. The rhetoric of the surviving portrait, more stolid than effervescent, might have been as declarative of status as an arriviste might dare offer to the rest of the townspeople in North Adams.

The several biographical sketches of Sampson, some produced posthumously, can all be traced to two early essays written soon after the Chinese arrived in North Adams, when journalists began

excavating more details for their stories. Perhaps not surprisingly, their main source about Sampson was none other than shoe manufacturer himself.[1] It is clear he was anxious to propagate several details (some would say myths) about his ancestry. First, his family had founding-father lineage. He claimed that an ancestor, Henry Sampson, had arrived with the *Mayflower* (the grand ancestor is sometimes called "Abraham," perhaps a more fitting patriarchal name).[2] Another had come in the second wave and settled as part of the extended company at Plymouth Plantation. And yet another had married into the Miles Standish family. Second, his family earned Revolutionary War credentials. His great-grandfather had fought in the French and Indian War, served in the Continental army, and battled side by side with Ethan Allen at Ticonderoga. And third, his family had been displaced from its original landholdings in Massachusetts. His grandfather, who had merely supported Shays's Rebellion in the 1780s, had subsequently had his property confiscated and been forced into exile in Stamford, Vermont. There, the Sampsons were living as modest farmers when in 1826 Calvin T. was born, the youngest son of a working family. That would have made him forty-four when the Chinese arrived.

Of his own early life, Sampson had other points to declare. He was set to work to contribute to the family income at age seven. By eleven, he was cutting and hauling wood from the farm to North Adams, several miles across the border. And by fourteen, he "was strong enough to do the work of a man."[3] He had "little schooling . . . [but had] a thirst for knowledge, and by working extra hours earned some money, with which he purchased text-books: these he studied by himself." His father died when the young Sampson was eighteen, leaving him "with only his father's debts as a legacy" and a mother, sister, and older brother to care for.[4] (He revised the story a few years later to say that the family had inherited forty-four acres and enough money to purchase an adjoining tract to bring the estate to about a hundred farming acres, a little closer to the truth. By southern Vermont standards, he was quite comfortable.)[5]

The self-portrait painted by Sampson was a curious mixture. He was part colonial aristocracy, part pull-yourself-up-by-your-bootstraps Yankee yeoman, privileged by blood but without the

privileges of education, a descendent of the *Mayflower* and the Revolutionaries but also a descendent of Shays's victimized, and a man whose raw physicality was matched by an equally raw, untutored intellectualism. In these many ways he was both pedigreed and self-made. The Horatio Alger–like portrait was not at all uncommon in the post–Civil War era in describing successful men of his generation, allowing them to accommodate the values of both the landed and working classes at a time when both were much in the news. Most early biographical sketches of New England manufacturers had versions of it, helping to justify through this mix of an inheritance of character and a gritty determination of the entrepreneur the enormous success they enjoyed. It certainly provided Sampson a ready-made identity for him to try on. Whether he came to believe the portrait is hard to tell and, at any rate, a matter of guesswork. But it had its many uses, as we will have ample opportunity to see.

As he told it, Sampson entered into the shoe business in 1850, when he was nearly twenty-four. A cousin, George Millard, had purchased the stock of a small boots-and-brogans factory in North Adams, which he invited Sampson to take up and sell off. Millard was no angel, and the details of how he came upon the stock, though murky, are suspicious. Although a merchant by trade (he owned a country store selling hardware, grains, and tools of "general public necessity"), Millard rented out space at the back of his store to two shoemakers.[6] Skilled artisans, they evidently fared poorly as businessmen, soon declared bankruptcy, and sold their stock at below cost to Millard. How much Millard contributed to their business woes (he quickly opened his own shoe manufactory and tried to push out most of his competition) is unknown. An educated guess is that he wanted to dump his former tenants' shoes as quickly as possible before they could try to reclaim them; and he sent for an unsuspecting and obliging younger cousin to help him out. Sampson piled the stock into his wagon, toured the neighboring towns, "and in four days had disposed of his load for cash and for butter."[7] The potentially disputed stock dispersed throughout the countryside, Millard turned to other matters. But Sampson, with three hundred dollars suddenly in hand, was hooked by the

sheer excitement of the merchant world. It beat growing corn and hauling wood in Stamford. He left the one hundred acres, moved his mother and sister to North Adams, and followed the business lead of his successful, if slightly conniving, older cousin.

Histories of early shoe manufactories in New England focus heavily on developments in Lynn, just outside Boston. There, as historians have shown, during the late 1840s and early 1850s several huge factories sprang up and began to dominate the national industry.[8] Between 1845 and 1855, the factories grew so large that the number of workers in Lynn increased by more than half, the small city simply swallowing the young men and women from Maine, New Hampshire, and the eastern Massachusetts countryside and becoming a full-fledged factory town. When Horace Greeley undertook an evaluation of the general state of the American shoe industry in 1873, he turned naturally to bustling Lynn to make his assessment.[9] And while other New England towns had their share of small shoemaking businesses throughout the late eighteenth and early nineteenth centuries, Lynn, with its huge flowering at midcentury, came to be seen not only as the dominant place but also the historic center of shoemaking, an image that persists even today, its earliest shoemaker, as Greeley reported, appearing "in the shipp the May Flower [with] divers hydes, both for soles and vpp leathers, [which] hee intends to make vpp in botes and shoes there in the country."[10] Any enterprising shoe salesman worth his salt would have made a pilgrimage to Lynn, as the young Sampson did in 1851.

The experience must have been eye-opening. A slightly later print of a Lynn manufactory provides an example of the kind of image these new industrial shoemakers liked to provide of their businesses (fig. 1.2). Six stories high, smoke belching from its central chimney, placards announcing the ownership, the blinds all pulled to a uniform half-length, and the massive structure casting a huge shadow, the new shoe factory is an imposing and well-ordered behemoth. There are other stacks spewing smoke in the distance to the left and right, evidence that the factory of V. K. and A. H. Jones takes its place amidst a productive industrial complex. Men and women are out for a stroll, but there is hardly anything for them to see or do except to attend to the gigantic building.

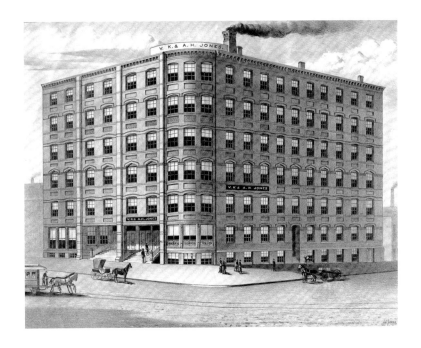

J. L. Jones, *Shoe Factory of V. K. and A. H. Jones,* 1883

Some enter the front door; others stand idly outside. They serve mostly as the human scale by which the massive façade might be measured and praised. The illustrator had no other conception for them. North Adams had nothing remotely like it.

Sampson claimed to have purchased ladies' shoes from at least three Lynn manufacturers, loaded them into his wagon (perhaps not unlike the wagons pictured in the Jones factory print), and returned to North Adams. He toured the vicinity selling shoes straight out of the crates, sometimes, as he later described, he "carried his goods from house to house in a valise," and sold his stock like a traveling salesman.[11] He later revised the story to say that "when a lad [he] started peddling shoes in a basket from house to house." In his revisions, he usually got younger—a "lad"—and the means of conveyance got humbler, from "wagon" to "valise" to "basket."[12] But whatever his rosy recall, he was active enough up and down the hills that he was finally getting the attention of credit reporters (he was at first mistaken for a bumpkin from Hancock), who regarded his overstuffed, weighted-down wagon with interest

and sometimes sardonic humor; he seemed to them to have "all his property" in it.[13] He must have been a great talker, a schmoozer, and a fibber—"he makes quite a trader," the credit reports said a year later.[14] He never had a problem selling his whole stock. How many of the economically strapped farmers' wives actually needed so many new pairs of ladies' shoes is hard to estimate, but enough that Sampson was soon placing larger and more detailed orders from Lynn. Fancy uppers and eyelets, Congress gaiters, boots with elastic gores, slippers of leather and cloth—Sampson and his Berkshire patrons got to know the latest materials and fashions. That George Millard was by then producing shoes at his new factory and trying to sell his stock must have caused some competitiveness among the cousins. Sampson was undaunted. Considering that transactions often meant selling shoes for butter, grains, bread, promissory notes for labor, and everything but hard cash—the typical barter of the antebellum countryside—he must have beaten the roads up and down in order to come up with enough currency to restock at Lynn. The eastern manufacturers had no use for butter or any other domestic goods.

By 1854, the energetic Sampson had saved enough money to open a shop in the center of North Adams, giving up the wagon and horse for a storefront and shelves.[15] That he was able to do so within such a short time suggests how quickly he had resettled in North Adams, how far his networking in the Berkshires had already extended, how comfortable he felt tending the daily chores of a merchant (bookkeeping, retail forecasting, measuring supply and demand with an array of merchandise, comforting himself with the margins of profit and loss), and how much he became part of the town's growing mercantile and manufacturing community. The brief passage in one of the early biographical sketches in which this overall transition is described, and the ensuing passage narrating Sampson's turn from shoe shopkeeper to shoe manufacturer, is worth quoting whole:

> On the 18th of the following November he opened a store
> in North Adams, which he carried on, with a retail trade,
> until 1858, passing successfully through the financial crisis of

1857. He then sold out his retail business, and began manu-facturing in a small way, also jobbing his own goods and those of other manufacturers. This business was prosperous until the breaking out of the Civil War, when he had accu-mulated about $16,000. He lost considerable sums from Southern debtors, so that his whole capital was sunk, and he became seriously embarrassed. He kept at work, however, and by 1863 had regained a substantial foothold. In that year, to secure a new and wider field of customers, he opened a store in Boston, which he gave up two years after; and has since filled orders directly from his factory.[16]

Thirteen years of the ups and downs of business, including the em-barrassment of near bankruptcy, are condensed into a few sen-tences; but even so brief a paragraph reveals much. Sampson had learned enough about shoemaking, perhaps through so many re-peated visits to Lynn, that he resolved to try his hand at manufac-turing "in a small way." It is an uncharacteristically modest claim because the business, even at the outset, was hardly small. Manu-facturing on his kind of scale meant obtaining a ready source of leather from the New York or Pennsylvania tanneries, getting cot-ton linings from the South, discarding his horse-drawn wagon and contracting with the railroads in order to import the huge quanti-ties of raw materials, investing in newfangled machines and gather-ing enough hired help to run them. In short, he had to connect himself to a much wider labor, goods, and technology market than was available in North Adams. (He later claimed that he operated his whole factory with "but one employee, Wm. G. Vial of this city, who is yet living"—another fib, another puffing of himself to the interviewers about his heroic, manly beginnings.)[17] Part of his early effort at manufacturing was secured by producing goods for others, not only for local retailers but also the manufacturers, re-tailers, and wholesalers in the South. And thus, quite unlike most of North Adams's shoemakers and far more like Lynn's businesses, Sampson began to think early on in grander terms, inserting his merchandise into the national supply. (Not mentioned in the biog-raphies but in other sources, the Union army proved to be a huge

customer for the town's most aggressive manufacturers. With ladies' shoes, Sampson had no army contracts, but he filled the void in the market that others left to get those contracts. No wonder he suddenly accumulated sixteen thousand dollars.)[18] He even thought to compete directly with Lynn by opening a store in Boston, the heart of the eastern shoemakers' territory. In that market, he was probably in over his head, as the quick closing of the store suggests; but the effort is telling of his enormous ambition.

～♒～

So much for Sampson's image of himself. As journalists clamored for a general portrait, he was happy to feed them the identity of a grand manufacturer, which in his mind issued from a combination of the colonial blood running through his veins and the singular entrepreneurial ambition he exhibited in the face of modest or difficult means. It was a familiar portrait. Yet, what is striking, above all, is that while he claimed to be a shoe manufacturer, he nowhere thought it necessary or desirable to proclaim that he actually made shoes himself. And in this, he differed considerably from all the cobblers who had lived and worked in North Adams prior to the late 1850s. Sampson represented a new kind of shoemaker, whose business was built on his management skills, not his abilities with leather, knives, needles, and thread, and certainly not his hands-on familiarity with the new stitching, cutting, sewing, or pegging machines. As we shall see, he was utterly useless in front of them.

This represented a significant transformation. Previously, shoemaking in the Berkshires, as in most regions in Massachusetts besides Lynn, was the main province of artisans. It was most often a family business, with a few workers hired season to season to fill out the benches. Often the seasonal workers were neighbors who needed extra money or traded labor hours for goods. An illustrator for Horace Greeley's 1873 study of the shoe industry imagined a shoemaker's shop "of the olden time" as nothing more than a single room in the family cabin (fig. 1.3), a somewhat fanciful image in terms of its rusticity (the paddocks and fences were the preserve of farmers, not shoemakers) but not terribly far from the truth in its smallness and domesticity. The shoemaking rooms "were generally

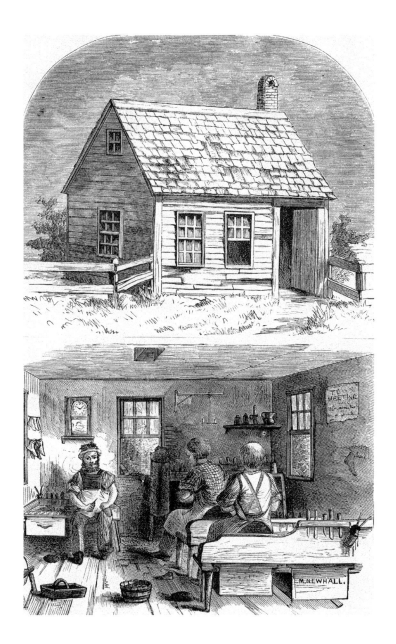

FIGURE 1.3
M. Newhall, *A Shoemaker's Shop of the Olden Time*, 1873

from ten to twelve feet square," Greeley wrote, "and contained from four to eight 'berths,' as the space occupied by each workman was called."[19] He had probably never been in such a room, but that did not deter him from trying to be empirical. And besides, by the time

he was writing in the 1870s, there were no olden shops left against which to measure his claims.

Although the stitching and sewing machines arrived as early as the 1840s, the new technology did not at first decenter the authority of the shoemaker in favor of the shoe manufacturer. After all, the new machines, including the much-ballyhooed McKay sewing machine, did not fundamentally transform the cobbler's craft. The stitching machines simply stitched together the strips of leather faster; the McKay sewing machine put the uppers and lowers together more quickly and uniformly; and the pegging machines connected the soles and heels more efficiently. But the basic procedures to make a shoe—the uppers and lowers, the bottoming, and so on—remained unaltered. Those shoemakers who could afford the new machines simply added them to their business. It did not require a significant revamping, either of the conceptual or practical sort.

Of course they could make more shoes, by one estimate five times as many with a single machine.[20] But that kind of rapid increase in productivity was rarely the case. For example, although a fancy new machine could stitch uppers and lowers together faster, the shoemaker still needed to have enough prepared uppers and lowers—five times as many—for the machine to work its magic. Otherwise it was no benefit. Sometimes, if he was resourceful and had a good reputation around town, he could hire more workers to fill out the berths for making uppers; other times, he outsourced, meaning he sent leather or cotton strips to neighbors who did the work at home, and paid them on a piece-by-piece basis. Although more and more common in the 1850s, this outsourcing was not necessarily more efficient and did not consistently yield more usable pieces. The workers at home fit the shoemaking jobs in with their other domestic chores in a household economy; it was only one of the many ways they met their weekly competence.[21] The new machines were still dependent on the artisan's or farmer's clock.

In this mixed climate during the antebellum era, when the cobbler's trade was slowly being augmented by new tools and the industrial revolution contended with the village and countryside

economy, shoe manufacturing was in no way the strict preserve of business managers. Quite the opposite. Shoe manufacturing on an increased scale—and the ambitions to become a manufacturer—was still the dream of the local cobbler. All he needed was that extra stitcher, say; or perhaps if he got that pegger next month; or what if he could save enough leather to stockpile uppers for when his neighbors took off for the harvest season. Some shoemakers fared badly, like the two who rented space at the back of Millard's shop. Others, if they had enough judiciousness and wherewithal, expanded the business, usually slowly. It took a little luck, some business sense, and a willingness to trade the hands-on work of cobbling for some time devoted to managing, costing, and merchandising. The cobbler-turned-manufacturer had to become accustomed to a cash economy but also had to find ways to accommodate the older barter system, since so many of his hired helpers still operated within it. The new Lynn factories on the other side of the state gave him fright because they seemed monstrosities that ate up the competition. But the belief that his sons could continue the family trade, expand the shop even more, and become large factory owners in their own right was still extraordinarily vivid.

The Civil War abruptly changed all that. With the huge army contracts available for the taking, only those manufacturers who could organize production had any chance of securing them and meeting the enormous demand. In practice, this meant a manager who could oversee shoemaking not as a hands-on process but as a confluence of economic units. It did not hurt to have some long or deep experience in the trade, but it was no longer mandatory or even conventional. The historian Judith McGaw suggests that in the nearby Berkshire papermaking industry nearly all the successful manufacturers had only the most minimal experience on the machine and much more substantial training as paper mill managers.[22]

To meet army contracts, those lucky few North Adams factories that received them ran night and day. Their machines begat more machines in order keep pace. In Sanford Blackinton's woolen mill, for example, blue army cloth was being pumped out

ın such quantities—acres and acres of it, all for the uniforms for the soldiers marching off to war—that Blackinton was earning an average of a thousand dollars every day for the entire war and soon outdistanced all of his woolen mill rivals, sending most out of business. There was so much material being sent off from his gates and so much money in his pockets that in 1862, as the army ranks were swelling, he had the cash and clout to open a private railroad depot right next to his factory. In 1863, the year of Gettysburg, the New York draft riots, and the Army of the Potomac's push into the Confederacy, he added more machines and expanded production by yet another quarter. In 1864, with thousands of new recruits continuing the war effort in the march to Richmond and Atlanta, even the extra quarter of productivity was not enough, and he bought a second mill in nearby Braytonville. He had done so well during the boom years and afterwards that in 1868 he bought a third mill on the outskirts of North Adams.[23] In 1865 at the war's end, he declared his property to be worth more than a quarter of a million dollars and his personal wealth more than fifty-one thousand dollars, astronomical figures considering that North Adams census and tax poll records for that era suggest most townspeople owned no property and claimed no personal wealth at all.

Sampson kept pace. There are no surviving business records for Sampson's various factories, certainly nothing with the kind of detail that exists for the Blackinton mills, but the shoe manufacturer must have contracted well. The "substantial foothold" of which his biographers speak was in 1863 the purchase of a factory in the middle of town.[24] It can be spotted off to the right in a badly damaged photograph (fig. 1.4), just in front of the white, two-columned building. With a small sign out front announcing "C. T. Sampson Boot & Shoe Store," it tried to hold its own amidst the big churches and mansions suddenly springing up all over town, an example of which can be spotted in the distant background. The new buildings were the architectural manifestations of entrepreneurs and manufacturers capitalizing on war and doing astonishingly well. Sampson brought in new Wells pegging machines, McKay stitching machines, partitioned the building into various departments, and contracted year-round labor.[25]

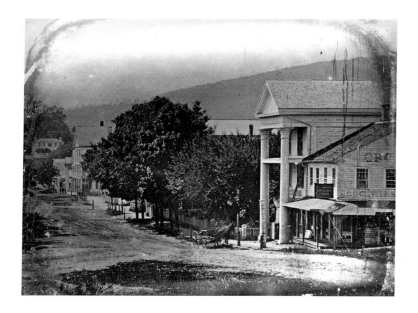

Figure 1.4
Unknown
photographer, untitled
photograph, ca. 1863.
(Courtesy of the North
Adams Public Library.)

Business was extraordinarily good. He "makes money all the time," the credit reporters were soon singing, and the former shoe peddler, who once worked out of a wagon and was the object of chuckles and lampoon, had by the end of the war a reputation as "good as wheat."[26] In 1866 Sampson moved his whole family into the top floor of the swank new Wilson House (fig. 1.5), a stone's throw away from his factory (we can spot the same mansion in fig. 1.4 in the distance). Part Venetian fantasy, part Florentine monstrosity, the Wilson House, with its main towers dwarfing all the modest wooden buildings in town, was the gaudiest evidence of new money.[27] It had elegant shops at ground level, including milliners, jewelers, at least three confectionaries, and a nearby photography studio; a restaurant serving exotic, fresh game ("the best viands that the market and season afford"); over a hundred "lighted, airy, handsomely furnished" rooms in the midlevels; and spacious apartments for high-paying residents above.[28] There is something faintly ridiculous about this ambitious arrangement captured in this photograph of Main Street. The magnificent buildings—all the fashionable mansard roofs, decorative carapaces, Corinthian columns, turrets, spindles, awnings, and tidy lawns—are fronted by the scruffy

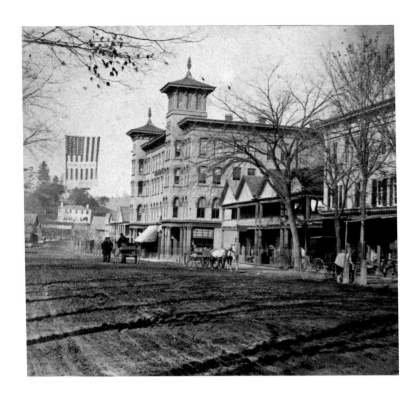

FIGURE 1.5
J. L. Bowen, *View in Main Street* (no. 20, "Views of North Adams and Vicinity"), 1866

dirt road of an old Berkshire town. The effort to transform dusty Main Street is only half-finished, the seam between buildings and road looking edgy and poorly fit. The incongruity did not prevent the proprietors from celebrating. In 1866 at the opening of the Wilson House, an event photographed in figure 1.5, the street's renewal is linked to patriotism and nationalism (it is an *enormous* flag strung across the road), a bald attempt to link the new luxuries afforded by new wealth with the larger reclamation project of Reconstruction. But amidst all the high-blown grandeur, life on the streets seems to amount to no more than a passing carriage. How many in North Adams could afford to eat fresh venison brought down from Maine? At the time, Sampson was paying each of his workers little more than a dollar a day.[29]

In the Civil War manufacturing climate, the artisan's facility with leather and needle, once an absolute prerequisite for successful

shoemaking, became, ironically, quite secondary to achieving success in the industry. The cobbler soon had very little expectation that he could ascend to owning a large factory. Not only he, other workers had to reorient themselves to the reality of management-run shoemaking. With the workbenches expanding and the machinery humming, outsourcing, though still practiced in the war years, became much less the norm. It was simply too inefficient.

To keep the machines working at full tilt and recognizing that North Adams's local population simply could not supply enough bodies for outsourcing or manning the berths, the new manufacturers resorted to bringing teams of workers from afar and, in doing so, began the great age of immigration to the town. Whereas the Lynn factories tended to draw from the Yankee countryside, the North Adams factories drew aggressively from outside the country. Blackinton contracted the Welsh; the mining and tunneling companies contracted the Irish; and Sampson contracted the French Canadians, who would soon constitute the bulk of his workforce. North Adams's population exploded, by a third during the war years to eight thousand, and just a few years later in 1870 when the Chinese arrived, reaching twelve thousand.[30] More than a third of the town was foreign. There were few places in the Berkshires, indeed the entire Northeast, where so huge a percentage of the population became so suddenly different and where the babble of thick accents and foreign languages filled the air. Some of the workers came with families; many did not. The French Canadians in particular left wives and children behind in Quebec and viewed North Adams as a temporary abode for work. But in all cases—immigrants, migrants, teams of laborers, the single worker—their presence could not but be keenly felt as they settled into town and began to partition it into ethnic neighborhoods. The locals responded with the familiar catalogue of horrors, anxieties, and doom and gloom attending American immigration of this mass sort. The immigrant neighborhoods were "the headquarters of rum and rowdyism, crime and debauchery."[31] The right citizens of town were forced to form a Temperance League because of all the "rows and riots, fighting, quarreling, swearing and cursing" of those damn foreigners. They wished for quieter, more civil

days and fancied a time when the town was not beset by such so-
cial and cultural infelicities. Of course, they knew the factories
were responsible for the changes. "The best and only wish I have
for the place," a local told his neighbors, "is that the anvil and the
loom may soon cease their operations, and that the grass may grow
and flourish the length and breadth of your streets." But he knew
the image of a bucolic town comprised of old-time settlers was
sheer fantasy and the removal of the factories equally fantastic. Any
look down Main Street told him so.

~∂∂~

The single photomechanical portrait of Sampson is, we might say,
framed everywhere by the new manufacturing, by all the develop-
ments in industry and in town that enabled a man like Sampson to
conceive of himself as a manufacturer. Those developments, while
often described as technological, can likewise be described as social.
Indeed, the web of social relationships that had been spun—between
Sampson and his imported workers, Sampson and the successful
Lynn shoemakers, Sampson and the most aggressive of North
Adams's entrepreneurs, even Sampson and his paternal past—gives
the portrait its particular seriousness and gravity, its attempt to pro-
vide an image of the man in keeping with self-sufficiency. (Perhaps
self-sufficiency was the best way to name—understand, cover, de-
flect, redescribe—arriviste.) The portrait's imagined viewers—those
same workers, entrepreneurs, North Adams locals, and the like—
were the very people whose relationships with Sampson had
brought his new identity into being.

Sometimes the word *patriarch* or *paternalistic* was used to de-
scribe the position in society and the relationship with laborers
that men like Sampson had secured in the new manufacturing
climate. Of course the terms were carryovers from the home and
lent an atmosphere of familial responsibility and expectation to the
cold world produced by the new economic relationships. Marxist
historians do not much like them because they obfuscated the class
conflicts at the heart of industrialization. And yet they were terms
available to men like Sampson in fashioning their self-conception

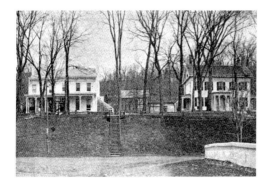
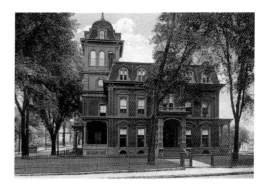

FIGURE 1.6
Left
Unknown
photographer,
Blackinton Homes, n.d.

and managing their new status. But the curious feature about Sampson is that he only partially accommodated himself to them, and only under extreme duress.

FIGURE 1.7
Right
Unknown
photographer, *The
Sanford Blackinton
Mansion,* ca. 1880

Compare him to the other great North Adams manufacturer, the woolen mill owner Sanford Blackinton. When Blackinton imported the Welsh to his factories, he built tenement houses to settle them. These were not the hulking boardinghouses of Lowell or Lynn, where single men and women were stuffed like sardines into small rooms, but two-family homes, where large families were encouraged to settle in, live with a measure of comfort, even tend the small grassy yards—as an early photograph is earnest to show (fig. 1.6)—and plan for a future. A village "of exceptionally high grade" sprang up around the mill (it was one of the lures to the Welsh to immigrate), complete with company store, a school, a church, a library, even a cemetery, all built by the woolen manufacturer.[32] Of course, Blackinton benefited from the arrangement. The company store kept the wages circulating in his economy, and when workers bought foodstuffs on credit, the store kept them in his debt. The church taught temperance, discipline, self-denial, and community responsibility, all values in keeping with the factory's needs. The library was stocked with books Blackinton preferred his workers read; and the school was led by teachers Blackinton had approved. Even the homes mirrored the familial tranquility the manufacturer modeled and supported. His own massive, Second Empire house (fig. 1.7), built in 1869 to much fanfare, could be

understood by his workers (though it rarely was) as on a continuum, rather than as a break, with the domestic arrangements he encouraged around his mill. In these many ways, Blackinton had produced a factory village—a small community of like individuals, with elders (supervisors), the give-and-take of village obligations, the instilling of values from above—that had its roots in a capacious sense of paternalism. When his workers finally struck in 1876, their grievances were specific, about the low wages, numbing hours, indenture brought about by the company store; but their general dissatisfaction had to do with how Blackinton, in their eyes, had broken an implicit contract about providing reasonably for their welfare.[33]

The patriarchal sensibility evidently did not reach Sampson. He offered the French Canadians no homes, no stores, no schools, no churches, no libraries, and certainly no cemeteries. He did not encourage them to bring their families and resettle and made no provisions for them once they were in town. When the French Canadians sought to build a Catholic church, Sampson provided no help; he was a Baptist (and eventually a deacon in the local congregation) and had no use for popery. When they wanted time off during the slow December and January months so that they could visit their families in Quebec, he complained that they "don't care to do more than a certain amount" of work. When some left anyway, he groused, in one of his most extended tirades on record:

> If the best workmen would work all the time they were able to, we should also have better shoes than now; because, to take the place of these good workmen when idle, we have to introduce many that are incompetent. To keep the machinery running we have to employ a surplus of men professing to be shoemakers, but who know nothing about it.[34]

Damn your families and idle time with them! Get back to the factories and work! The French Canadians felt absolutely no loyalty to him. Unsurprisingly, they were one of the first groups of workers to organize and strike in North Adams. It was not until the Chinese arrived that Sampson changed his hard-nosed stance

about providing and became, against all expectation, something like a patriarch.

<center>⁓⧸</center>

The first signs of conflict could be seen only a few years after the French Canadians started work. Sampson brought lasting machines into the factory, and the men, believing the machines would begin to shrink their numbers, simply rebelled. Short of striking, the usual methods of rebellion were slowing the pace, making bad shoes, or tinkering with the machines to make them malfunction—small acts of sabotage. Perhaps the shoemakers did all three; whatever the means, "the men managed to make it cost me more than to do lasting by hand," Sampson complained.[35] Their resistance to machinery must have irked him sorely. While the Lynn manufactories and the Blackinton mill had been almost completely mechanized, Sampson admitted the he had "not as yet been able to do the greater part of my work by machinery."

In 1869, in a move of either colossal arrogance or blithe indifference, Sampson purchased a new factory and attempted to introduce, once again, more machinery and regimentation.[36] The new building was huge—115 feet wide, 120 feet long, three stories high, a main carriage entrance for the traffic of raw materials coming in and finished shoes going out, a central courtyard, and perhaps most importantly, direct access to the Hoosic River, whose flowing waters the manufacturer "may use . . . for the purposes of power or otherwise in any manner [he] shall deem fit," as the deed of sale is careful to elaborate.[37] He was preparing for large steam power. He broke the building into three parts, each floor corresponding to a different aspect of shoemaking: the top for the uppers, the midlevel for the bottoming, the ground floor to hold the steam engines, for storage, and for crating and shipping the finished merchandise. The building was no longer an empty husk in which the shoemaking process was arbitrarily fit; the architecture began to have a logical design function. The men and women were split apart; the berths were organized around the central courtyard, where windows illuminated the stations; the belt-driven stitching and sewing machines were organized in neat rows and the overhead pipes carrying the steam were positioned to

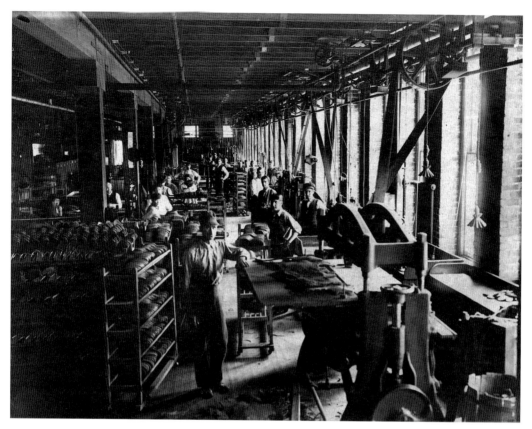

FIGURE 1.8

Unknown photographer, *Interior of the C. T. Sampson Shoe Factory*, n.d.

deliver optimum pressure; and the various pieces for assembly were conveyed to and from the several departments using rolling carts, chutes, and a system of pulleys. A slightly later photograph of his factory, although full of alterations, still reveals something of the original internal structure and design (fig. 1.8). The shoe assembly worked top down, literally, as the process began on the upper floor and the ladies' shoe, as it began to take shape, traveled downward toward the shipping crates and wagons. It was the first time such a comprehensive assembly logic—it is not quite right to call it an assembly line yet—was introduced into Berkshire shoemaking.

Sampson must have been extraordinarily proud of the new factory. It was a visible sign of his reach, and while it did not quite rival the Lynn manufactories in sheer size, it began to approach that level

of industrial splendor and order. No wonder he wanted his Chinese workers to stand in front of it when he arranged for the photograph. The local papers poured unrestrained praise, took their readers on a detailed walking tour, as if the factory were a wondrous monument to industry, and delighted in all the mechanical advances. "It is a model establishment," the *Transcript* declared.[38] Turn this way and that, look at "boiler rooms, coal house, and other store rooms—all arranged and adapted for convenience, dispatch and safety." Take the elevator upstairs, where "30 sewing machines, 1 punching machine and 3 eyelet machines" are humming along. Stand in the central courtyard and be amazed that the "entire building is heated by steam, lighted by gas, supplied with wash rooms, cloak rooms and conveniences of every kind." Take notice that all the work "is executed upon a careful system and proceeds with the regularity of machinery." And remember this prediction: "Large as the business now is, we have good reason to believe that plans are in contemplation for its enlargement, which in the end will make this the most extensive manufactory of this style of work in the state."

The French Canadians responded to the factory by organizing into a union.

<center>≈</center>

Named after a Christian martyr in the third century, the Order of the Knights of St. Crispin traced their beginnings to a medieval French shoemakers' guild. The French Revolution did away with the original centuries-old guild, the preserve of generations of cobblers. When it was revived a few decades later, in Troyes in 1820, the new guild set about reestablishing its medieval identity, often with grand enthusiasm. It revived pageants and customs, resuscitated arcane sayings (to have too tight a shoe was to be "in the prison of St. Crispin," so they said), founded an annual festival (October 25), even put together nonsensical but zealously repeated ditties ("To-day is Monday, my friend / The shoemakers dress up to visit St. Crispin, my friend / Who used to work in his shirt").[39] How much the guildsmen poked fun at themselves in their energetic recovery of a medieval past seems evident. Equally clear in all the chivalry and song was that the revamped guild was not only an

economic and political entity meant to protect craftsmen but also a social club of the working classes.

The first Crispin lodge in the United States was established in Wisconsin in 1867, but its largest membership, beginning in 1868, soon proved to be in Massachusetts, the king state of shoemaking. The increase in the state's lodges was dramatic. In 1867, there were only three, but in 1868 forty-three, in 1869 sixty-seven, and in 1870 eighty-five. By the turn of the decade, there were somewhere between forty thousand and fifty thousand Knights.[40] In the central and especially the western part of the state, the swell in numbers occurred, not coincidentally, with the mass immigration of French Canadian cobblers. They imported the songs and sayings of the mother tongue, no doubt as a means to nurture a social community, as had been encouraged by the guild elsewhere. They transplanted rites and secret rituals, including some of the more bizarre (rumor had it that new members were tossed up and down in blankets as part of the initiation rite—tossing forty thousand at one time or another must have been lunatic).[41] But in the face of industrial-style shoemaking, the main efforts of American Crispins were to monopolize the skills needed to run the new machines, to diversify themselves in the new industry while at the same time legislating who of the shoemakers learned what particular skills and when, and to enforce a closed shop. The secret pledge was unequivocal on these scores.[42]

And so it happened in 1869 that the French Canadians at Sampson's factory, already chafing at Sampson's bit and surely sore that the manufacturer had introduced yet more technology and was being lauded for it by journalists, organized the entire bottoming room. They must have taken the secret nature of their blanket-tossing initiations seriously because Sampson later declared he had no idea his workers had formed a lodge.[43] Almost immediately they tested their muscle. Something of Sampson's bewilderment and annoyance at his learning of their presence and first demands can be glimpsed in his recall of events:

> I employed a man, who was an excellent shoemaker, to make up a certain class of work. He could make a very nice shoe, and I wanted one of that kind made; so I set him to

work in the room with other bottomers, not knowing any-
thing about the Crispins. A few days after, my foreman noti-
fied me that there was a man at work up stairs that the help
did not like to have there. When I asked why, he answered
that he believed they had an order called the Knights of St.
Crispin, and that it was so constituted that they could not
work with a man not belonging to it. I replied that that was
nothing to me; that I employed him, and I employed them.
The matter rested until the next day, when they applied to
the foreman to know if I wasn't going to turn the man off.
He said he guessed not; and they, in turn, said they would
not work in the room with any such man as that; his morals
were too bad. They made that excuse.[44]

"That was nothing to me"; "They made that excuse"—the clipped
responses and quick dismissals spoke volumes of his indifference to
the French Canadians' concerns. There was never any chance of
compromise.

Events moved quickly after that. The Crispins struck, simply re-
fusing to work. Sampson let them go and claimed that he pro-
ceeded to operate the entire bottoming room with his single man,
the "excellent shoemaker" (another of his tall tales). According to
the shoe manufacturer, the Crispins cornered the man one evening
and "whipped him," forcing him out of town. Rather than accede
to the Crispins' demand for a closed shop, Sampson "filled up our
shop then with green hands." The green hands made a poor shoe.
He sent his superintendent to Maine and his foreman to Quebec
to find more workers "that did not belong to the order," imported
them, and made them sign a pledge that they would not join the
Crispin lodge. But to no avail because—the exasperation in Samp-
son's account has an understated but palpable and almost resigned
tone by this point—"[v]ery soon I found they all belonged to the
order; but they kept very quiet until last winter." Their numbers
increased, the Crispins struck again, not only demanding the
closed shop but this time also wanting to inspect the shoe manu-
facturer's books and set their wages to his profits. To Sampson,
opening his books must have felt like a violation of his hard-
earned entrepreneurial identity. The demand clearly infuriated him

because he immediately fired the new Crispins and sent for more workers from North Brookfield. The North Brookfield men—yet more Crispins, it turned out—arrived in North Adams but quickly recognized they were being brought as scabs, met with the local lodge, soon after refused to work, and made plans to return home, but not before Sampson held forth to their representatives. As Sampson recalled his tirade:

> You are going, and I am very sorry. It has been a consider-able expense to me. I expected to get my shop to running in such a manner that things would move along smoothly. . . . Boys, if you leave North Adams, you will never work for me. "What do you mean," said they, "are you going out of business?" No, said I, I am not, but shall just as sure enter a wedge that will destroy your order in five years.[45]

Seemingly surrounded everywhere by those unruly, demanding Crispins, Sampson sent his superintendent, George Chase, to San Francisco to hire a gang of Chinese. Chase left for the coast in late April or early May 1870, in either case less than a year after Sampson's model establishment had opened. By late May, the superintendent had rounded up a crew of seventy-five—a foreman, two cooks, and seventy-two would-be shoemakers—and on June 1 set off with them for North Adams.

<center>ൟ</center>

Thus far, I have wanted to narrate events in North Adams that led to the Chinese arrival and provide some footing that will enable us to decipher what the shoe manufacturer saw in the photograph of his new, imported Chinese shoemakers. Sampson's generous sense of himself matters, of course, especially as this was calibrated against the notions of what being a manufacturer amounted to in the Reconstruction era. In Sampson's case, such an identity em-phatically did not encompass the patriarchal or paternalistic sensi-bilities that other manufacturers attempted to incorporate. His extraordinarily poor relationship with his workers was an impor-tant result. The truculent rise of the French Canadian Crispins also matters, especially as this was coincident with a mass immigration

and new migration patterns across the border and a general trans-
formation of the town's overall geographic and demographic con-
tours. Indeed Sampson's move to the Wilson House and the
congealing of ethnic neighborhoods and tenement housing evi-
denced an increasing social differentiation in a town previously
unmarked by that. "Immigrants," "migrants," "townspeople," "work-
ers," "manufacturers"—these means of distinguishing people sud-
denly took on much more material, visible meaning as the town
itself began to bear the look of a new economic and social order
for its many inhabitants.

What happened in North Adams was a microcosm of what
happened in many industrializing towns throughout the North-
east. Those uneven developments from hamlet to factory village in
the antebellum and Civil War Berkshire hill towns, the mill towns
in the great Connecticut River valley, the textile towns in Worces-
ter County, and more, were variations on a theme. What tended to
separate these developments from those in eastern Massachusetts,
particularly the famous and much-copied enterprises in Waltham
and Lowell, were the existences of local proprietors (as opposed to
absentee landlords and corporate manufacturers) and the hiring of
individual men and families (or in North Adams's case, immigrant
men) as opposed to the hiring of unmarried daughters of Yankee
yeoman and the sequestering of these girls in supervised boarding-
houses.[46] They made the distinctions and demarcations between
the key actors, the commingling and volatile relations between
them, and the excited debates about their changing social identi-
ties more intimate, visible, and fraught.

What made North Adams unique, however, and what made it a
historic crucible are, first, the prominence given to photography
and the picturing of workers and, second, the turn to the Chinese.
These two stories will be taken up at greater length in following
chapters, but for now we need to provide some small sense of
them to help us understand what the shoe manufacturer saw.

❧

Photographing workers came about almost as an afterthought as
part of an effort to picture the construction of the nearby Hoosac

Tunnel. In 1851, excavation began at the Hoosac Mountain, the large natural barrier on the east side of North Adams, to make way for a railroad line connecting the town to the lucrative markets in and around Boston. Begun and spurred on by North Adams's budding manufacturers, including the same George Millard who had brought his obliging younger cousin Calvin Sampson to town, the Hoosac Tunnel's proponents had no real idea how difficult the undertaking would prove to be. Tunneling began with "a ponderous and costly boring machine," an early account admitted, hardly marking the mountain face, like a spoon digging at acres of granite, but "with which it was the intention of the company to cut or bore a hole through the mountain the full size of the tunnel," an estimated length of five miles, easily the longest tunnel in the world.[47] The initial bore quickly gave out; others replacing it gave out too. Tunneling stopped almost immediately; it was an embarrassment of national proportions. If Millard and his cronies hoped to keep the failure quiet, Oliver Wendell Holmes made sure it was widely publicized, setting the overweening ambition and humiliation to awful verse:

> When publishers no longer steal,
> And pay for what they stole before;
> When the first locomotive's wheel
> Rolls through the Hoosac Tunnel's bore,
>
> *Till* then let Cumming blaze away,
> And Miller's saints blow up the globe;
> But when you see that blessed day,
> *Then* order your ascension robe.[48]

In 1854 the North Adams company convinced (some would say scammed) the state legislature to loan it $2 million to resume the job. Work restarted but groaned along slowly, hardly a third of the way through the mountain by 1861, when funds from the loan ran out. Exasperated by the bungling tunneling company but having invested so much money and energy already ("years of incessant poverty, frequent misunderstandings, serious trouble . . . and much legislation," as another early account put it only slightly more delicately), the state took over the job and kept the project moving,

mostly by fits and starts.[49] The reports from this state-run era are most notable by the colorful names given to the various obstacles—"demoralized rock," "disappointment dam," and the like. ("Demoralized rock" is actually a descriptive term for rock that "when exposed to the influences of air and water ran like quicksand." Of course, the ironists had other uses for the name.)[50] By 1869, just months before Sampson opened his new factory, the state's Hoosac Tunnel commissioners, "weary of making constant appropriations and seeing small results," gave up control and contracted a Quebec company to take over the job.[51] Already costing $7 million, the tunnel seemed a black pit that swallowed money and spat out only debris.

However, 1866 marked a rough turning point. In that year, the company put to use two new ideas for tunneling. The first was the introduction of machine drills driven by compressed air, what quickly became celebrated as the "Burleigh drill." The second was the introduction of nitroglycerine to explode the hard rock to smithereens, a dangerous process never before used in any tunneling project. There was a good bit of experimentation, leading to unwanted explosions, causing mutilations and deaths. (The papers took a strange glee in reporting them; "The remnants of [E. J. Wilson] were gathered in a small box," one noted, and "the peculiar circumstance is the fact that more in bulk of his clothes was found than of his body.")[52] The investment in these new procedures was considerable. The Burleigh drill required a massive amount of compressed air to make any useful mark, so the company had to dam the nearby Deerfield River at an expense of $128,000 in an effort to produce enough power (the results were initially miserable). The highly volatile nitroglycerine required manufacture on the spot, so the company had to build a factory just for the purpose. But the tunneling began to quicken, if incrementally so. Eager for any kind of positive news to report, the company invited images of all kinds—but especially photographs—to be made. And it was then that an imagery of work and of workers in North Adams first took shape.

Most of the initial photographs are declarative, if not a bit celebratory. Here is the air compressor house (fig. 1.9)! Look at how well it sits at the river's bend and catches the current. And here are

FIGURE 1.9
William Hurd and
Henry Ward, *The large
building in the foreground
contains the machinery
which drives the drills,
over one mile from that
point, in the bowels of
mother earth. Also
engineer Ellis' House,
Office, &c.* (no. 810,
"Hoosac Tunnel"), ca.
1867

the air compressors inside the compressor house (fig. 1.10)! Observe their military orderliness and readiness to do the bidding of the engineer. The pistons and rods are primed for action. And here is the tunnel (fig. 1.11)! The bricks lining the vault are wondrous; they catch the light like gemstones. The photographs became the basis for prints and illustrations and began to appear in the national journals, much to the company's delight (fig. 1.12). The tone of the journals became more approving. "If the mountain would not give way to Mahomet, Mahomet must go through the mountain," *Scribner's Monthly* explained (if Holmes cited the apocalypse in his denigrating verse on the company's early humiliation, *Scribner's* would proclaim divine inspiration at its more recent achievement).[53] The Burleigh drill soon proved so much more efficient than the previous bores that it became a kind of holy weapon. The men were pictured holding it in reverence (fig. 1.13). Four drills were combined and put on a carriage, and during operation swung this way and that like snakes on a Medusa, hissing and clanging ferociously from the sound of thousands of poundings per minute— the whole thing like a monster machine gone berserk (fig. 1.14). Nitroglycerine was inserted into each drilled hole, and then whole

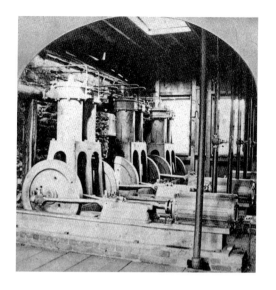 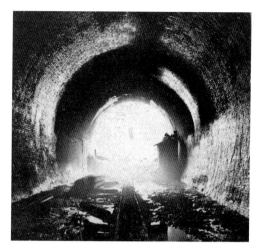

FIGURE 1.10
Left
John Moulton,
*Machinery for
Compressing Air*, ca.
1868

FIGURE 1.11
Right
John Moulton, *Entrance
to Tunnel, West End*, ca.
1868

sheaths of the heading were blasted. The explosions became more frequent. The journalists complained of the deafening noise but also noted with relief what it represented. The photographers tried to keep pace with all the changes in technology and monitor the increasing length of the tunnel, recording every development at the excavation site, no matter how seemingly insignificant.

We should say "sites" because there were several. Boring had begun at both the western and eastern ends of the Hoosac Mountain, the progress (and uncertain achievements) of which the photographers studiously observed (figs. 1.15 and 1.16). On the mountain's extended plateau, the company dug three deep shafts—known simply as the West, Central, and East shafts—to reach down to the proposed tunnel route and provide as many headings to drill. The photographers were on the plateaus too, capturing the buildings sitting over the shafts (fig. 1.17), the several elevators used to lower men and supplies into the tunnel, the water lines, the stacks of lumber, the growing mounds of excavated debris, the machine shops, the nitroglycerine factory, the dumps, the pumps, the ruins, the aborted shafts, the surveyor's towers, the wells, the piles of iron strapping, and brick and stone rubble, and on and on. On the backs of their photographs, they added captions providing brief

FIGURE 1.12

Unknown illustrator,
*Hoosac Tunnel—
Air-Compressing
Buildings and Machine-
Shops,* based on
photograph by George
Rookwood, 1868

FIGURE 1.13

Unknown
photographer, *Burleigh
Drill,* ca. 1868

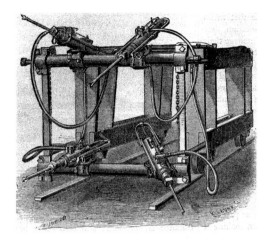

FIGURE 1.14
Unknown illustrator,
based on photograph
by the Kilburn
Brothers, *The Burleigh
Drills Upon the
Carriage*, 1870

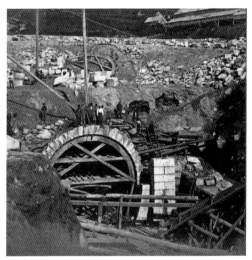

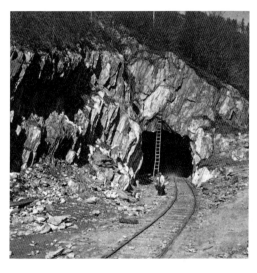

FIGURE 1.15
Left
William Hurd, *View at
West End of Tunnel*, ca.
1867

FIGURE 1.16
Right
William Hurd and
William Smith, *East
End, Near View* (no.
220, "Hoosac Tunnel
Route"), 1870

information about what was pictured and also, for the long suffer-
ing, measurements about how deep or far the tunneling had pro-
ceeded—in effect, providing both a catalogue of technology and a
running statistical commentary in photographs.

For our purposes, what began as a photographic compendium
of the tunnel's technological wonders and incremental progress in-
cluded, almost as a by-product, an archive of the Hoosac's many
workers. In order to show the elevators at work, the lifts were filled
with miners (fig. 1.18). To reveal the supplementary wells' locations

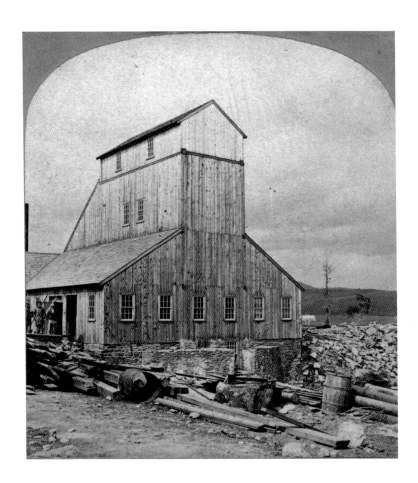

FIGURE 1.17

John Moulton, *Entrance to Central Shaft* (no. 269, "Hoosac Tunnel and Vicinity"), ca. 1869

(they were notorious for being stumbled upon), overseers were stationed nearby (fig. 1.19). And to suggest how large and deep East Portal had become, the photographers showed it receiving seemingly endless cartloads of drillers and diggers (1.20). The men were carefully posed, as in figure 1.18, with the elevator suspended part way to simulate either its ascent or descent. Sometimes they were called to attention, as in figure 1.20, where they all take note of the photographer on the hill above (a man has even brought his horse to a halt). They were captured with tools (fig. 1.13), on the rail carts, near the shafts and buildings—anything that helped identify the machinery and key sites of the tunneling process. They were rarely shown at work, in that their muscular activities with

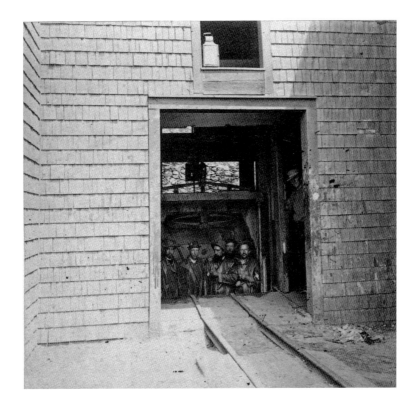

the drills or dump carts were never pictured (and never thought
worth picturing); and the general impression of their workdays, at
least as the pictures have it, seems to amount to nothing more than
a series of stilled gestures, primpings, and formal addresses. Of
course there were technical constraints with the early cameras,
which prevented capturing subjects in action (Muybridge's mo-
tion studies notwithstanding); but in North Adams, these went
hand in hand with a general attitude about what was worth photo-
graphing and how to accomplish the task. The captions rarely
mention the men because, after all, the idea of picturing *them* was
secondary. Consider, for example, the long caption for figure 1.19.
Though to our eyes the man with rolled sleeves may seem a signif-
icant aspect of the picture, for the photographer, the scene was best
understood as "Supplementary Shaft and Well No. 4, with Grey-
lock Mountain in the distance. At the bottom of this Shaft is a

FIGURE 1.19
William Hurd and
Henry Ward,
*Supplementary Shaft and
Well No. 4, with
Greylock Mountain in
the distance. At the
bottom of this Shaft is a
mammoth Steam Pump
which raises 1000 gallons
of water per minute a
distance of 215 feet* (no.
802, "Hoosac Tunnel"),
ca. 1868

mammoth Steam Pump which raises 1000 gallons of water per minute a distance of 215 feet." The man is merely a prop and pointer to the shaft, the mammoth pump, and the gushing water that exist entirely off-frame.

But the important point is that the Hoosac's workers, in these many side roles, actually achieved visibility and, equally important, their presence was defined in relation to the new technology. Although rarely named or described in the captions, they were *shown* as having occupations of the industrial sort, being carefully juxtaposed to the mechanical inventions and engineering ingenuities celebrated by the company—men next to costly machines, siding up to the hallowed portals, in front of the shaft houses (fig. 1.21), even witnessing the wafting steam of an invisible water pump. The Hoosac's photographers, almost in spite of themselves, had produced an iconography of the worker. It was no small thing—in

Figure 1.20
William Hurd, *East End, Miners Going In* (no. 221, "Hoosac Tunnel Route"), ca. 1870

these many pictures, the industrial worker obtained visual representation that, in North Adams at least, he had never previously enjoyed.

◦◦

There was a rough equivalence between the appearance of industrial workers in photography and their appearance as labor unions in the state's political arena. Both had come about as effects of the huge investment in industries during Reconstruction. If the Hoosac's workers gained visibility because of the ambition to photograph other kinds of developments at the tunnel, the state's labor unions gained political visibility because of the aggressive ambitions of manufacturers to mechanize their factories and maximize productivity. This is not to deny the obvious social benefits the

Figure 1.21

William Hurd and
William Smith, *General
View of Central Shaft
Building* (no. 235,
"Hoosac Tunnel
Route"), 1870

Crispin guild, for example, provided for its members; or the ways in which it brokered the traumas and dramas of immigration for French Canadians. But it is to suggest that the enormous push by manufacturers to create the proper economic and technological conditions for factories in the late 1860s brought about mass worker organization and agitation. And equally so, it brought about keen political interest.

The signs of labor's political visibility were everywhere. Wendell Phillips, the longtime abolitionist, put himself up for governor on the ticket of the newly founded Labor Reform party. Ira Steward, a Boston machinist, founded the politically active National Labor Union and almost immediately began agitating for an eight-hour day. For our purposes, the most pertinent sign was the establishment in 1869 of the state-run Massachusetts Bureau of Statistics and Labor; it was the direct result of Crispin agitation. The Crispins

petitioned the state for a charter—in effect, asking for official recognition for their right to monopolize shoemaking skills and enforce the closed shop. The legislature denied the petition— hardly surprising—but understood "that something [should] be done for labor."[54] Observing the incessant strikes and factory shut-downs, it created an agency with the express purpose of investigat- ing the reasons for labor's organized behavior and proposing recommendations for new legislation aimed at addressing the many causes. The bureau's prolabor sympathies were unequivocal, as the investigators openly declared. "The subjects to which, dur- ing the past year, we directed our attention," they wrote,

> were the conditions of wage-laborers, both men and women, their wages, earnings, hours of labor, cost of living, savings, education, moral and physical status, their opportunities for improvement through unions of any variety, cooperative experiments, libraries, reading-rooms, or other intellectual as- sociations, &c., the surroundings of congregated and out-of- door labor, the conveniences or inconveniences of their working places and homes, and the employment and school- ing of children in factories, stores, shops, or on the street.[55]

Of the conditions for manufacturers, they had no interest. Their findings included the grisly and yet by-now familiar inventory of horrors that appeared in countless social reformers' reports throughout the late nineteenth and early twentieth centuries. But even today, the conclusions, written in the clipped and understated official language of the state, still have the capacity to outrage. The conditions of the working people of Massachusetts were dismal. Labor's children were uneducated and being abused as the lowest factory help; wage-laborers barely subsisted on the pay they re- ceived, "being oftener in debt than out of debt"; reduced wages, more and more prevalent during Reconstruction, was not accom- panied by reduced hours, in fact quite the opposite; housing con- ditions were horrid—claustrophobic, filthy, infested—and needed "some means of relief and perhaps remedy"; while the banks were busier than ever, "the greatest amount of deposits is not the de- posits of wage-laborers"; in fact, extreme poverty is "the normal

condition of wage-laborers." The agency's recommendations were equally clear in its prolabor sympathies. "Any and all legislation that tends to make men better, or more valuable," it declared, "is in favor of labor. Legislation in the interest of production, solely, is not in favor of labor. Any legislation giving additional power to capital, is against labor." And the agency concluded, in extraordinary understatement, "Capital has the necessary power and knowledge to take care of itself."[56] For the workingman, wages should be increased, hours decreased, child labor abolished, and children guaranteed a minimum of three hours of schooling every day. The factories should be made safer, educational facilities made available, and the conditions should be regulated by the state. In fact, the factories should be monitored by specially appointed inspectors "who shall have the power to enter the premises of any establishment when in operation, to make research and to enforce the law"—a detail that surely irked Sampson.

For its first annual report, the bureau made a special trip across the state to North Adams and investigated Sampson and the Crispins. In the interviews, the shoe manufacturer came off badly—arrogant, uncompromising, and, with his testimony juxtaposed to contesting testimonies from the Crispins, untrustworthy. ("He never kept a single bargain with me that he ever made," one complained.)[57] After reading the complete report, the shoe manufacturer met with and railed bitterly at the bureau's inspectors. The transcription of the meeting is worth quoting at length; it gives a sense of Sampson's wounding and his near-hysteria at his word being contested by labor. "I have a bone to pick with you. . . . You have done me a great injury by going outside and getting affidavits . . . which I can prove are false in every particular, and publishing them in this book. . . . After you got my statement, you went outside and got testimony that I can prove to be false, from persons that I had had in my shop and I could not get along with at all, and were prejudiced." And to the request for another interview (another opportunity to assess the conditions of the factory), he balked. "I decline to give you any information whatever."[58]

How it must have inflamed Sampson that the shoemakers, who had prevented him from mechanizing more fully, whom he would

rather dismiss than accommodate and would happily replace with Chinese, were gaining unprecedented visibility. Even more enraging, they seemed to be eliciting political and legislative sympathies for their cause and, in the official reports, transforming him into one of those dark, satanic mill owners of Dickensian proportions. Representation, even the false sort, began to matter. He closed off all further inquiry not of his own choosing.

<div align="center">❧</div>

Debates about Chinese workers took place in North Adams well before Sampson ever decided to send for them; but what is most striking about these early discussions is how airy and abstract they were. The excited national arguments about Chinese labor, at least as it was being read about and interpreted in North Adams, centered on developments far away in California. They all seemed so petty and ungenerous. Responding to reports of vigilante violence in San Francisco, for example, a townsman opined in the local *Transcript*, "If the Chinese are to be permitted to come to this country, the authorities ought to see that they are fairly treated."[59] The editor for the paper spelled out what fair treatment might require of his readership. "Christianize and citizenize the Chinese by the touch of human kindness," he offered, to which the local churches gave their approval, while a few other locals, no doubt prickled by their experiences with so many new French and Irish Catholic foreigners in town, groaned. There was mild debate among the would-be missionaries about which ministrations might prove most effective. Should they be taught English first? Should they read the Bible or have it read to them? What passages were best? The editor tried to put the matter to rest, since it was so removed from events in the town anyway, and declared of the Chinese, "As yet we know almost nothing practically about them . . . let us therefore wait till the contrary is demonstrated before we denounce them as a plague of locusts, a curse for the coming years."[60] The sentiments were no doubt noble, but when these calls for Christian patience and kindness were made, no one in North Adams believed the Chinese would ever appear and put them to the test.

The early discussions, however, had a measurable impact on North Adams's manufacturers. In 1869, Southern industrialists, recognizing how the recently completed transcontinental railroad made Chinese immigration to the east possible, if not desirable, began to float the idea of importing Chinese labor to replace Southern black labor now freed by Emancipation. The most famous of these proposals was offered that summer in Memphis at the nation's first Chinese labor convention. "They are just the men, these Chinese, to take the place of the labor made so unreliable by Radical interference and manipulation," the editor for the *Memphis Appeal* declared.[61] Some were less delicate about the "labor made so unreliable" and the need to find suitable replacements. "Better a few years of Confucian philosophy than a cycle of Ashantee feticism [*sic*]," proclaimed the *Montgomery Mail*.[62] The proposals at Memphis were strident—the wounds of the Civil War still festering, the conditions of the Southern economy desperate, and the worries about uncontrolled immigration and dirt-cheap labor, so vexing to the organized working classes, hardly considered. The scheme was given a measure of concreteness when Cornelius Koopmanschap, the owner of a fleet of clipper ships and procurer of Chinese laborers for Stanford and Crocker and the Central Pacific, took the podium and offered to deliver thousands of Chinese direct from the mainland for a hundred dollars a head. What had begun as speculation transformed into real possibility; Koopmanschap was soon fielding orders.[63]

The unabashed Southern enthusiasm for Chinese labor, as evidenced at Memphis, almost immediately reached northeastern shoe manufacturers. In the June 1869 issue of their trade journal, *Hide and Leather Interest and Industrial Review*, the editors proposed that "now that the Pacific Railroad is open, that the appearance of forty or fifty pig-tailed Chinese in one of the New-England shoe factories would begin to open the eyes of the Crispins, and be most effectual in bringing them to their senses."[64] But many Northern manufacturers, eager to outflank organized labor with Chinese but wanting to distance themselves from the Memphis radicals and their unreconstructed attitudes, began to insist that they were *not* proposing to assemble yet another enslaved population, not trading

Ashanti fetishes for Confucian robes; and they created an important distinction to argue their position—fretted over and repeated endlessly—between voluntary and involuntary work, between the immigration of free individuals and the forced immigration of gangs of coolie labor. Read the agonized distinctions offered in *Scribner's Monthly*, in which the author, Frank Norton, after disparaging coolie labor of the sort procured by the likes of Koopmanschap, attempted to describe the situation concerning Chinese labor.

> [T]he Chinese emigration . . . is very different. In the first place, it is entirely voluntary. The Chinaman, disgusted with the injustice and poverty in his life, seeks to escape to the rich and generous country of which he has heard; and if he has not the passage-money from Hong-Kong or Canton, mortgages his wife and family, giving his notes with large interest, and commission for brokerage, bribery, etc., payable a certain length of time after his arrival in America. This insures his passage to San Francisco, where he is immediately taken in hand by the company from his district. . . . These companies are entirely honorable and trustworthy; and will, if desired, guarantee the conduct of those whom they supply for positions. Of course they have a firm hold upon the Chinese immigrants, as a threat to dissolve connection with them would be equivalent to robbing them of their only trusted proprietor. At present . . . Chinamen are unwilling to come East in individual cases, or except in gangs of twenty-five or fifty. This is natural enough.[65]

Chinese men mortgaging their wives and children, signing promissory notes with huge interest rates, indenturing themselves to labor companies, and working at low wages until their enormous debts were paid (often years), and never fleeing these companies because of the jeopardy to their families—these were hardly the signs of unfettered immigration. Yet they could be tolerated and explained away because, as Norton proclaimed, the Chinese choice was "entirely voluntary." Of the move to bring Chinese to the Northeast in coolie-like gangs, this was "natural enough," apparently befitting the Chinese herdlike sensibility.

In North Adams, *voluntary* and *involuntary* became important catchwords, the distinction between them honed to a fine point. They were augmented by the dogma of "Christianize and citizenize," repeated like a mantra, because it allowed manufacturers to imagine they could import an immigrant labor as a free workforce, capable of being Americanized. Sampson, proud of his Yankee roots and a deep advocate of the Union (though he eagerly stocked the South with boots and shoes), happily chanted along. When the *New York Tribune* suggested Sampson's Chinese had arrived under coolie contracts, the shoe manufacturer shot back in no uncertain terms: "It should be understood that the immigrants came east of their own volition, and that Mr. Sampson's enterprise has no connection whatever with that of Mr. Koopmanschap."[66] No Yankee would have been caught dead advocating either the Southern proposals at Memphis or the controversial coolie trader.

For a man who had previously shown no interest in "citizenizing" his immigrant laborers and cared little about their well-being, Sampson was put in the unexpected position of having to declare his interest in Christianizing and saving Chinese souls and insuring the Chinese were not treated as slave labor. And it got more compromising. The terms of his contract with the Chinese labor company, Ah Young and Ah Yan, which had organized the men, specified that "house, wood, and water" be "furnished free" to the Chinese. "Railroad passage over to be furnished free," and if the men fulfilled their contracts, Sampson was to provide "free passage back." If the economy took a turn for the worse and the factory had to slow its operation, the men would still "receive full pay." If the factory closed and work stopped for whatever reason, including the bankruptcy of the company, the shoe manufacturer owed "free passage back."[67] Of course he paid the men less than the French Canadians had wanted, about twenty-three dollars per month or about ninety cents a day, compared to nearly twice that for the Crispins.[68] Yet, free housing, free heating, free transportation, caring for his workers' souls, providing them full pay even if his own pockets were quickly emptying, making sure they had water to cook and drink, clean and bathe themselves, and (rumor had it, which turned out false, though Sampson seems to have let it

have a life) paying for the return of any Chinese who unexpectedly died—Sampson had suddenly become paternal.[69]

≈

At its most obvious, the photograph of the Chinese against the south wall records an unusual sight, insofar as it pictures men from afar, Chinese no less, who have come across country in an unprecedented manner and arranged to take their places in the northeastern workforce. The uniqueness of their race mattered, of course, but their apparent unattachment to class mattered just as much. Unlike previous workers who had been brought to North Adams to work in the factories but who were never pictured in this way, these men were being held up as sufficiently different, not only by race but by their difference from the organizing working classes. They were an unorganized workforce, at least insofar as "organized" was understood in the Crispin stronghold of Massachusetts, and were brought under conditions favorable to a gambling factory owner, who had attended carefully to proposals like those offered in Memphis and *Hide and Leather*. (Or perhaps it is better to say that the Chinese were "organized" only by Sampson or, even more strictly speaking, only by the photographer in Sampson's pay on that June morning.) The Chinese came on limited, cheap contracts, were isolated by language from the persuasions of labor organizers, and held no widely agreed-on legal rights to drag Sampson before the increasingly worker-friendly legislature. With the wide distribution of the photograph as a stereoview, Sampson was flaunting his independence, risk-taking, and ingenuity in the battle over the future of labor as it was being waged in New England.

≈

It may seem eminently proper that when newspaper illustrators came to cover events in North Adams, they depicted Sampson at the head of his workforce, showing him teaching the Chinese how to run the machines in the bottoming room, picturing a hands-on entrepreneur who had finally found laborers capable of keeping up with his rugged, manly energy and learning the steam-powered tools of the trade (fig. 1.22). The Chinese gather around still wearing

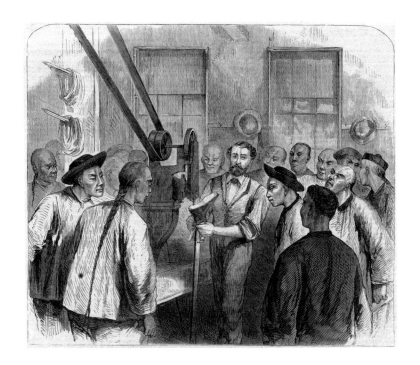

FIGURE 1.22

Unknown artist, *The Avant-Couriers of the Coming Man—Scene in Sampson's Shoe Manufactory*, 1870

their traveling clothes, some with their broad hats and skull caps. They have not even bothered to unpack, simply tossing their hats onto pegs and ready to launch into the business at hand. In their eagerness, they take their cues from Sampson, dressed like the grand manufacturer, who has not even taken time to change into work clothes. There is a job at hand.

The problem was that Sampson did not know how to run any of the machines. To teach the Chinese how to use the kind of pegging machine pictured in figure 1.22, he had to sneak "master workers" into the factory (an appropriately vague name offered by the local journalists, making it wholly unclear whether they were non-Crispins, Crispin scabs, or general machinists).[70] The master peggers provided several weeks' worth of lessons, Sampson paying them three times what he was paying the Chinese. But we can be sure, given the circumstances, he was not at all displeased by the image of him as a working shoemaker at the head of his factory, of capital and not labor taking hold of production; he found ways to imply to journalists who came from afar that the illustration was pure and true.[71]

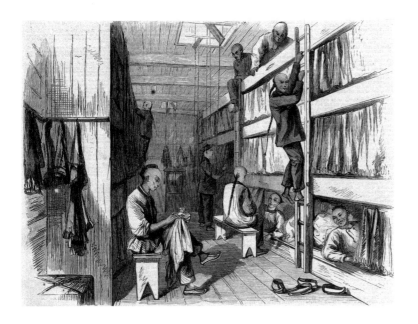

FIGURE 1.23
Unknown illustrator,
*The Avant-Couriers of
the Coming Man—The
Sleeping Quarters of the
Chinese Workmen*, 1870

Whereas the inspectors for the Bureau of Statistics and Labor were kept out, Sampson invited the journalists in. He had many other things to show them, chief among them the domestic arrangements for the Chinese. The illustrators eagerly complied. The "special agent" for *Frank Leslie's* was almost immediately on the spot.[72] To house the Chinese, an entire room on the ground floor had been cleared of supplies and spare parts, new studs and crossbars hammered into place, and bunks arranged in long rows, four beds high (fig. 1.23). It looked like a ship's berth or a dormitory, and the illustrators and journalists couldn't resist the suggestions. Theodore Davis of *Harper's Weekly* pictured it as a vast warehouse with plunging aisles, almost like the narrow alleys of a neighborhood—of a Chinatown (fig. 1.24). Men socialize as if they were on the streets, read books, darn socks, and loiter. He followed the men to a new dining hall—another huge room on the ground floor cleared out to accommodate their three-times-a-day meals—making sure to depict the bowls of rice and chopsticks everywhere in evidence (fig. 1.25). He took a peek into the kitchen (fig. 1.26), where a stove had been installed and the two

FIGURE 1.24
Top left
Theodore Davis, *The Dormitories*, 1870

FIGURE 1.25
Top right
Theodore Davis, *The Mess-Room*, 1870

FIGURE 1.26
Bottom
Theodore Davis, *The Kitchen*, 1870

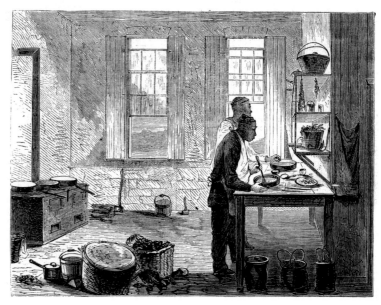

cooks worked all day to feed the entire crew. And he went to the south lawn where a makeshift playground had been outlined (fig. 1.27), and the men were imagined to fly kites and throw confetti (a peculiarly pageant-like form of play, no doubt gleaned from stories of New Year's celebrations in Chinatowns).

Sampson was keen on the playground, though it was more like a compound; he had erected an eight-foot picket fence around the factory, turning it into a fortress.[73] He wanted the environs sealed to keep the Crispins out; but the effect on visitors was to see the

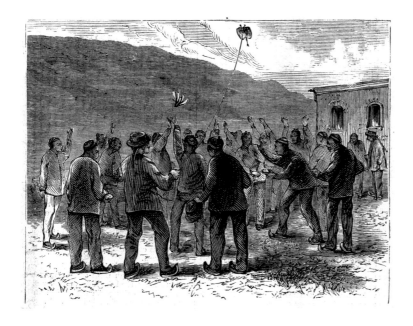

FIGURE 1.27
Theodore Davis, *The Play-Ground*, 1870

whole place as a special preserve, almost removed from North Adams entirely. "Here we are in China," the editor for *Harper's New Monthly Magazine* declared upon seeing the factory. The effort to transform the complex into a quarantine home seemed to elicit other kinds of associations.[74] The place had a "quiet, domestic air," like that found in a "college quadrangle."[75] The building was a neighborhood, a college house, a steamship's hold, "a steerage,"[76] a living theater, a nursery, a glorified "sleeping chamber,"[77] and of course the Forbidden City itself. At any rate, the arrangement was no Lynn factory.

Perhaps Sampson's most dramatic effort to accommodate the Chinese—certainly the one for which he received the most resounding notice among visiting journalists—followed through on the key mandate to "Christianize and citizenize" them. About a month after the Chinese had arrived, Sampson instituted Sunday school. All the early debates about the proper course of Bible study were unleashed again. The dining room was rearranged, missionaries and townspeople came tumbling in, and English, arithmetic, and Bible instruction offered to the Chinese. The New York papers were stunned and sent another round of journalists to the Berkshires to

report. They gave rise to easily the most sympathetic portrayal of Sampson's experiment yet. The Chinese are earnest in their studies, the newspapers wrote, and the process of Americanization is very much visible. "They are capable of thorough culture and religious impression," *Scribner's* observed, and "so long as they love the school and its associations, are open to kindly Christian influences, are temperate and industrious, we see no reason why our broad territory, a haven for the oppressed of every clime, should be denied to the Celestials."[78] Of course, there was a good deal of bafflement and horror among the visitors too. "I was terrified to see and hear all these strange creatures singing, 'Washed in the Blood of the Lamb,' " one of the young missionaries recalled.[79] We can just about imagine the shrieking choruses that passed for song, made all the more unbearable by the earnest, death-march rhythm. But the larger point is that the Chinese sang, apparently enthusiastically, and Christian patience and kindness seemed to be having their intended effect.

❧

Perhaps his newly found paternalism, however much it was summoned in response to the debates about labor and the use of the Chinese, caused Sampson to pursue yet another curious, unprecedented course of action. Perhaps it was the good press he was finally receiving from the national journals and how this corrected, in his view, the unjust characterizations of him by the Crispins and their supporters. And perhaps—we can be more certain of this—something in the photograph of his workers against the south wall piqued his interest. Their long lineup, their spread across the flat plane of brick and glass, and yet paradoxically their compact dark mass, their togetherness, their belonging to—he thought he knew what—gave inspiration about what pictures could manufacture. Whatever the several spurs, he sent his Chinese workers to visit the studios of two local photographers.

The Chinese went in their finest clothes, sat for the cartes de visites, obtained the six or eight copies that were usually printed, and returned to the factory (figs. 1.28 and 1.29). Sampson took a copy of each portrait upon the men's return, collecting a kind of visual archive of the factory workforce and providing testimony to

Figure 1.28
William Hurd, *Ah Har*,
1870. (Private
collection.)

his paternalism. One of the men seems to have understood the
reasons he was sitting for it and may have asked that Sampson's
name be written on his picture, a nod to the boss man; but the
transcriber misheard the name and request and wrote "Simpson"
instead of "Sampson" (fig. 1.30). However the name got penciled,
the gist was clear. They were Sampson's community of men, and
as their ushering to the studio suggested to them, Sampson wanted
that announced in photography.

The album does not survive, and we have no strong clues about
its format or all of its contents. But it must have been nonetheless
an astonishing compendium of the Chinese; I know of no other
like it from the era. My guess is that the album was the typical
thick, squat, leather-bound kind, which allowed one carte de visite
per page (fig. 1.31), the kind of album sold at countless local

FIGURE 1.29
William Hurd, *Chung
Him Teak*, 1870.
(Private collection.)

photographers' shops. Some had clasps; others had gold embossing
on the edges of the pages; and still others had metal studs, porce-
lain knobs, or relief work applied to the front and back covers. Our
example has all of the above, one of the more expensive models
available. These ornate objects exuded a precious, treasure-box-
like quality, as if unclasping and opening them would yield small
riches. The pictures could be inserted and just as easily taken out of
the heavy cardstock leaflets of the album—not glued or seamed
into place, as sometimes became common with tintypes and, espe-
cially, the so-called jeweled or miniature ferrotypes. In this way, the
album's owner could sequence and resequence pictures over time,
add or remove what seemed most fitting.

The treasure-box photo album in Reconstruction America
played a rather different role for its owners than the common fam-
ily albums a few decades later played for theirs. That later album

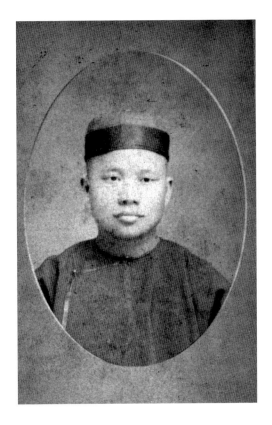

Figure 1.30
Unknown
photographer, *Sam
Toy*, 1870. (Private
collection.)

took shape when the very idea of the modern (white) family was also taking shape, when the belief in "heredity" passed from being the preserve of the wealthy to becoming the stock-in-trade of the middle classes, when the parlor world and its domestic pleasures (including the pursuit of photography as private entertainment) became mass culture, and when owning a handheld camera was within the easy reach of shopkeepers, schoolteachers, clerks, tellers, and their ilk. In those albums, men and women stitched together accounts of their lives, often in the face of dramatic social and cultural changes during which "private life" took on the quality of an oasis. Of course those accounts were often wildly fantastic and gave space for nostalgia and longing out of all proportion. But in the main they offered an image of the family as a stable and enduring phenomenon, however and for whatever means that was conjured. Sampson's album predated all that. The Reconstruction-era

FIGURE 1.31
Photo album, ca.
1870. (Private
collection.)

photo album included members of the immediate family, true, but
it just as easily contained images of strangers—theater celebrities,
politicians, famous literary figures, great beauties, admirals, opera
singers, inventors, President Lincoln, General Grant, even human
curiosities, especially the ever-popular Chinese giants and midgets
(fig. 1.32). Often it included illustrations, name cards, and chro-
molithographs (sometimes called "chromos"), the last of these a
huge part of the photography studio's over-the-counter business.
The compilation of these came out of a logic alien to that of
today's albums; indeed it is hard to fathom a portrait of Vladimir
Putin or Bill Gates plopped between pictures of aunties and un-
cles, birthdays and graduations. And yet something like that hap-
pened regularly in the early albums. There was simply no strong
sense of organizing a "family," at least as a sequence of cartes de
visites might have proposed it. Rather than inward-turning, the
early album was outward-moving, not private-making but public-
seeking, not an account of an intimate life but a projection of one-
self (and yes, of one's family) into the world. The album construed

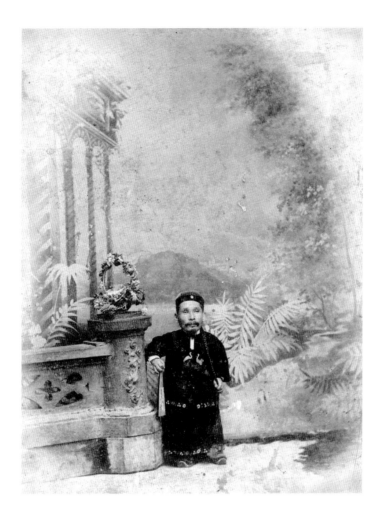

Figure 1.32
Obermüller and Son,
Che Mah, ca. 1875

social relationships not between members bound by blood but be-
tween individuals (portraits) out there. No wonder they were so
ornate; they imagined a display of public relationships.

Some of these functions animated Sampson's album. He was not
conjuring a family of Chinese, still less a surrogate family for him-
self. (He was married but had no children.) Instead, the album was a
statement about what paternalism and patriarchy might actually
mean, at least for him. Paternalism was not only an inward quality, a
feeling of responsibility or empathy for another's welfare, an out-
pouring from an inner well of Christian patience or kindness in

an effort to mediate the cold and harshness of industrialization. In addition, it was also an outward declaration, a public stance towards one's inferiors, and a means of characterizing the necessary social aspects of a more fundamental economic relationship. The portraits and the album were ways of making paternalism exterior to himself, a thing to behold, an index of faces, a catalogue and cross-referencing of relations that included himself. This was as close to being "paternal" as he could imagine. Or to put it another way, photography enabled him to feel his way toward understanding this strange creature, the paternal manufacturer.

<p style="text-align:center">⌒</p>

There was no other factory owner in all of the Berkshires who went to such lengths to house his workforce inside the factory space itself. While some workers were put in factory-owned bungalows, and others found rooms in people's houses, their rent offsetting the bad economic times, the bulk were simply left to their own wiles to find a pillow and a warm meal. Sampson's decision to contract the Chinese came at a price he was willing to pay: converting part of his factory, carefully designed for a smooth and efficient downward flow of raw materials from the top to the bottom floors, into a busy but decidedly domestic space. The storage rooms at ground level, once used for storing leather, were now set aside for the many sacks of rice that the Chinese wanted to import. The big bins, once used to sort the wood molds for the uppers and the spools of stitches for the soles, were now used to hold the sweaty laundry of seventy-five men. And it got more congested. In 1871, a year after the first group arrived, Sampson sent for and received forty-eight more men; in early 1873, he brought another twenty-two, and then later that year, in October, another fifteen; in 1874, another forty-one. There was some attrition—a few died and a few were dismissed—but by mid-decade, the total number of Chinese gave the factory on Marshall Street a larger Chinese community than nearly every other *city* east of the Mississippi. Business was good, and the Chinese were undeniably productive. However, in his wishes to import more of them for the bottoming room, Sampson was working at cross-purposes insofar as he was also,

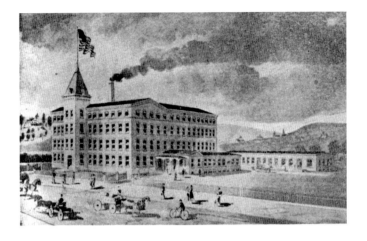

FIGURE 1.33
Unknown illustrator,
*C. T. Sampson
Manufacturing
Company's Plant*, ca.
1890

with each shipment of workers, having to remove machinery and clear space to make way for the extra bunks, tables, and foodstuffs. The factory became what some of the journalists had proclaimed at the beginning, something akin to a Chinatown.

At one point, when bales of laundry and bags of rice began to overflow the factory, Sampson determined to send the workers out to the community to find beds, but the men refused to leave each other. The contract had been clear about the shoe manufacturer's responsibilities about housing, wood, and water. So beginning in mid-decade, he began building an expansive residence area abutting the original sleeping quarters (a much later illustration [fig. 1.33], although inaccurate in all kinds of ways, provides some clue to how it may have jutted from the main building). And that was not all. When the men demanded a joss house, he had to carve out space for an altar and allow candles and the smelly incense to be burnt. With nearly two hundred men burning incense, the whole factory reeked for days on end. When the newer men wanted the same Sunday school instruction as the initial recruits, he had to convert part of the central courtyard, a bigger space with more windows, into a cavernous light-filled classroom. When one of the men died in August 1872, he had to clear out part of the coal room for the proper mourning rituals and allow for a solemn procession around the playground and to the cemetery a mile away; the men banged drums and clanged cymbals and bells the entire

route.[80] The same thing happened when another died in the middle of winter in 1873.[81] Without the coal room, the place must have been freezing.

During an era when the great brick buildings in the Berkshires and the Connecticut River valley were finally being touted as the gigantic industrial engines on par with those found in the eastern part of the state, and when in word and image they were being invested with a kind of grandeur never seen on the western Massachusetts landscape—an image Sampson had helped to bring about—the factory on Marshall Street was already being retrofitted by the Chinese for decidedly social and cultural, not necessarily economic or productive, ends. Over time, the building was becoming what the early visitors remarked of it—anything but a factory.

Others noticed. Despite his wish to tout the new ladies' shoes he was manufacturing, Sampson was bombarded with reporters, tourists, and students who cared nothing for his products, no matter how dainty and affordable they had become. Visitors came to see the Chinese at home. Weekend carriage outings from Boston soon included a stop at the factory. A commuter rail from Greenfield put it on a tour itinerary, fitting it between meals and mountain vistas. What a "delightful excursion" for the fifty passengers, wrote one of the sightseeing travelers: "Friday morning [we] visited Sampson's Chinese shoemakers, came back here to dinner, and then to Brattleboro for the night."[82] What could be more pleasant! To some, the whole compound seemed like a gigantic nursery. "Such a merry sight we never saw in a Yankee factory," the editor for the *Boston Commonwealth* declared on a visit in 1873. "Laughing, jumping, slapping their companions on the back, tickling their ears, and other pranks, their eyes glistening with roguery and sport, they poured up the narrow staircase into the room, one hundred eleven strong [sic], as though they were going to an all-day frolic."[83] To be sure, the image of the frolicking men corresponded to clichés about Chinese in general—unsophisticated creatures from a world built on fulfilling irrational, infantile pleasures—but Sampson must not have wanted to repeat them and instead have the opportunity to tell all the visitors about his manufacturing. He was battered with questions about Chinese behavior, their childish

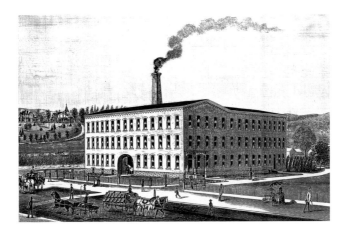

FIGURE 1.34
Unknown illustrator,
*C. T. Sampson
Manufacturing Co.,
North Adams*, ca. 1874

play, their obscure beliefs, their odd eating habits. He had become a tour guide. "Rice is their bread and butter," Sampson had to announce. "They have it at every meal. . . . Besides their tea they have some preserved things from China." And as if to punctuate his awareness of (or maybe his disgust at) being reduced to popular anthropology for the morning tourist, he quipped that "coffee is not drank by them."[84]

<div align="center">⁓</div>

It should not come as any surprise to us that Sampson soon undertook his own promotional campaign and hired an illustrator to counter the increasingly popular view of his factory as an Oriental playhouse (fig. 1.34). In his fantasy, the factory spits out wagon after wagon of boxed merchandise. A dark plume of smoke rises high into the sky, a sign of the prodigious industry inside. North Adams itself is sketched as a pastoral landscape, as if all the town's prolific industry were reduced to Sampson's factory, the gigantic but picturesque machine in the garden. Rather than head up a sprawling industrial town, as the Lynn manufacturers were fond of promoting, this factory, in keeping with the old romance of the Berkshires so conjured by Nathaniel Hawthorne and others in an earlier generation of travelers, is part of the larger community of decent folk.[85] Half the townspeople seem to take their daily air on the street outside, including nursemaids and their charges, flâneurs

in top hats and canes, even a father out for a stroll with his daughter, who pauses to admire the tiny garden just outside the south wall, the very place where the Chinese had once stood for their picture. Most signs of habitation are omitted; those that remain are mostly centered on the fancy multigabled house Sampson imagined he could build for himself on the hill above, side by side with another built for Chase, his chief assistant and treasurer (Sampson was at the time still living at the Wilson House; Chase had built a gargantuan house on the self-proclaimed "Chase Hill"). Industry is the harmonious order of the day; it spawns leisure without apparent labor. The Chinese, of course, are nowhere to be found. The small back door at the far end of the factory, cut out for the men to enter and exit their quarters, is unused.

But while the print provided a more palatable image of the factory, at least from Sampson's point of view, it was ultimately a photograph that could speak most directly to his ambitions. And this—the turn to photography and its powers, the way it imaged labor in its proper place—is what the shoe manufacturer finally saw in the first picture of the Chinese against the south wall. Sometime in mid-decade, probably mid-1875, he arranged for another picture of his workers (fig. 1.35), asking a local photographer, Henry Ward, to lug the heavy machine down to Marshall Street and prop it across the road. Ward took several shots in a row (fig. 1.36).[86] There was no hill or building opposite the compound, so the shoe manufacturer and the photographer may have arranged for a tall scaffold to be erected just for the occasion. The carefully constructed point of view gave the photographer several advantages. In contrast to the early photograph of the Chinese, where the factory fills the visual field but remains an indistinct backdrop, the new view approximated the larger vantage the illustrator had offered in the print, placing the factory in space and suggesting its relation to its environs. Like the print, the new photographs transformed busy North Adams into nothing more than a couple of houses on the hills behind, condensing its prolific industry into the glories of one magnificent building. The composition gave the shoe factory a much more identifiable presence as a complete structure, a behemoth that stands rocklike in the middle

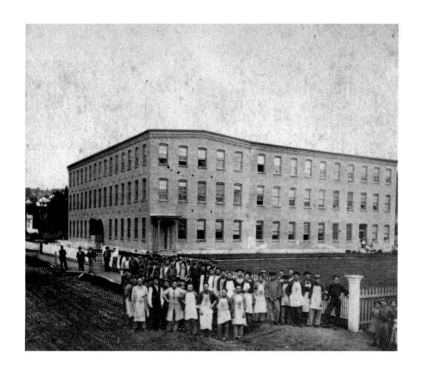

ground, a gigantic slab that divides ground and sky and abruptly cuts the view of distance. Judging by the cast shadows, the workers have been pulled out of the bottoming room in early afternoon. Not the beginning of the day, before the steam engines were cranked, nor the end, when the rhythms were slowing down; but smack in the middle of the day, when the engines were going full bore, productivity was at its highest, and the men deeply engaged in the business of shoemaking. It seems a deliberate gesture, an argument by Sampson that a portrayal of his workers would in fact be structured by work and the workday itself, not by any other set of references. In order to make the claim, he was willing to sacrifice the cost of taking the men away from their pegging machines, even when the steam engines and belt-driven motors were chugging away. Indeed, in figure 1.36, we spy the thin puffs of smoke rising up over the factory's roofline, evidence that the engines were still being stoked.

In contrast to the traveling clothes worn by the Chinese in the early photo, most of the men in these photographs are in their work aprons. No time to change out of them to pose for the camera, but also no real need to because the cartloads of shoes were awaiting their imminent return, as another photograph from the same shoot emphasized (fig. 1.37). In the exterior views, some of the townspeople gather off to the side, as if drawn by the commotion but also, in the rhetoric of the photographs, serving as a frame of difference to the Chinese and standing witness to their presentation. Where the Chinese are massed in front of the factory in the early photograph, they stream from the front door in these, as if they have poured out through the gates, just like the merchandise they were making. Behind the long line of workers, Sampson brought out his managers and office boys, some having donned suits and vests for the occasion. Labor is hierarchically arrayed. Although he is nowhere seen, the factory owner sits at the top of the labor pyramid and is its organizing principle, an absent presence that structures the picture's entire logic and the claims that are being made in it.

In his worldview, Sampson understood that the factory, despite the kinds of alterations he had to make inside to accommodate the

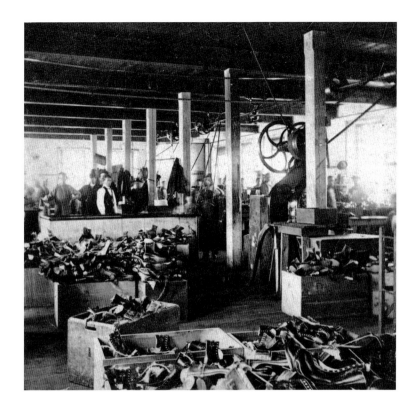

Figure 1.37

Henry Ward, *Interior View of C. T. Sampson's Shoe Manufactory*, ca. 1875

Chinese, was still the center that bonded immigrant labor to him, and leveled all of the misguided interests in their presence. There is no domestic community between the men, no possibility of self-sufficiency or self-determination, no fantasy of identity or belonging, and no paternal relationship, if these did not include the factory. Get back to those pegging machines and make shoes!

TWO

❧

What the Photographers Saw

The View: The photograph of the Chinese against the south wall was not only novel—nobody in North Adams had thought to picture factory workers, let alone Chinese, with such unabashed, unadorned focus—it was also, from the point of view of the town's photographers, a provocation. One among their ranks had gotten the call, maybe the idea, to expand upon his normal habits and stretch the possibilities for camera work. The usual fare—of studio portraits, landscapes, the Hoosac Tunnel's construction, the occasional homestead—had become almost commonplace, mostly formulaic, even a bit boring. This picture seemed to represent a whole new avenue of inquiry. As a stereoview, the picture had a relationship with those on any number of lists of local views, which had become key in putting forth a vision of the northern Berkshires. An expansive national audience, whose interests were being piqued by images of a new, tableau-like, postwar nation, was buying them by the wagonload, the stereoviews filling confectionaries, corner shops, and parlors everywhere. That is to say, because of its unprecedented subject matter, the picture of the Chinese got the photographers' professional and competitive juices flowing. Not to be outdone, not to be left behind, and certainly not to miss the opportunity to enter a potentially lucrative market—those were among the worst fears of ambitious photographers—they confronted the subject.

But what, in fact, was the subject? Against the wall, were the Chinese men having their portraits taken, and therefore requiring the photographer to enlist the habits associated with portraiture? Or were they objects of journalistic attention, and therefore would-be subjects for the newspaper and popular magazine and the kinds of print imagery associated with them? Or given the many new and excited debates about how factories were remaking the landscape, what was

later called with equal measures of hopefulness and ambivalence the "machines in the garden," were they quaint human elements raised for inspection against the backdrop of industry—primitives in the midst of modernity—and therefore part of the emerging language of the picturesque? It was not that any of these genres or modes of picturing had hardened into numbing orthodoxy. Despite the repeated complaints by critics who worried that photography was reaching a state of banality, the field was still in its infancy and capable of rough experimentation. But nonetheless, picture-making had accrued certain practical and conceptual habits, which photographers knew well. Faced with a novel subject, they had to come to terms with the conventions of photography, their meanings, purposes, and attitudes. What disposition should the photographer bring when picturing these men, and in what overall context should he try to embed them? At a practical level, what particular reflexes with his camera—his way with props, his understanding of the field of vision, his sense of priority and focus—should he enlist? The photographers never developed clear answers to these and several other important questions, but at least two—William P. Hurd and Henry D. Ward—figured importantly in the quandary caused by the picture of the Chinese men, as this chapter tells.

In 1866 when they agreed to become partners and open a photography studio, William P. Hurd and Henry D. Ward had already attempted, and failed at, doing other things. At the time, they were still young, adventurous enough to jump careers, and willing to speculate in a new and risky venture. Hurd was thirty-eight, Ward thirty-six. They were each married, had families and, worrisomely, no great prospects for long-term employment. Relatively new to town (the 1860 census does not mention them) they arrived along with the mass of other "foreigners" who came to North Adams during the Civil War, Hurd from Quebec, Ward from eastern Massachusetts. It's safe to assume that they, like the many other new arrivals who overflowed the town, initially came looking for work in the expanding North Adams economy, possibly in the new factories, possibly at the Hoosac Tunnel, maybe to hook on with a

merchant or salesman. They definitely did not come with the intention of working with a local photographer or learning the picture trade from him. Prior to Hurd and Ward's studio, the region had only one photographer of note, Lucius Hurd (no relation), who at the time took neither partners nor apprentices and was struggling mightily to make ends meet in his small south village shop.

Whatever the many ways William Hurd earned money and fed his family as he first settled in town—there was talk of him speculating in real estate (more likely he was trying to farm), repairing jewelry, and dabbling in sales—by 1864 he could be found working for a local printer, W. B. Walden; and it was this job that brought him to the camera.[1] For a brief spell in 1865, Hurd's boss, Walden, decided to try his hand at photography, expanding the print business to include a tripod camera, glass plates, and albumen paper. The decision wasn't as far a stretch as would later be the case for men in his kind of business. Many in the print world could and did make that move, the materials (the tablet-sized plates, the toxic chemicals, the rolls of paper) and procedures (the negative/positive process, the goal of multiplication) between the two fields seemingly, if only roughly, related. If nothing else, it gave printers another means of producing and reproducing images on an expanded scale, or so they hoped. That hope was especially nurtured after 1863 and the introduction of the dry plate process, in which the light-sensitive surface of the plate negative could be prepared well ahead of time and stored for days. Although most practitioners still used the wet plate and would continue to do so for at least another decade, the promise of the dry plate gave all sorts of would-be photographers license to dream. Where the laborious and mercurial wet collodion process made picture-making something closer to a frantic dash than a leisurely stroll—the process requiring that the photographer prepare his light-sensitive plate only minutes before he had to expose it, and then rush to his darkroom to develop it only minutes afterwards so as not to risk losing the precious image—the dry plate promised to make the whole business of getting a picture decidedly less volatile, less prone to mishap and disaster, more deliberately rhythmic, and potentially more profitable. Without the syrupy wet

plate, the variations in the air temperature would matter less, the changing humidity levels would not cause as much difference in the exposure times, and the camera would yield more consistent results throughout the change of seasons. The idea of photography as a year-round business or at least a worthwhile bonus to a print shop seemed to men like Walden worth a risk. In addition, getting albumen paper in large sheets had become by the mid-1860s commonplace, making it possible for locals in even the most remote parts of the country to buy and use it in bulk. The idea caught on like wildfire. The albumen-based carte de visite had become so widespread that *Humphrey's Journal*, one of many new trade journals sprouting in the Northeast, could declare as early as 1862 that it "is now the rage, and our country operators must learn this process very thoroughly if they wish to keep up with the times."[2] Professional photography on a mass scale could finally begin.

Despite what must have been keen optimism, the experiment with photography at Walden's print shop did not last. Although a good printer, Walden was a miserable businessman, frittering money away like bread crumbs and not making or saving enough to meet his bills, the credit reports soon declaring he was "frequently assisted by his wealthy relatives" just to get by.[3] In a cost-cutting move, Hurd was let go. However, the experience with the camera stayed with him, and almost as soon as he left the print shop, Hurd took steps to open a photography studio. Although the records don't say, it's a good guess that he bought Walden's photography equipment, probably at a huge discount; he certainly got hold of his old boss's card stock and had no qualms using it, even though the cards bore Walden's name. After 1865 and the end of the Civil War, there is no further mention of Walden as a photographer in the papers or in any of the local archives, just as Hurd's new career was taking root.

Meanwhile, Henry Ward was facing his own problems settling in North Adams. Not only did he need to find work to feed his family, but the family itself was expanding. Two daughters were born in town soon after the family's arrival. (By contrast, Hurd had four children, three of whom were born elsewhere and already reaching

working age.) Ward's wife, Julia, was sickly and could not keep a job, leaving him as the sole provider. He spent time tunneling the Hoosac, selling goods at a local confectionary, even mining and panning for precious metals in and around the Deerfield River. It's hard to imagine how he could save money, given the miserable pay for most who worked on the Hoosac, and the river did not yield much of anything, let alone precious metals. But by 1866 he had miraculously saved enough that he could begin dreaming of his own business. The two men, Hurd and Ward, seemed destined for each other—Hurd, with a rudimentary know-how in a nascent and seemingly promising practice, access to low-cost equipment, and some familiarity with the customers for printed materials; and Ward, with the spirit of speculation and enough capital for a down payment in a business (almost any business) that would keep his daughters clothed and fed and his wife at home. In April, they leased a small storefront on Main Street for the purposes of opening a "picture gallery," as the registry of deeds was careful to spell out.[4] It was the first such venture in north village and probably raised more than a few eyebrows; the registrar had to name such a newfangled thing with the closest description he could think of. The storefront was not large, and the two men had to share the rear with two cobblers, Jewett and Rand, the deed making clear who was entitled to what floor space. Whatever the fine print and the constricted space, Hurd and Ward must have been full of hope, because they signed a ten-year lease. Perhaps that extended lease was a wish for the kind of long-term employment neither man had previously enjoyed; certainly it was a projection of their lives into the future for a period much longer than either man had been in town. Of course it was a considerable risk, but the studio's location was ideal, and optimism sometimes runs boundless. The whole enterprise was worth commemorating in pictures, which the photographers did several times over; figure 2.1 dates to a few years later. Their gallery stands on the other side of the drug store on the street corner. Out front, they erected a makeshift billboard to hold sales advertisements and samples of their work. Perhaps the many photographs of their store were integral to their sense of settling down, as if repeatedly training the lens on the place was a representative, transformative act.

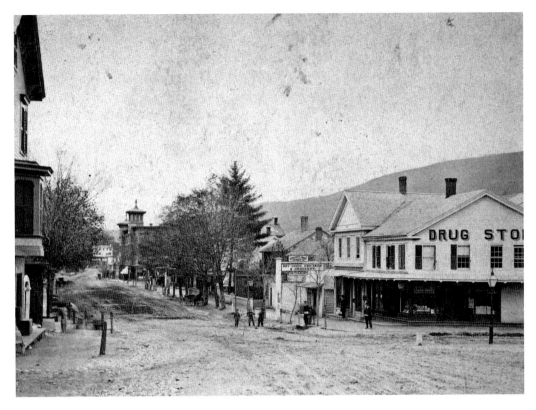

Hurd and Ward could not have guessed just how good the location was or what was awaiting them as budding photographers. The picture gallery was next door to Sampson's first shoe factory (fig. 1.4).

❦

FIGURE 2.1
William Hurd and Henry Ward, untitled photograph (no. 794, "North Adams and Vicinity"), n.d.

The roundabout way in which both Hurd and Ward came to photography was not uncommon. The early profession was rife with individuals who tried and failed at other careers. As in the case of Hurd, they often came from occupations that cultivated related skills (printmaking, jewelry repair) or, given the need to experiment with chemicals, a knack or at least a tolerance for amateur science. But just as often, as in the case of Ward, they came from nowhere related at all and, like those panning for gold, were more like speculators in a quick-rich scheme. In either case, they were usually

self-taught, poorly trained, or trained by another nominal photographer, as Hurd's brief time with Walden might suggest. If they could read and had enough spare coins for a subscription, they got hold of one of the trade journals like *Humphrey's* or the *Philadelphia Photographer*, which tended to be stuffed with how-to articles and letters to the editors from aspiring cameramen asking all sorts of process-oriented questions. The advice was plentiful, if sometimes torturously difficult to follow. If they couldn't read, they had recourse to salesmen, who peddled various photography supplies and demonstrated how they were best used. There was occasionally an air of gentlemanly exuberance and disinterested experimentation when some took up the camera; but most often there was rank amateurishness, fumbling, and sometimes outright danger.

The profession developed names for these two kinds of practices and practitioners, somewhat contrary to what we might expect: "amateurs," for those who viewed photography as a quasi-scientific, learned pursuit; and "professors," for those who went into the business to make money. Although there was much more fluidity between the two than most of the trade journals liked to admit, the class underpinnings that distinguished them were not hard to fathom. It led to barely disguised antagonisms and filled the journals with lively debate. The professors comprised an "army of cheap Operators," the editor of *Humphrey's* lamented in 1860, though he well knew that his journal's livelihood depended on them.[5] Even Oliver Wendell Holmes, in his key 1863 assessment of photography for the *Atlantic Monthly*, made sure to call his photography heroes, Edward and H. T. Anthony, "amateurs" and their studio an atelier, as if the men and their practice existed in a world not of profit and loss but of artistic-scientific expression.[6] Despite the generous attention to amateurs in the 1860s, most who took up the camera were professors, who fumbled about, gave the profession something of a charlatan's air, cast "shadows of stigma and disrespect" on the more respectable establishments, as another wrote, and usually dropped from the business in a few short years.[7] Besides Hurd and Ward, at least four other men and one woman in North Adams tried their hand at photography during the late 1860s and early 1870s. All were professors, and none lasted more than two years.

If the training to become a photographer was often more hindrance than help, the finances needed to construct a practice were an obstacle. There were basically three ways one could begin a studio. One was to buy all the equipment and start from scratch; another was to expand a portion of a related business, meting out funds in increments until the photography concern became large enough to sustain itself; and the third was to buy an existing practice, or at least a portion of it (preferably from someone going out of business who was selling below cost), the most crucial purchases being the cameras, lenses, and plates. The fancy furniture, the many props, even the head brace to position and immobilize sitters could wait. Developing a practice from scratch was exorbitant, upwards of several thousand dollars for a high-class joint. Hardly anyone could afford that, and most went one of the other two routes, as Hurd and Ward did. But even then, the outlay was substantial. It took all of Hurd's and Ward's combined savings and then some; the two had to borrow an unspecified amount, the credit reports telling potential lenders they could be trusted for up to $1,000 but no more.[8] After obtaining the equipment, the men had nothing left to put toward either the security or the first year's $250 payment of the lease. To the great manufacturers like Sampson, Blackinton, and Millard, the amounts must have seemed trifling, but to men like Hurd and Ward, they were astronomical, given that most who worked in North Adams earned only a dollar or two a day. Beginning a picture gallery was thrilling, to be sure, but ridiculously precarious. The would-be photographers were soon borrowing more—much more—with disastrous results, at least for Hurd, as we will discover.

The new business on Main Street, if not brisk, sustained them for a while. In the start-up, Hurd and Ward had gotten at least two cameras, one for the studio, outfitted with a lens for making multiple images for the cartes de visites, and another for pictures of the local scenery, outfitted for stereoscopy. The early studio pictures are not hard to spot (fig. 2.2). They are spare, the props few, the background simple, the dispositions of the sitters consistent and, if two people were being pictured at once, tending toward symmetry. Compare the early picture to a contemporaneous one by Lucius Hurd of South Adams, the lone photographer in the region

FIGURE 2.2
William Hurd and
Henry Ward, untitled
photograph, ca. 1866

whose business was established before William Hurd and Henry Ward's gallery (fig. 2.3). In the comparison we see the differences between experienced and more untutored hands, the sitters in Lucius Hurd's picture more varied in gesture and comportment, the exposure of the negative plate more carefully controlled, the light more lush and evenly handled, the cast shadows on the faces

(compare them on the two women) managed with a subtle and discerning attention, revealing enough of the sitter's jowl and cheek and giving them a proper fullness. The woman's fancy dress, all diamonds and dots, must have caught Lucius Hurd's eye; he highlighted it in the overall focus (it is in slightly clearer focus than the boy's trousers, for example) and made sure his camera captured the right amount of its rich texture and long folds. There is enough mention—but not too much—of the diamond motif in the carpet, just enough to set off the sitters and play off the busier motif of the dress. The background has a muted gray scale to soften as well as frame the silhouettes of mother and child.[9] The photograph is as fine a picture as one could expect from a Berkshire professor. Hurd and Ward had much to learn if they wished to keep pace.

The two were nothing if not dogged. A picture made about a year later, in late 1867 or early 1868, shows Ward's wife and daughter (fig. 2.4). The photographers had learned the benefits of a darker background and the variation of having Julia kneeling or sitting

(it is hard to tell exactly which) on the floor. For one thing, the pose kept Hurd and Ward from having to cart in so many props; for another, it got around the whole problem of their having a limited supply of furniture. Compared to the woman in figure 2.2, Julia is revealed with deep-set eyes—the lights and shadows handled in so precise a manner as to suggest that the photographers had begun paying attention to contours and the set of the eyes, the width and length of the nose bridge, the breadth and angle of the jaw, the key physiognomic features that photographers learned immediately distinguished sitters from each other and needed sensitive handling in the lens. Perhaps it was the familiarity of a loved one's face that made Ward attend to those details more carefully; but more likely it was evidence of his own and the profession's greater attention to, and valuing of, facial particularity. Indeed, it was an awareness of precisely those features that criminologists and phrenologists began to accentuate and decode; the development of the rogue's gallery had much in common with the photographer's increasing micro-level sensibility. In Julia Ward's portrait, the decorative garland on the shoulder and belt called for equally fine attention, as did the creases and folds on the arm. All these details added up to an "appreciation of solidity by the eye," as Oliver Wendell Holmes had prescribed in his early and influential essay on the state of photography.[10] And yet in trying to get the precise texture of fabric and flesh, the photographer sacrificed poor Nettie. She was washed out completely, her dress and long blanket nothing more distinct than a blinding white. A year or so into the practice, the men still had more to learn.

In the arena of stereoviews, Hurd and Ward began scouring the environs, climbing hills and getting good vantage points for their pictures (fig. 2.5). The ongoing construction for the Hoosac Tunnel obviously caught their attention, being perhaps the most marketable subject for a wider audience. But that was not their only prize catch. Already in 1861 collectors of stereoviews began attending to reports in the national magazines about particularly memorable pictures. In an important review for the *Atlantic Monthly*, Holmes inadvertently gave North Adams a hook. "The best we have seen," he wrote, were pictures highlighting the dramatic,

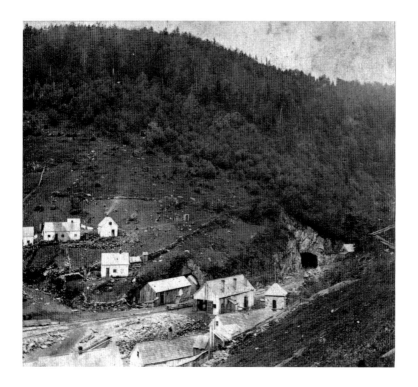

Figure 2.5
William Hurd and
Henry Ward, *This is a
bird's-eye view of the
Tunnel and other
buildings from Blood's
Hill* (no. 808, "Hoosac
Tunnel"), ca. 1868

rough-and-tumble juxtapositions on the American landscape: "the
level sheets of water and broken falls of Trenton,—at the oblong,
almost squared arch of the Natural Bridge,—at the ruins of Pem-
berton Mills, still smoking," and on and on.[11] Waterfalls, ruins, rock
faces (New Hampshire's craggy Old Man of the Mountain got
a special nod from him), "the magnificent drapery of hanging
foliage"—these were given pride of place in his photographic
iconography of America. He flipped through pictures, spanning
the whole continent and bringing the faraway to his fingertips.
That mobility in virtual space and that capacity for nonstop
heightened experience were what "views" promised and what
Holmes relished. Tucked into his parade of passing scenes was that
brief reference—it was easy to miss—the "oblong, almost squared
arch of the Natural Bridge." The region to which it belonged was
never named in Holmes's breezy account, but in fact, as everyone
in town knew, it was situated on the eastern slope of North

FIGURE 2.6
William Hurd and
William Smith, *Profile
Rock*, ca. 1871

Adams. The photographers dutifully took their camera to the
bridge and the nearby Profile Rock and made countless views
(fig. 2.6). (The imprecision on the part of Holmes—where in fact
was the Natural Bridge?—made it just as easy for others across the
country to proclaim *their* bridge as the one named, as photogra-
phers in Yellowstone, Colorado, California, Pennsylvania, and Vir-
ginia eagerly did. The competing claims did not silence North
Adams's photographers but rather emboldened them to picture
again and again, in sun and shade and through all the seasons, as if
sheer repetition and determination would solve the case [fig. 2.7].
It did not matter if their countless pictures were even legible as a
"bridge" or a "profile.")

Hurd and Ward took many of their cues from the trade journals
and photographers elsewhere, including the suggestion to assemble
their views into lists for sale. Like others, they gave their lists themes
and headings, one simply called "Hoosac Tunnel," another called
"North Adams and Vicinity." Each photograph in the list had a num-
ber and often a title assigned to it, but the practice of numbering and
titling did not mean that pictures obtained rigid identities. Pho-
tographs on one list could suddenly find their way onto others, and
back again, the titles generic enough to permit fluidity. Sometimes
pictures were simply retitled whenever it seemed convenient or an-
other list needed enlarging, promoting, or indeed manufacturing.

FIGURE 2.7

Left
E. and H. T. Anthony,
The Natural Bridge,
North Adams, ca. 1869

FIGURE 2.8

Right
Kilburn Brothers,
Under the Great Snow
Arch, Tuckerman's
Ravine, ca. 1870

 The list was a way to organize experience, to provide some semblance of stately order for those like Holmes whose tendency was to flit back and forth across the vast continent, and to insist upon a regional identity in the face of so much national competition. (Characteristically, Holmes chafed at being hemmed in; "beware of investing largely in *groups*," he told his readers: "The owner soon gets tired to death of them . . . vulgar repetitions of vulgar models.")[12] But in addition to being a conceptual, even touristic framework, it also had practical value, serving as a way to control and catalogue an expanding inventory and to create placeholders for pictures made later. For example, any number of future photographs could be slotted into "Natural Bridge," no matter how much they departed in style or point of view from previous pictures. In a sense, the early commercial practice of the list requires that we reconsider one of photo history's most commonplace understandings. Photography, which to most critical observers always carries within it a sentiment of time passed ("what has been," as Roland Barthes proclaims of looking at things within pictures),

also, in the logic of the professor's list, anticipated and prepared for images yet to exist ("what will be," the list says).[13] That reversal of meaning, at any rate, was the result of two would-be cameramen trying to prepare for the future and help the long-term prospects of a risky enterprise.

Business for the new studio was helped by the fact that tunneling for the railroad had suddenly achieved a noticeably brisk pace, and, as seen in the previous chapter, the tunnel's supervisors were eager to have any advance through the hard rock, however imperceptible, celebrated in pictures. It so happened that 1866, the year Hurd and Ward set up shop, was the same year that the Hoosac's engineers made the decision to turn to nitroglycerine and the Burleigh drill. The loud explosions on the hilltop caught everyone's attention, including the photographers', who took their tripods to every conceivable spot on the construction site above. With good weather throughout the summer, the number of stereoviews quickly expanded. The "Hoosac Tunnel" list boasted at least fifty to sixty different pictures by autumn, the overall collection promising to serialize and, with each new picture on the list, monitor every facet of the Hoosac's operations and growth, no matter how redundant. The photographers even had stereocards made with back labels declaring that "views are constantly on hand." The phrase was commonplace among enterprising professors throughout the country, but in Hurd and Ward's case, it was more fact than fiction. Of course it didn't matter which view monitoring what advance could be found at any given time among the stock; that ambiguity was another advantage of the list.

How it must have shocked Hurd and Ward when the national magazines, finally turning their attention to developments in the tunnel, used someone else's pictures as the basis for their illustrations! There, on page 781 of the December 5, 1868, issue of *Harper's Weekly*, the magazine had reproduced an image of the compressor house on the Deerfield River based on a photograph by some "Rookwood" (fig. 1.12). It looked remarkably like their own (fig. 1.9) but with enough differences—the greater lateral spread to catch the road raking in from the upper left and the thick crop of trees on the lower right—to know that it wasn't a pirated picture

but a different one altogether. This Rookwood character had spied the compressor house from a greater distance (maybe he couldn't get any closer, maybe he was sleuthing) and gave the building at the bend in the river a more situated aspect amidst the northern Berkshire range.[14] The sun shimmering on the water lit up the scene. It was a lovely picture, and it was awful. How horrible it must felt that some other photographer had beat them to the publishers, gotten a picture of *their* town, absconded with *their* subject matter. Who were these people—Rookwood, Ramsdell, and especially this Kilburn fellow, who had gotten a close look at the mad, Medusa-like Burleigh drill on its carriage (fig. 1.14)? The drill was perpetually in the tunnel—in the dark, that is—and in that surrounds was deemed impossible to photograph. And yet, Kilburn had somehow gotten a crisp picture, good enough to be developed into an engraving. The devil! He did not even have a studio in town; he seemed nowhere and everywhere.

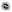

Benjamin and Edward Kilburn were born and raised in the rugged mountain town of Littleton, New Hampshire, not far from the Quebec border. They apprenticed as foundry men in their father's shop; spent time training in Fall River, Massachusetts, where they learned new aspects of the trade; returned to Littleton in the late 1840s to modernize the family business; took over its daily operations and ran it successfully, if modestly, for some fifteen years. During the early years of the Civil War, the two got swept up in Northern patriotism and nationalism and, leaving the foundry for others to maintain, enlisted in the Union army. Whatever their initial enthusiasm for combat, they had the misfortune in 1862 of fighting and losing at Fredericksburg under Ambrose Burnside. For many wide-eyed young soldiers, the Union loss at Fredericksburg was devastating and morale among them afterwards notoriously low. Some twelve thousand young men had died before Confederate guns; for the Kilburns, that number represented more than twelve times the size of their entire town. The dead bodies strewn about must have seemed a horror of unspeakable dimensions. The nightmare experience on the battlefield was enough to

extinguish whatever chords of patriotism the brothers might have originally had. The quick prosecution of the war, prophesied by generals and pundits, seemed much too optimistic. By early 1863 the brothers had had enough of fighting. Edward fell mysteriously ill and was discharged; Benjamin, with no illness to speak of (or to feign), paid a substitute to take his place. They returned once again to northern New Hampshire, hoping to ride out the war as far from the front as possible.[15]

In 1865, perhaps buoyed by a new atmosphere and confidence in peace and perhaps no longer finding foundry work nearly as profitable as it was during the war years, the Kilburns gave up on the family factory and, importantly for our purposes, opened a stereoscopic view business. What caused them to make the change from foundry to, specifically, stereoscopy is unclear; but what is abundantly clear is the fact that they were astronomically successful in their new venture and transformed small and remote Littleton, previously known for its potato whiskey and potash, into a hotbed of the image industry. Perhaps the factory experience aided them; the brothers believed in quantity, variety, and speed. Their first issue of views, introduced to market in late 1865, included more than two hundred different pictures. It proved so popular and profitable that the brothers issued a second list a year later, adding nearly a hundred more titles; a third list six months later, adding another two hundred; a fourth and fifth set over the next three years, adding some six hundred more; and a sixth set in 1875, adding over a thousand, bringing with that set the total number of titles to more than two thousand. They built a factory almost as large as Sampson's and employed nearly as many hands to apply the albumen prints to the card stock and pack photographs by the case. By the mid-1870s, hardly any photographer—certainly not Mathew Brady, Alexander Gardner, John Soule, George Stacy, or any of the other luminary figures among the national studios— could begin to approach the brothers' massive stereoview production or factory-like approach to photography. Only Edward and H. T. Anthony of New York—Oliver Wendell Holmes's heroes— could try to keep pace. If, as Holmes observed in a famous passage about the Anthony studio, production in the back rooms appeared

like an assembly process, including subdividing labor into such specialties that a "young person who mounts photographs on cards all day long confessed to having never, or almost never seen a negative developed, though standing at the time within a few feet of the dark closet where the was process was going on all day long," that description was more apt of the Kilburns' studio.[16] The difference was that the distinct processes occupied whole floors in the four-story building, and the "young man" who mounted photographs on cards all day had become scores of young women laboring at dozens of mounting stations. The brothers had produced an image manufactory. For decades, they were the largest stereoview maker and distributor in the entire country. Perhaps only the London Stereographic Company could rival them on a global scale.

The Kilburns' initial success consisted of capitalizing on northern New England's mountainous and much celebrated landscape. Their first list reads like a tourist's guide of geological anomalies: stereoviews of Mt. Washington, Franconia Notch, the Falls of the Ammonoosuck, Tuckerman's Ravine (fig. 2.8), Pulpit Rock, Kinsman's Bluff, Echo Lake, Crystal Cascade, the Giant's Grave, and so on. Not only did they survey their home region and picture its odd formations, they offered photographs of what viewers could *do* in the land: "Waiting for Deer," "Partridge Shooting," "Deer Hunting," and so on. It was precisely this combination of landscape—as dramatic as anything northern New England could offer—and land-use that gave them a special niche in the stereoview market. But it would not have given them anything more than a regional identity if the Kilburns had not pursued the factory logic of their business with relentlessness. Not only did they expand the manufacture of stereoviews, they expanded the kinds of views they offered; and it was in that voracious searching for new views and markets that the Kilburns in late 1866 or early 1867 descended on North Adams. Not just North Adams but, as the early lists suggest, Bar Harbor, Maine, the Boston Common and Boston Harbor, the landing at Plymouth Plantation, Niagara Falls, the walls and cobblestones of old Quebec, Springfield and the towns in the Connecticut River valley—in short, everywhere of note in the region. Soon Benjamin Kilburn saddled up his camera, tripod, lenses, and glass plates and

took extended photography trips in the South, hankering after sites in and around Savannah, Charleston, and Tallahassee, capturing scenes of ruin and rebuilding. It was as if he were marching through the post–Civil War South with his camera in a way he opted not to do during the war with a soldier's rifle. The brothers bought entire collections of negatives from regional photographers going out of business (getting Boston photographer's John Soule's large collection in the 1870s was a major coup; it simply destroyed regional competition), pirated other collections, and contracted with now-forgotten photographers to take pictures in places the brothers could not reach themselves.[17] They hired salesmen to take their lists and sets from door to door, monopolized supplies and dictated wholesale prices, and continued to expand views and open markets. By the early 1870s, Benjamin was taking long trips out of the country, to Mexico, Bermuda, England, Scotland, and Ireland; and even more extended trips to capture the West, to Colorado and Utah, Yellowstone and California—all these at the same time that western survey expeditions under George Wheeler and others were still taking place, and photographers like Timothy O'Sullivan and Carleton Watkins were obtaining views. The difference was that Benjamin Kilburn, loaded down with cameras and plates and stumbling along the dirt trails by mule and cart, had no use for the scientific premises of the surveys; he was building his view market.[18] Throughout the travels, northern New Hampshire always remained a base, not only in terms of daily operation but also in the company's trademark imagery. It provided a template for the kinds of pictures obtained elsewhere, the brothers continuing to ply their signature interplay of landscape and land-use, even when the railroads arrived (figs. 2.9 and 2.10). It was as if the touristic imagination, as it was nurtured in New Hampshire, shaped how the rest of the world took form. (Whole regions of the world, of course, remained below the threshold of the Kilburns' sense of the marketable view.)

With the Kilburns' arrival in North Adams, we face a conflict between national and regional photographers and glimpse some of the reasons for Hurd's and Ward's anxiety. It was not simply that the Kilburns, who had opened their studio at nearly the same time that Hurd and Ward had begun theirs, were doing better or had

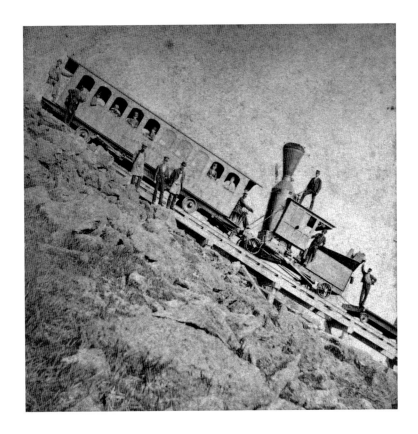

FIGURE 2.9
Kilburn Brothers,
*Ascending Mt.
Washington*, ca. 1869

shown themselves to be more accomplished photographers. Nor was it the sense they were bullies who, with propitious connections with the New York magazines, ran roughshod over local workers. The larger anxiety was that the foundation of the Kilburn business—a factory model of photography—was entering the terrain of a more local, artisanal practice, and threatening to squash it. How could Hurd and Ward keep pace? There were two of them, in contrast to the Kilburns' army. In a sense, the Kilburns represented to local photographers precisely what Sampson represented to local cobblers, the introduction of high industry to a trade. If men like old Samuel Morse, the venerable Marcus Root, or the New York University chemist John Draper were photography's "amateurs," and men like Hurd and Ward were its "professors," then the Kilburns were its industrial capitalists. Even photography, built on

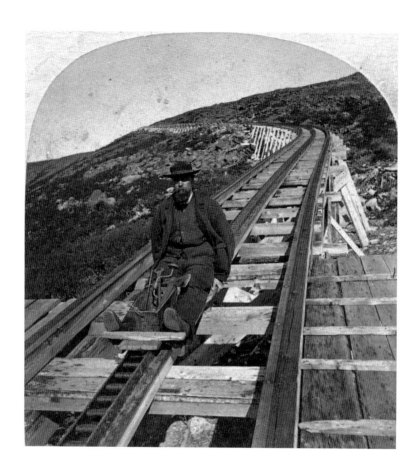

FIGURE 2.10

Kilburn Brothers, *Track repairer coming down Mount Washington Railway*, ca. 1869

the principle of mass reproduction, could be distinguished by levels of industrialization—of efficiency, subdivision of labor, recourse to the most advanced technology, pursuit of maximum productivity, and the extreme version of "reproduction" out of which pictures got made. The brothers from Littleton represented the photo industry's pinnacle.

As it did for Hurd and Ward, the example of the Kilburns should give us pause and ask us to reassess the development of photographic practice. One long-standing claim in the history of photography suggests that the key developments in the profession can be charted by its aesthetic or stylistic innovations—the increasing facility in the darkroom with dodging and cropping exhibited by some photographers, for example, or the idiosyncratic "eye," the memorable sense

of composition and use of gesture, the je ne sais quoi of taste shown by other photographers.[19] Another equally long-standing claim suggests that photography's key developments can be charted by its dizzying technological innovations and the highlighting of the more useful ones over the less—the introduction of the dry plate in the early 1860s (a huge success), the introduction of the carbon print process in 1867 (a spectacular failure), or the development of the Woodbury type in 1870 (something in between).[20] However, perhaps the most important motor driving photography's early development is best represented by the Kilburns. They attached photography—this most modern of practices—to modernity in a more lasting sense than was obtained by either aesthetic or techno-logical inventions, however felicitous or influential they may have been. The brothers made the photograph *belong* to industrial modernity by making it partake of as expansive a factory and mar-ket logic as a post–Civil War economy could offer. The Kilburns' success did not really depend on aesthetic originality, whatever one thinks of Benjamin Kilburn's skills with the camera. Nor did it rely on technical innovations in how pictures could be made; the broth-ers plied the same process for making albumen-based stereocards for their entire decades-long career. Their innovation lay in repro-ducing and distributing pictures under the same general logic as Sampson used when he reproduced and distributed ladies' shoes.

❧

The pressure of the Kilburns and of factory-style photography shook Hurd and Ward's practice to the core. They had neither the financial wherewithal nor the large comprehension to compete on Littleton's level. But there is ample evidence to suggest they tried. Soon after *Harper's* published its engraving of the Burleigh drill based on the impossible Kilburn photograph, the partners ven-tured into the tunnel and tried to get their own picture of the drill; only theirs would be a picture of it *at work* (fig. 2.11). The light source was uncontrollable, the drill barely visible, the precise activity indistinct, facts they must have recognized but did not let deter them from further efforts. They somehow got hold of the drill that had been used *before* the Burleigh's introduction and took

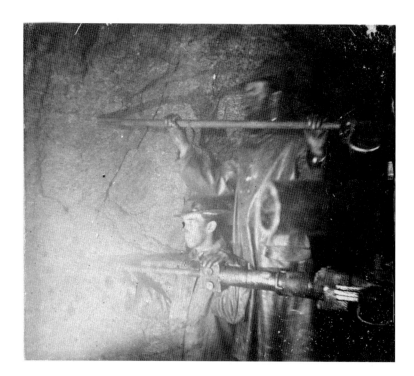

FIGURE 2.11
William Hurd and
Henry Ward, *Interior
View, Hoosac Tunnel*, ca.
1869. (Courtesy of the
North Adams Public
Library.)

a picture of it too (fig. 2.12). It's unclear what market or promo-
tional material such a photograph could be used for. The Hoosac
company did not want it; drills that had failed summoned too
many embarrassments. The partners dredged up an even earlier
drill that had also failed (fig. 2.13). The specimen-like qualities of
these photographs were typical of photographic conventions, but
in a sense, the eerie emptiness surrounding all these tools was a
metaphor for their impotence and uselessness. Any such negative
interpretations did not deter Hurd and Ward. They wanted pic-
tures of anything they could lay their hands on—and better if the
tools could be scrutinized in sunlight, however limp it made them
seem, since the photographers' efforts inside the tunnel amounted
to little that was usable.

For a while, the portrait side of the business kept the partners
afloat. So many people were arriving in North Adams during its
heyday of immigration that the photographers had not yet reached
a saturation point in their business, not needing to tease for repeat

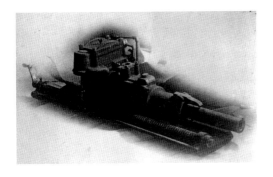

sitters since so many new ones kept showing up. But there was an endpoint to the line of new patrons, as they well knew, and besides, portraiture had limited circulation. One client bought only so many pictures, no matter how comely Hurd and Ward could make them. The larger issue—whether they could maintain their niche in the more competitive, more widely patronized, and assuredly more profitable stereoview side of the business—was still before them.

One event brought them a temporary reprieve from having to rethink their studio. In October 1867 tunneling at the Hoosac's Central Shaft met with disaster. A fire broke out at the top of the shaft, causing all the riggings, air compressor lines, timber-framed elevator, pulleys, and air and water pumps to go up in smoke. Thirteen tunnelers were trapped in the shaft below, some six hundred feet below the entrance. There was no way to get them out, as an early observer told:

> The attendant instantly dumped the bucket and attempted to lower it for the men, but the flames prevented. The fire soon melted its connections and it plunged down the shaft. The first landing above the opening, arranged for tools of all kinds, gave way, and 300 drills, hammers and chisels poured down the shaft, an awful shower of steel. Then the timbers and roof fell, covering the mouth of the shaft with a layer of charred wood and gray ashes and entombing the miners, alive or dead, in that long elliptical vault.[21]

The trapped miners faced unknown horrors, each of them too gruesome for the men above to contemplate. Timbers and tools

FIGURE 2.12
Left
William Hurd and Henry Ward, *Rock drill invented by John Christiansen*, ca. 1869. (Courtesy of the State Library of Massachusetts.)

FIGURE 2.13
Right
William Hurd and Henry Ward, *The first pneumatic rock drill used at the Hoosac Tunnel*, ca. 1869. (Courtesy of the State Library of Massachusetts.)

could have fallen the six hundred feet in that "awful shower" and simply pierced and crushed the men. Without fresh air being pumped into the dark cavern below and the opening above charred and ashed into a tomblike cover, they could have suffocated. Without water being pumped out (the water used to cool the infamous Burleigh drill) and the level rising beyond control, they could have drowned. It took a day to put the fire out, and, with the shaft finally cleared of debris and cool enough to descend, a miner, Thomas Mallory, was lowered by rope to explore the damage, find the men, and, if the worst had happened, recover the bodies. Hundreds had gathered to observe his descent. The "time seemed interminably long—twenty, thirty, forty minutes elapsed before the expected signal came from below and then Mallory was drawn up, breathed the single words, 'no hope' and fainted."[22] He had found a cavern filled with water, burned timbers floating on its surface, the air so foul he was "nearly insensible," and no sign of the men.[23] To the Hoosac directors' and engineers' extreme horror, it took an entire year for the water to be pumped out of the shaft, the men finally located in October 1868, the bodies in "such a state of preservation as to be easily identified, though quickly crumbling after exposure to the air."

The entire event was macabre and also, of course, photographable. The Kilburns could not reach North Adams in time, but Hurd and Ward were immediately on the spot, getting pictures of Mallory before his descent (fig. 2.14), the crowds in attendance, the charred debris piled up. Mallory made several attempts into the depths over the course of two days; the photographers planted themselves at the shaft entrance prepared to picture each one. Picturing the disaster and its aftermath constituted their first attempt at reportage in the journalistic sense; their previous photographs of the comparatively infinitesimal advances in the tunneling did not ask them to work with urgency or to try to keep up with a rescue operation moving along with such frenzy. Their inexperience showed. In the photograph of Mallory, the intrepid miner paused to look at the photographers' commotion with the camera, his stilled body a tacit acknowledgment of their presence but also, in a rescue operation where the passing of time amounted to a death

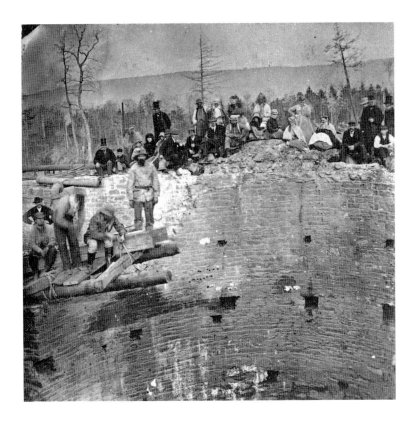

FIGURE 2.14
William Hurd and
Henry Ward, *Ruins of
Central Shaft. This view
represents Mallory
making his third perilous
descent for the recovery of
the bodies of the thirteen
unfortunate men, the
second morning after the
fire* (no. 799, "Hoosac
Tunnel"), 1867

knell for the miners below, an interruption to the task at hand. On
the one hand, cameras were not capable of capturing people mov-
ing quickly; the photographers needed temporary moments of
stillness, no matter how they disrupted or intruded on the flow of
events. (The rescuers had no real interest posing for the photogra-
phers; Mallory's head was in motion, his companion continued
working on the rope and beam; the rest paid no attention to the
camera and tripod but rather to the men at work.) On the other
hand, Hurd and Ward had no strong conception of what it meant
to report, at least as it was formulated in the papers and journals.
Their habits with the camera had been conditioned by landscape
views and portraiture, the common currency of the professor. In
their hands, the photograph of Mallory stood somewhere between
these two habits—not quite portraiture, though the miner's up-
rightness and frontality borrowed from it; and not quite landscape,

though the careful registration of the shaft's gaping hole, like a ge-
ological anomaly, and its play against the stark backdrop of the
Berkshire range borrowed from that. The photographers set their
tripod and measured their lens in a manner that had truck with
their usual practice, and they waited for an image that seemed, in
their limited repertoire, recognizable. It was all they knew how to
do, and it was wanting.

This verdict is not offered simply from today's perspective. The
papers and magazines in the late 1860s found Hurd and Ward's pic-
tures wanting, too. Of course the editors still gobbled them up. The
story was huge, Hurd and Ward had learned from the Kilburns' ex-
ample to market their work aggressively in New York, and anyway
there were simply no other photographers on the scene to offer
better pictures. *Scribner's* gave the photograph of Mallory to an illus-
trator to use as the basis for an engraving. He took liberties with his
source—not an atypical practice for magazine artists—and adjusted
the picture to bring a sense of drama the photographers could not
achieve themselves (fig. 2.15). Mallory's uprightness was bent to a
slight lean, his face turned toward the cavern below, his right hand
given the job of holding the rope he would soon have wrapped

around his waist, his left hand extended to help keep his balance on the precarious plank. The changes gave Mallory a more central position and a buoyant, active, almost magnetically tense feel. In his new guise he was more firmly heroic and, as a hero in the business of saving victims, did not have time to notice the observing camera. His concentration was instead fixed wholly on the darkness below. The mountains have been reduced to a hazy choir screen; the trees echo the forms of the people, even bending here and there like them to get a better view, as if all of nature is focused on the dramatic action and full of expectation for the imminent plunge. One senses from all these changes that the magazines would have wished for a photograph of Mallory actually descending from the plank.

However inexpert and in need of sprucing the photographs of the disaster may have been, the larger point is that Hurd and Ward had momentarily entered a national market and grabbed a small corner in it. The debacle of the yearlong effort to pump water out of the shaft in order to recover the bodies kept the Hoosac tragedy in the news and Hurd and Ward's pictures in demand. The income must have given the photographers optimism for their studio. In 1867 Hurd went on a spending spree, buying a homestead, a house and lot, and some land.[24] The total price was hefty, more than four thousand dollars, an amount he could not have imagined spending just a year before. What he needed with all these properties was unclear, but he was willing to take out at least three separate loans to help cover most of the costs.[25] In 1868, Ward bought a house on the trendy new Church Street and Spring Street corner.[26] It was a princely forty-four hundred dollars, for which he, too, had to borrow nearly all the sum. The many new mortgages on top of the original lease for the studio did not seem to deter either man. In January 1868, just months after the fire and attempted rescue, the credit reports declared Hurd and Ward were "good men, habits good, are cons[idered] good and safe for wants."[27] Disaster was certainly awful, but it made for very good business.

&

In the years immediately before the Chinese arrived in North Adams, the picture of Hurd and Ward is of professors doing their

utmost to make careers in a fledgling profession, one already in the midst of large transformation. In Reconstruction America, the two were typical of most photographers in their mixed backgrounds, minimal training, calculated ambitions, and cobbled finances; and if their situation seems to us more precarious than stable, propelled more by chance encounters and propitious turns of events than by educated planning and the knowing pursuit of traditional paths to success, that was also commonplace in this early period in the professionalizing of photography. Artisans by temperament and circumstance, they confronted the increasing industrialization of photography—what would soon become an even larger, more corporate development in the 1880s—and they responded in the way many of their class of operators did, neither with a careful program of industrializing nor with one of research and invention. That is to say, they became neither industrialists nor amateurs but remained, simply, professors, living by their economic wits, capitalizing on whatever seemed marketable, trying their best to balance the local needs for portraits with the national mania for views. If we have attended more carefully to their business identities, monitoring them by considering credit reports, the signing of leases, the transfer of deeds, the taking out of loans, then we have followed, properly, the traces of their lives that characterized who they were: small entrepreneurs who lived in a world of commercial exchange. The history of photography is filled with men like them, though we do not often enough import the tools of social history to understand them.[28]

Of course for their prospects Hurd and Ward also depended on a facility with their craft. Being fluent with the camera did not insure success, but being inept almost always spelled failure. Yet in pursuing the more skill-based aspects of their careers, we should not lose sight of their entrepreneurial sensibility. That is to say, we should attend to Hurd's and Ward's facility and skill not in how they can be interpreted as, or confused with, "originality," "vision," or even "sensitivity," at least as those terms have been celebrated in the art museum, but in how they exemplify the photographers' application of practical advice, their concrete way with theory, and their willingness to look at, adapt, mimic, learn from, and even expand upon the examples put before them.

For the carte de visite portrait, the major models for learning were offered by the nearby competition, as our earlier comparison of Hurd's and Ward's pictures with those of Lucius Hurd might suggest. But the examples found in trade journals, how-to books, and magazines were also hugely significant, especially for those cameramen who lived at a distance from Boston, New York, and Philadelphia, the key centers for exhibitions, discussion, and experimentation. The 1860s and early 1870s, the time of professional photography's rapid growth, witnessed a veritable explosion of subscription publications, all aimed at giving advice to the lowly operator. What did they offer? The photography historian Elizabeth McCauley has argued that in contemporaneous Paris, portrait photography borrowed from much earlier ideas surrounding painted portraiture. Photographers turned to old artists' handbooks, which set out rules for composition; studied paintings by Raphael, Rubens, and Titian, who were celebrated for their way with posing figures; reckoned with a tradition of emblems and attributes, which had been codified since at least the late sixteenth century in Cesare Ripa's *Iconologia* and passed down in any number of guidebooks; and looked at the canvases being pumped out by the painting academies, which tended to recycle older conventions.[29] Something of that structure of influence took place in Reconstruction America—not directly, as was possible in Paris, but reformulated and regurgitated, often with exacting directions, through popular publications and the New York and Philadelphia trade journals. Read a long but typical piece of advice from *Humphrey's*. For the seated portrait of "everyday people,"

> The head must be placed perfectly erect within a perpendicular to the rest of the body, whether observed from before or from the side. If a front view is taken, a foreshortening of the forehead, nose, chin, etc., take place, and the look, to which proper direction is always given, is either squinting—which is never a desirable feature, being the most disagreeable of any— or, in case it is kept slightly sideways, when it is indistinct and lifeless. For the same reasons the head should not be taken partly from behind, since, from the same foreshortening, the

expression will be very tame, the eye will be small, and, what is more reprehensible, the portrait will show the nostrils too prominently. . . . The arms, hands, and breast must exactly coincide in harmony with the expression, which is introduced by the position of the head, from which it follows that they must be unconstrained, yet so situated that a proper character is thereby expressed and preserved. . . . Stiffness, or want of ease, whether relating to the chest, arms, or hands, is under all circumstances to be avoided. The upper part of the body must, above all things, present a roundness and give an impression of comfortable ease. The chest is first placed in such a position, that the axis of the plane in which the shoulders lie shall not be parallel with the inclination of the head, which prevents the picture from appearing broad and disagreeably harsh. The arms should never present parallel positions in any of their parts, but must either rest free and easy on the lap, yet not carelessly so, or be placed in a position corresponding to the particular position of the hands, which must be so situated that they lie as near the body as possible, without resting upon the knees, nor be closed so as to make a caricature. . . . The next in order will evidently be the arrangement of the lower part of the body: this admits of very little application of any rules, with this provision, that the position of the feet must be perfectly natural and easy, and so placed as to ensure rest and security to the upper part of the body. In the position of the feet the first thing to be observed is, to avoid their being placed far apart, or put into constrained attitudes; on the contrary, when the person is seated, the feet should be placed rather near together or the legs crossed, in case the sitter is a man, or the legs may even be placed perfectly straight, projecting to one side.[30]

Never candidates for bedside pleasure reading, these articles were dogged and insistently practical. There were equally lengthy directions for the standing portrait, the male portrait, the female portrait, children's portraits, all of the advice aimed at securing "ease in posture, relief in outline and beauty of composition, harmony in

all parts, and—what is of utmost importance in a good picture—the general impression of natural life and ease." There were essays on props, backgrounds, furniture, and clothing; more essays on the proper dispositions for actors and actresses, painters and sculptors, orators and politicians (for whom "an irregular and inclined position" was judged more apt), even disquisitions on pets.[31] The many suggestions on proper figuration had their roots in the kind of models McCauley has identified, though never recognized as such by editors and authors. Armed with the weight of ancient conventions, the journals had no shortage of advice and no hesitation to propagate formula.

A photographer could go mad trying to follow all the directions, but at least several impressionistic suggestions obtained, which served as general guidelines. Work from the head down, the manuals were consistent in saying; from the head flowed all the body's other geometries and habits. Consider the body an upright axis (necessary because of the ubiquitous neck brace), and consider all signs of naturalness to be lodged in how the arms, hands, and legs were freed from that axis. It was precisely the play of a central rigidity and a lateral freedom and fluidity that gave rise to the impression of "natural life and ease." Understand the sitter's body as a plane that should be judged inviolable and positioned parallel to the camera. No looking up noses, no looking down pates. And while the overall goal is harmony, that is only achieved if each part of the body is treated separately, almost as if they were individual units of meaning. "When you look upon a printed page as a *whole*," the Connecticut photographer H. J. Rodgers advised, "the words are seemingly confounded and intermingled together. Although the words which form meaning, look confused as we *glance* at them, yet when we study them as connected together, we comprehend their full meaning. This is precisely the way a picture should be read—each of its component parts separately."[32] Following these suggestions—the primacy of the head, the body axis, the free flow of limbs, the frontal plane, and the integrity of parts—gave a photographer the rudiments for picture-making and a baseline to develop facility. Of course, pursuing them meticulously did not insure success. There were countless sitters who ended up looking like mummies.

Perhaps the most important suggestion given by the manuals, and also the most difficult to follow, asked that the photographer notice the sitter's place in society, usually understood in occupational terms, and identify a disposition to match it. Indeed, "[T]he position of the body becomes more expressive, when it assumes a pantomime of some familiar action . . . [a gesture that] arouse[s] their figural nature, and mental activity."[33] The charge was important because it brought to the studio a sense that sitters were not so many variations on a theme but fully individual people who could expect (or be flummoxed by the illusion) that they would be photographed in all their self-conscious uniqueness. How this call for individuality matched the many rigid directives about body position was never clearly elaborated by the journals, but some shuffling back and forth between the two poles of formula and uniqueness was recommended, since we "all look, act and appear widely unlike, consequently we should be arranged in positions equally diverse, and becoming, for a picture."[34] The charge was also potentially complicating, not merely because it seemed to raise for inspection the applicability of the manuals' detailed recipes but also because it relied on a limited understanding of occupations and "figural natures." "Every-day people" were one thing, orators and ministers another, painters and sculptors still another, but Chinese factory workers were something else altogether.

<p style="text-align:center">❧</p>

If portraiture had procedures, so too did the view. The journals had their share of plodding directions. As *Humphrey's* declared, there were seven simple steps to follow: position the camera to the height of the operator; warm or cool the lens so that it reaches the same temperature as the atmosphere; adjust the diaphragm to obtain even illumination; avoid violent color contrasts, since green, the dominant landscape color, acquired "actinic influence" slowest and set the other colors too far off the gray scale; aim for cloudy days because if "the sky is too clear, a heavy, dingy, blotty proof will be the result"; sacrifice details in favor of masses of light and shade; and measure the camera's range by placing a glass tube over one's eye and discerning how much field can be seen through it.[35]

FIGURE 2.16
Henry Ward, untitled
photograph
(unnumbered, "North
Adams and Vicinity"
series), ca. 1870

The directions were easy—Hurd and Ward took many pictures
that are patent (fig. 2.16)—but they left unaddressed the central
question of what constituted a good or interesting view, the Kil-
burns' examples about landscape and land-use notwithstanding,
and chose instead the much safer question of how to obtain a
legible one. The problem, as all professors knew, was that views
depended on the idiosyncratic nature of local terrain and the
touristic value of local sites that no amount of directions, however
thorough, could anticipate. In New England, the problem was
compounded by two large issues. First, a landscape tradition had
already been cultivated by generations of painters, Thomas Cole
and his paintings in and around the nearby Catskills and Connecti-
cut River valley only the most famous. Second, the view, at least in
the environs of North Adams, had become entangled with the
complicated needs of the Hoosac Tunnel.

The vexed relationship between landscape painting and land-
scape photography is as old as photography itself. One common
critical attitude holds that photographers were bound within the

conventions developed by painters, that the aesthetic apprehension of the land structured how photographers selected and composed their own pictures. Another holds the opposite, that photographers, rather than being bound by landscape painting, relied on a range of other representational and conceptual strategies to inform their attitudes, from mapmaking and geological inquiry, to the excited natural science debates in the 1860s and 1870s about "gradual" and "catastrophic" versions of the earth's development, and so on. (North Adams had its own version of an alternative framework for conceiving of the view.) But a third option in the weighted relationship to landscape painting was also open to local photographers. Rather than serve up photographs that approximated or, worse, merely replicated famous painted views, they decided instead to peddle chromolithographs of them. The Louis Prang Company, established only a few years earlier in Boston, had begun reproducing famous paintings as chromolithographs ("chromos," as they were widely called) and, through Prang's *Journal of Popular Art*, made obtaining them simple. With such a large supplier only an afternoon's ride to the other side of the state, Hurd and Ward in 1869 became chromo retailers and added a huge section of Prang views to their store. With the chromos for sale, the two men were freer to view the environs in a photographically different manner. (To come up with the money to buy a healthy stock of chromos, Hurd refinanced a loan and, to squeeze even more money for the down payment, took a recalcitrant debtor to court.[36] It must have been worth all the aggravation and legal hassle, including enlisting the sheriff and sending poor George Boyer to jail. Later that year, the photographers commemorated the expansion of the business, changing their studio name from "Hurd and Ward" to the "Excelsior Gallery," finally fulfilling the initial and rather befuddled description given their studio by the registrar in 1866, a "picture gallery.")[37]

The second issue, the essential but complicated relationship with the needs of the Hoosac Tunnel, was both constricting and, in an odd way, liberating. Picturing the tunnel was not merely an exercise in venturing to the site and choosing a daily vantage in the mud and muck that could somehow accommodate a tripod. Rather, it was filled with the sense that the views needed to register

engineering feats.[38] This charge certainly had a booster element to it and was the result of a company wanting to provide good news about progress for a project sorely in need of it. But it also had an appreciative aspect, as the tunnel became understood in town not only as a project but, equally important, as a process. The newspapers were filled with lengthy reports about engineering and technological changes, the sorts of details that previously had no coinage in local journalism but had become by the late 1860s common currency. Nearly two decades' worth of digging, drilling, excavating, shafting, and lining had produced a community familiar with specialization. The engineers tried eighteen buckets of dualine, the *Transcript* reported in its running column, which "occupied three hours of tamping and charging" and ultimately did no good, encouraging them to resume nitroglycerine blasting in "eight and nine feet holes in submarine blasting [which] has shown 50 percent economy over holes of half the depth."[39] The papers did not need to explain what any of these ratios and choices meant; their readers already knew. When reporters from the national magazines arrived to get their stories, they were overwhelmed with technical details that had become, in local parlance, completely familiar and standard. "Do I hear my intelligent readers suggesting they knew all this . . . before?" *Scribner's Monthly* asked its more national audience. "I must beg your pardon, ladies and gentlemen, for doubting whether half of you know it now."[40]

Hurd and Ward participated directly in disseminating the specialized knowledge. Not only did they take pictures of pumps, compressors, and drills, they made and published photographs of the engineers' drawings. These included elevations of buildings, designs for safety cages (fig. 2.17), the portable derrick (fig. 2.18), even the lowly dump car (fig. 2.19), much improved in its load capacity, of course. Of particular relevance for us are their many pictures of drawings for the main tunneling sites. These included the detailed plans for the large shaft house and machinery at Central Shaft (fig. 2.20) and the air compressor at West Shaft (fig. 2.21). The two locations were notoriously problematic—Central Shaft because of the yearlong disaster of the buried miners, and West Shaft because the soft earth near that site made tunneling a decadelong

FIGURE 2.17
William Hurd and
Henry Ward, *Safety
Cages for West Shaft of
Hoosac Tunnel*, ca. 1866.
(Courtesy of the State
Library of
Massachusetts.)

nightmare, the walls and ceiling continually caving and requiring re-
newed efforts and experimentation on the part of the engineers. The
papers covered activity at both locations assiduously.

A comparison between a photograph of Central Shaft (fig. 1.21)
and the drawing of it immediately suggests visual affinities. The

FIGURE 2.18
William Hurd and
Henry Ward, *Derrick
Car used for loading stone
at the East End of
Hoosac Tunnel*, ca. 1866.
(Courtesy of the State
Library of
Massachusetts.)

photograph is careful to examine the shaft house in precise profile, similar to how it appears as a line drawing in the engineer's design. Likewise, the several pitched roofs, jutting overhangs, and covered entrances are reduced to a single, flat plane, as if on a page. The engineers cared little about shading and contouring, had no concern for providing illusionistic depth, and made no effort to include suggestions of atmosphere or clues to how, in fact, the main building would sit in relation to the stunningly beautiful mountainous terrain. The photographer did not bother to try to capture any useful shading (the roofs are undifferentiated planes), had no interest in obtaining a penetrating depth (seemingly so necessary for stereoscopy and the view camera), and no concern for positioning the building in a manner that would yield more information about the surrounding peaks (they are reduced to a low-slung, indistinct band in the distant background). The photograph provides little sense of

CARS
Used in carrying stone from
HOOSAC TUNNEL headings up the West
Shaft, to the dumping ground.
1864. Thomas Doane.
 Ch. Engr.

FIGURE 2.19

William Hurd and
Henry Ward, *Cars used
in carrying stone from
Hoosac Tunnel heading
up the West Shaft, to the
dumping ground*, ca.
1866. (Courtesy of the
State Library of
Massachusetts.)

the building's depth or, indeed, how many buildings actually comprised the site (there were in fact many). Instead, it spurns a panoramic view in favor of a graphic profile—all crisp outline, clear delineation of height and width, registration of spatial relations on the flat. Even the smokestacks are measured against each other across the lateral spread of the page.

We need only contrast the local photographers' picture of Central Shaft to one by an out-of-towner, John Moulton of Salem, to understand the particularity of their graphic vision (fig. 1.17). Whereas the locals were attuned to the engineer's design, Moulton had no such experience or familiarity; and his picture of the main building on the site suggests a radically different interest. He saw no profile worth picturing, no estimation of related heights and widths, no stark outline of the structural elements of the building. The odd churchlike facade caught his eye, along with the strange combination of a flat face fronting a series of pitched forms; and he set his camera at an oblique angle to the funny building to capture its main drift. His picture offers much more detail about the weathered vertical clapboards, the three-over-four windows, the

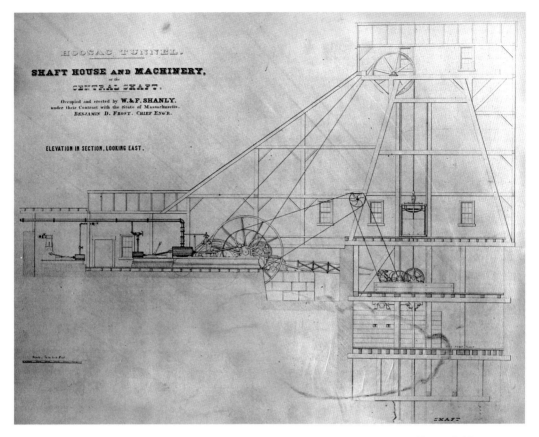

FIGURE 2.20
William Hurd, *Shaft
House and Machinery of
Central Shaft*, ca. 1870.
(Courtesy of the State
Library of
Massachusetts.)

scattered debris, even the stone foundation rising out of a depression. The barrels provided not only a sense of scale and contrast to the building but also, in a stereoview, a foreground that helped to establish and gauge the recession of space. He did not spurn the many extraneous details that the engineer had no use for; instead they caught his eye, and he found ways to incorporate them.

If the comparison between the Hurd and Ward photograph and the drawing of Central Shaft suggests a related set of pictorial values, a comparison between the information offered in the drawing of the West Shaft's air compressor (fig. 2.21) and that offered in other pictures indicates other sorts of correspondences. Perhaps the most immediately recognizable aspect of the drawing—the clapboard building—is accorded, in the engineer's priorities, the least

FIGURE 2.21
William Hurd and
Henry Ward,
*Arrangement Air
Compressor at West
Shaft*, ca. 1869.
(Courtesy of the State
Library of
Massachusetts.)

significance, tucked into the upper right corner. Instead he elabo-
rates on the tangle of pipes and tubing, the blueprint of the com-
pressor's wheels and rotors, the system of pulleys and ribbed
connections. He offers a side view of the complicated delivery of
air power, in the upper left; an aerial view, in the lower left; and an-
other aerial view, offering the compressor's cross section as it sits
lower in the ground (including suggestions of the irregular con-
tour of the soil and rock that surrounded it), in the lower right. In
the rhetoric of the drawing, the modest building is almost ancil-
lary, made up of a few simple windows and eaves. Its significance is
that it is shown to hold engineering breakthroughs that far surpass
it in visual or technological interest. That hierarchy of value is re-
flected in the almost medieval arrangement of objects on the page,
highlighted according to their size and placement.

Of course the photographers had no ability to reproduce any of
that arrangement or unfolding of value on site, but something of its
underlying logic—the sense that modest structures contained un-
told, interconnected, elaborate riches—helped to structure their
views. We observed an example in the previous chapter, in figure
1.19, where the "modest structure" is a supplementary well that
amounts to nothing more visually interesting than a waft of steam.
And yet, as the back caption tells us, it represents a mighty torrent of

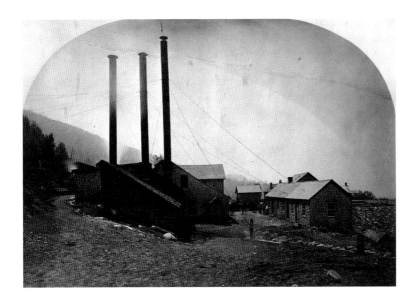

FIGURE 2.22
Williams Hurd and
William Smith, *Hoosac
Tunnel, West Shaft
Buildings*, ca. 1871.
(Courtesy of the State
Library of
Massachusetts.)

power, a "mammoth Steam Pump which raises 1000 gallons of water per minute a distance of 215 feet." Take as another example a photograph of the West Shaft complex containing the air compressor so meticulously outlined in the engineer's drawing (fig. 2.22). The building holding the hoisting machine sits smack in the middle (it has the tallest stack). It was the central point of entry to the depths below. From it radiate tethers that connect it to other key buildings essential for the tunneling, the boiler house on the left, the magazine holding the explosives on the right, the barn holding the carts and rails behind. The tethers had, of course, a stabilizing function, but in the graphic design of the photograph, they act like diagrammatic pointers, connecting building to building, function to function, a web of engineering processes all centered on the shaft itself.

All of these comparisons suggest that Hurd and Ward organized their views around other examples of the Hoosac Tunnel's display. Desperate to establish their picture business, keen on marketing the biggest prize of their locale, intimate with the drawings and designs they had photographed and published, and attentive, like all of North Adams, to the technological processes dominating the excavation and upon which the town's future seemed to rest, they

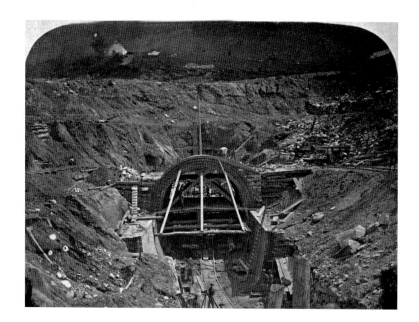

formulated views that were analogous. If the Hoosac's graphic feats
dominated their views, perhaps even constricted their understand-
ing of what a view could be, it also liberated them in the sense
that, amidst the plodding and welter of trade journal directions, it
provided a rough and extraordinarily useful template for what and
how to photograph. They were aware of their visual dialogue, as
one photograph suggests (fig. 2.23). In the picture, they had posi-
tioned their camera to capture, but also to mimic, the tripod of the
surveyor's instrument sitting before the great mouth of West Por-
tal. The surveyor regarded the photographer, as he in turn regarded
the view, each of them in line and bent on capturing the long,
straight path of the tunnel. The advice columns on views helped
professors only so far; the rest depended on such local knowledge.

❧

One thing was clear. Making portraits and making views required
entirely different procedures. In portraiture, the photographer was
to attend to each component part of the human body separately, to
value each as expressive, as a unit of meaning. In the view, he was to

subordinate components in favor of graphic clarity, to distill information, and to conceive of assorted details like the barrels and weathered clapboards as incidental, almost as visual noise. In portraiture, the photographer was to notice the sitter's occupation and find a pose or gesture to match it. In the view, he usually ignored occupations of any sort, since what mattered most were not the people who happened to appear in the field of vision, despite their significance to the actual dig, but registrations of the engineering feat. In portraiture, he was to provide an image of the sitter's uniqueness in the face of so much canned formula and studio contrivance. In the view, he was to provide some common grounds for measurement, understanding, and legibility in the face of so much congestion and hubbub. The differences between the two practices certainly gave professors a set of prescriptions that made it hard for them to confuse, being so utterly contrary (or complementary, as the case may be). But it did not adequately prepare them for treating mixed subjects—the outdoor portrait, for example, or the interior view.

The difficulties are not hard to spot. When Walter Shanly, the Quebec contractor who took over the tunneling operation at the Hoosac in 1868, wanted a picture of his family before the West Portal, he turned to Ward for the job (fig. 2.24). It must have been a coveted moment for the engineer from Canada. He had been imported to rescue an American project that had been years in progress and was already millions of dollars in debt; he was its anointed savior. Accompanied by family, he would pose in front of the beast he was about to tame. Ward's photograph certainly contained the Shanlys—he and his wife stand in the cavernous entrance, his daughters on the portal's roof. They were carefully posed—husband and wife face each other below, while the sisters stand in rigid profile and face each other above. But we would hardly guess the identities of any of them. Instead, the scene is dominated by the gaping black hole and the assorted buildings and debris scattered about. Observers, attentive to what views normally provided, noted the six rings of lining brick on the portal mouth, the timbering system used to hold back the soft earth abutting the entrance, the sturdy twin derricks stationed above, even the invisible forty-five hundred feet from the arch to the heading, as Ward duly

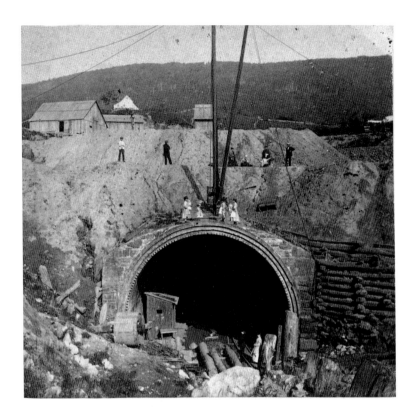

FIGURE 2.24
Henry Ward, *West End.*
Showing the Brick Arch.
The distance from the
mouth of this Arch to the
heading is now about
4500 feet. (no. 804,
"Hoosac Tunnel"
series), 1868

measured and captioned.[41] All decked out in a top hat and a fine black suit as if he were prepared for a proper portrait, poor Shanly, the new leader of the Hoosac project, was hardly noticed. His daughters, in their pretty white dresses and smart hats, were simply dwarfed by the view. Not finding the family members at all important to the rhetoric of the image, perhaps even confusing or antithetical to it, an illustrator, who based a print on the photograph, did away with them altogether (fig. 2.25).

❧

Optimism in the Excelsior Gallery bubbled. In 1869 Hurd bought more land.[42] It was a telling purchase, a tiny parcel at the eastern edge of North Adams on the steep slopes leading to the small town of Florida. All rocky and pitched, it was a useless site for farming and not much better for building a house. There are still

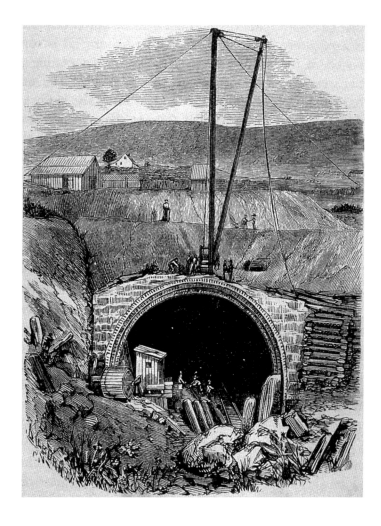

FIGURE 2.25
Unknown illustrator,
*Hoosac Tunnel—Western
Portal*, 1869

no houses on it today. Rail tracks could not be laid anywhere near it; the Hoosac engineers preferred to blast a tunnel through the mountain rather than go over it. But the site, not much more than a precipice, had a special relevance for the photographer: it had an extraordinary vantage overlooking the town.

The purchase may be the first time that a photographer bought land for the sole purpose of having access to an unobstructed view. The town had been photographed from a point looking east; it was the easier picture to get, the site less imposing, and a vantage that had

FIGURE 2.26

John Warner Barber,
*Western View of the
Center of North Adams,*
1841

been preferred by the town's earliest picture makers (fig. 2.26). What a coup it would be to get a picture looking west. Alas, there are no known photographs from the site. None may have been attempted. Yet the ambition to obtain one, however unrealized, tethered by obstacles, or simply financially wasteful, was indicative of Hurd's new reach. The profligacy was typical of an attitude that cost him dearly.

Spending too much money on risky speculation like the tiny eastern precipice, up to his eyeballs in debt, and buying even more land (in 1869 he got hold of old Harrington Farm, a small but choice parcel), Hurd was straining the studio.[43] Rather than reinvest in the business or find ways to expand its market, he spent his money on other schemes and, without a plan for increasing clients abroad, kept the Excelsior Gallery in a perpetual state of disadvantage in the face of operations like the Kilburns. It got worse. His sons were reaching working age, and rather than send them to the factories or the tunnel, he opted to apprentice them to the gallery. Whether Ward approved of the apprenticeship is not known, but what soon became clear was that the workload that had been established for two photographers could not sustain four.

In early 1870, just before the Chinese arrived, the partners split. It was not amicable; the agreement to dissolve reflecting bitter feelings. Ward bought Hurd's share of the business in an effort to rid

himself of an albatross. He kept the studio location and original lease, the negatives for all the views, and a share of the chromos stock. Hurd got his share of the chromos and, in a stunningly bad decision for him, mere *copies* of the many views the partners had laboriously amassed over the years. Unless he was willing to take new views—an expensive undertaking—he consigned himself to always peddling inferior pictures in comparison to Ward. He took an upstairs place on Penniman's Row, a stone's throw away from the Main Street gallery, renamed himself "Hurd and Sons," and began an aggressive promotional campaign. "Hurd Paddles His Own Canoe," he proclaimed, as if finally free to set his own course.[44] He put a picture together to help his cause (fig. 2.27). The argument in it was hardly subtle. Like a gigantic man-machine, the photographer is hitched to his camera and gallops across the landscape, pulling the townspeople along in his ferocious ride. He keeps pace with the chugging train, matching his stride with the clickety-clack on the rails. The modern man-machine promises to maintain a watchful eye on the Hoosac's progress, as it fulfills the town's long aspirations to open its markets and pushes North Adams toward a bright future. As the new day dawns, the sun shines down on the scene; Helios looks beneficently upon the photographer and his charge. It was no highfalutin or pompous studio, either, because he offered pictures at "living prices," Hurd declared, not the exorbitant rates out of the reach of ordinary folk. He understood the needs and competences of workingmen. Hurd did not notice, or perhaps it did not matter, that in his picture the man-machine, half-crazed (or half-blind), seemed to trample the little people in its way.

Ward responded with equal ferocity. He had a sign carved in the shape of a mammoth camera and hung it on the storefront, as if the "big camera" resided only there; made arrangements with Prang to get new chromos and tried to monopolize the supply; started his own ads in the papers, declaring with defiance his ownership of an *original* stock of Hoosac Tunnel stereoviews; and in a pointed gibe at Hurd and his crazed picture, proclaimed the sane, long-standing studio belonged at his old place of business, not the upstart, manic businesses taking root like wild weeds elsewhere.[45] The jousting led to war. Hurd put out another picture

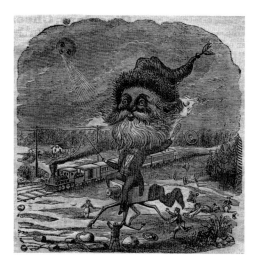

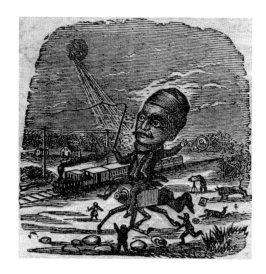

FIGURE 2.27

Left

Unknown illustrator,
"Hurd Paddles His
Own Canoe!" 1870.
(Courtesy of the North
Adams Public Library.)

FIGURE 2.28

Right

Unknown illustrator,
W. P. Hurd, 1870.
(Courtesy of the North
Adams Public Library.)

(fig. 2.28), correcting the half-crazed or half-blind look, but keeping the basic claims to heliography, progress, and attentiveness to the Hoosac and the town's future. With Ward trying to corner the chromo market, Hurd began marketing "oil paintings from old pictures," he declared.[46] Who painted the pictures he never admitted; they were probably hacks from Boston whose on-again and off-again supply made "this particular and difficult branch of the business" hard to rely on, as Hurd did admit. With his sons he opted to expand the nature of his gallery, promising to "furnish *any* article appertaining to *any* branch of the picture business."[47] Ward scoffed at the claims, especially the pretension to offer fine art. He soon renamed his studio the "Art Repository" and took the high road of supply, boasting Gustave Doré's engravings, new illustrations for Tennyson's poems, scenery from the Holy Land, and so on.[48]

All this energy and argument, not to mention the need to get their businesses on some footing, took money that neither man had in large supply. Their financial cobbling and strategies to outdo each other took on a desperate tone. Hurd sold the farm he had only recently bought in order to get more cash.[49] He took out another loan, putting his house up as collateral.[50] And as if that loan weren't enough, he bought more real estate, taking out a loan for

much more than the house cost so that he could keep the difference in his pocket for the needs of the moment.[51] He was soon in over his head and had to take on a partner, a shadowy character named William Smith, who loaned Hurd money to cover his debts and keep the business on Penniman's Row afloat.[52] The credit agents were suspicious of Smith, who had too suddenly appeared on the scene, declaring he was "not gen[erally] recognised as wor[th] anything."[53] The warning did not stop Hurd from opening Smith's wallet; to appear legitimate, he even renamed his business "Hurd and Smith," his apprentice sons for the moment disappearing from the official masthead, lists for sale, and cardstock. Ward was equally active and flailing with his finances. He took out a loan for half the value of his house, putting it up for collateral, and accepted an interest rate nearly double the norm.[54] The payments were stiff, but he needed the money to try to compete with that crazed, aggressive, bellicose ex-partner.

From the photographers' point of view, the Chinese could not have arrived at a better time. The competition between them was not only catty but fierce, the profits slim, the prospects for the future of their studios getting dimmer, despite Hurd's fantasy of a Helios casting beneficent beams on him. For the portrait business, any new bodies in town meant the potential for new sitters, whoever they might be and wherever they came from. For the view business, the photographers needed a new catch. The national newspaper interest in North Adams and the Hoosac had slowed, and at any rate the dream of monopolizing images of the tunnel was lost. A photographer named George Moore from Athol, in the center of the state, was regularly making trips to the region and building a collection of views; another, John Moulton of Salem, was getting inside the tunnel, capturing unique aspects of it, and creating his own list of Hoosac pictures (figs. 1.11 and 1.17). The previous boon for the national market, made possible by the disaster at Central Shaft, was over; the heroic Mallory was long gone; the bodies of the miners had been finally recovered a year and a half earlier and laid to rest. Of course, the great new story, potentially even more sensational

than the last, centered on labor strife and Calvin Sampson's bold move to import Chinese strikebreakers. The national reporters were sure to return; the engravers would need images. At least one of the photographers had his view camera and tripod ready.

❧

The famous photograph of the Chinese is not attributed—there is no label on the back, no list, no title, no number—but it has all the earmarks of belonging to William Hurd. The albumen prints are pasted to a larger cardstock than normal, the kind used in a slightly earlier generation of views. When Ward bought out the studio, Hurd was left with old supplies; many of his new views appear on older cards, the only North Adams photographer at the time who used them. In addition, Hurd's move to Penniman's Row put him closer to the Wilson House, where the embattled Calvin Sampson kept residence and was fending off Crispins and reporters. Having been a next-door neighbor for years—the original Hurd and Ward picture gallery on Main Street side by side with Sampson's early factory—must have helped the suddenly dislodged Hurd gain the shoe manufacturer's confidence. Whatever the many circumstances that led to the photographer getting the nod, he was on the spot when it mattered.

I do not think Hurd had a clear sense of what he should be picturing at Calvin Sampson's factory. The factory itself? Factory workers? Strikebreakers? Chinese curiosities? Portraits? A view? It did not help that during the Excelsior Gallery's heyday, the partners had not ventured into any of the factories sprouting along the upper and lower forks of the river, despite the fact that the whole town, with its sudden increase in population and development of an industrial economy, had been dramatically transformed by them. They had never pictured factory workers in situ, only those who had visited their studio. And of those studio portraits, none can be readily identified as "factory worker," since the occupation itself was so new and below the threshold of the professor's recognition, and did not seem to call forth a "figural nature" that the sitter should be asked to pantomime. It may be argued that Hurd had photographed tunnelers at work, but as the last chapter and the

earlier portions of this one have suggested, the men in those images were by-products of the demand to picture the tunnel's progress and feats; they were accessories and never shown to be at *work*. And it is safe to assume that he had never seen a Chinese man before, at least not in North Adams.

The strain on Hurd's habits, the relative incomprehensibility of the task at hand, and the completely ambiguous nature of the subject are everywhere evident in the photograph. As a stereograph it simply failed; the careful plotting of overlapping planes, so necessary for the three-dimensional effect, is mostly absent. The brick wall cuts off any possible illusion of deep recession; the lineup of the men created a dark, stringing mass that is nearly impenetrable. As a view it made no sense. Neither factory nor function is well elaborated; the building is reduced to brick and grass, its graphic clarity and outline remaining outside the frame. As portraiture it was useless. The men are unrecognizable. The attention supposedly given to the expressive meaning of each body part is deluged by the tangle of legs and arms and the utter sameness of costume. As an image for the magazines, it was wanting. The abrupt stillness that the illustrator had to overcome in Hurd and Ward's picture of Mallory is repeated and expanded seventyfold. The Chinese had arrived, but that arrival is nowhere marked as an action or effect in the picture. When the magazines opted for images to mark the Chinese appearance, they invariably chose others (figs. 1.22–1.27).

Today we are familiar with the outdoor group portrait—the lineup of figures in military attention before the lens—and we may be tempted to claim that something of the sort was produced by Hurd: that his ingenuity (or dumb luck) lay in conjuring the genre when no such thing had previously existed in town; that his own desperate need to keep his business afloat and his increasingly rancorous relationship with Ward pushed him into a job for which he had to improvise; that he came upon the genre because of the absolute strangeness of the situation, the appearance of a foreign matter that slipped through all of photography's normal prescriptions; that his picture borrowed slivers of strategies from his typical arsenal and, mostly by confounding them, produced something hybrid, explosive, and unique all at once; and that the photograph

of the Chinese, a new body of men who had no identity to North Adams except as a collectivity, was, poetically enough, the first group portrait of its kind. We would not be completely wrong (the group portrait is roughly what North Adams's other workers saw, though they named it something else); and yet I do not think we would be completely right.

As it soon became clear, the outdoor group portrait was a much expanded version of the interior studio portrait in that it shuffled between the poles of uniqueness and formula, or variety and unity, that was the basis of the professor's handling. Its special charge was not merely to expand that logic in an additive way, like individual portraits in simple proximity or juxtaposition, but to multiply that logic across the field of vision. Where expressiveness in the single portrait was supposedly achieved by the play of more fluid arms and legs around a rigid axis, expressiveness in an outdoor group portrait was obtained by the play of individual figures around a rigid architecture or architectonic form. Something of the sort was soon offered by the locally famous Howes brothers, photographers from nearby Ashfield and Turners Falls. They developed a thriving business in the genre.

The photograph of the Chinese did not multiply the logic of studio portraiture so much as make it seem beside the point. Figures played against the rigid architecture, to be sure, but in a manner that did not yield a mix of variety and unity but instead utter contrast. The photograph proposed three great elements—foreground lawn, background brick and glass, and like a gash between them, the thin, dark, ragged line of men. They were indistinguishable except for the fact that they seemed to interrupt the smooth grassy form in front of them and the rhythmic geometry behind. They seemed like interference in a scene trying for some resolution between architecture and land, industry and nature.

Full of visual and conceptual discomfort, the photograph was a metaphor for the way the Chinese made all those around them palpably uncomfortable. What the photographers soon saw was precisely that consonance between a pictorial awkwardness and an awkwardness that resided elsewhere. The picture proposed a relation between the three central issues that would come to define

North Adams, indeed the country, in the 1870s: the appearance of large factories, the place of immigrant labor within (and before) them, and the meanings attached to land. The photograph's uncertain way with them was that it did not resolve their relation in a compelling or even recognizable manner, simply letting them clash in the field of vision.

At least that was how Hurd and Ward, after rumination, eventually saw it. But at least initially, the photographers could not immediately name what they saw in the image of the Chinese. The picture simply confounded the conventions of their young and local profession. Not being able to name was not necessarily a bad thing, however, and not in any way debilitating or paralyzing to the scrambling photographers. In fact, it had quite the opposite effect.

❦

In the late 1860s, a new generation of travelers to the northern Berkshires began to give the land a pressing national meaning, related to the needs of Reconstruction. As the Kilburns' determined movements throughout the Northeast suggest, travelers were everywhere prowling about the towns, fording rivers, and climbing mountains, eager to provide accounts and representations of what they found. The scope and tenor of their interest can be gleaned by reading a passage from one of the most famous efforts of the era, William Cullen Bryant's *Picturesque America*. In a book devoted to elaborating the qualities of the picturesque in the entire country, the Berkshires represented its absolute pinnacle, "a region not surpassed, in picturesque loveliness, throughout its whole . . . by any equal area in New England, and perhaps not in all this Western world."[55] What made it so exemplary? The region was the "union . . . of all the forces—natural, historical, social, intellectual, and religious . . . crystallized in excess of loveliness."[56] Indeed, the combination made the place the promised land, the "Palestine of New England," as Bryant declared. In a book not known for its parsimony, the unrestrained praise of the Berkshires as a "union" (it was a loaded word) of all that mattered in Reconstruction America, all that could be desired in a peripatetic survey of the country, was well over the top. Bustling, manufacturing North Adams (the "'metropolis' of

FIGURE 2.29

J. Douglas Woodward, *Hoosac Mountain and Tunnel Works*, 1872

Berkshire") was happily included. The town's ubiquitous Natural Bridge made an important appearance ("a scene for the painter, as it and its accessories so commonly are for the photographer"—a subtle gibe at Holmes); but Bryant's interest did not stop with the unique terrain. The Hoosac Tunnel caught his eye and got its due ("a bold and fortunate feat of engineering skill"); and even Calvin Sampson's controversial shoe factory ("where 'Chinese cheap labor' has been a specialty and a success for years") found a proper, if seemingly unlikely place in his image of an American picturesque.[57] To help readers visualize sites that in all likelihood they would never visit themselves, large steel engravings by J. Douglas Woodward sat side by side with the text (figs. 2.29 and 2.30). (How Hurd and Ward must have shuddered; Woodward's images were based on yet someone else's photographs!) As if to punctuate the propitious convergence of so many noteworthy subjects, Bryant

FIGURE 2.30
J. Douglas Woodward,
*Natural Bridge, North
Adams*, 1872

included an illustration of "Profile Rock, North Adams" (fig. 2.31) that, in its disposition of two men standing on a perch and regarding the immense scenery, made reference to a painting extremely beloved to him (fig. 2.32), a picture of himself and Cole by Asher Durand as kindred spirits in their direct engagement with untrammeled nature. The reference and comparison must have seemed to some observers a stretch. Durand's painting was already an iconic image and represented an earlier generation's efforts to give visual form to a holy experience of the land. The belief in that project of engagement and expression was being updated to encompass the confrontation with North Adams, a place seemingly unlike Durand's Kaaterskill Clove, a metropolis frenetically and industrially developed, with noisy tunnel works and shoe factories and babbling immigrants.

FIGURE 2.31
J. Douglas Woodward,
*Profile Rock, North
Adams*, 1872

To be sure, Bryant's book, and countless others like it published
in the late 1860s and early 1870s, was nothing if not a booster's
guide for the tourist. It roamed widely throughout "the land we
live in," as the book's subtitle offered, celebrating without hesitation
its many disparate charms. The mode was contagious. Even so hard-
core a social activist as Washington Gladden, previously a minister
in North Adams who had fought ferociously for workers' rights and
a humane reworking of capital-labor relations, turned in the late
1860s to writing picturesque books about the Berkshire environs in
the manner of Bryant. It was not that such a mode was antithetical

to his previous beliefs. He took care to let his readers know he was not caving to industry ("these are not purchased puffs," he declared, "not prompted by that species of gratitude peculiar to politicians"); quite the opposite, he was aiming for some important and necessary accommodation of "nature, history, and industry."[58]

The relation of these guidebooks to stereoviews was nowhere stated but everywhere implied. Words and images conjured and played to an audience hungry for a new survey of the country— for a catalogue and, just as importantly, a reintegration of its many regions. Given the recent war, they promised an encompassing

narrative, keeping at bay the once debilitating social and political differences and bringing to the fore the familiar, seemingly natural qualities of "shores, valleys, cities, and other picturesque features of our country."[59] Although to some observers it seemed that the Union was fragmented beyond repair, that Reconstruction only exacerbated the conflicts between the regions (and, at any rate, did not adequately address the question of race and equality), and that no amount of feel-good survey could detract from the undeniable existence of ruin, the guides and pictures declared otherwise. The country could be conceived as made up of parts of a great, expansive whole. The key, the guidebooks and stereographers said, was to *look*—not just once or twice, but again and again. In a sense, Oliver Wendell Holmes's urge to span the continent, flitting through view after view without pause, was the booster's dream in the postwar era. Holmes did indeed look and look; and in the very process—in the quirky juxtaposition of pictures from wildly different parts of the country, in the fast sequence of scenes from North and South, city and country—a nation could just about be reimagined and reintegrated in pictorial form.

If Durand had once believed that paintings of the American landscape should be owned by every American and cherished as dearly as the family Bible, Bryant in his book was proposing why taking stock of the land still mattered, why such a belief in landscape still had currency, even or especially after the devastation of prolonged conflict. Whereas Durand did not feel the pressure to accommodate the effects of recent national combat (the Mexican War was hardly a disturbance in his worldview), Bryant had no choice. Sectional strife, the open gashes on the land, the fallout of a crushed economy, the flood of new labor, the question before most communities concerning race, equality, and citizenship—no map of the country could completely ignore them. But how to accommodate them? It was the Reconstruction era's ingenuity, as represented by men like Bryant and Gladden, to organize them under the "picturesque," a mode of representation that thrived on the co-existence of difference and ruin, of competing historical and social forces, and of the effort to resolve them (to deflate or dilute them) into a pictorial whole, an "excess of loveliness," as Bryant declared.

The key was not simply to omit the traces of history but to bring them into line by bringing them to "the mingled vegetation, the trees, the plants, ay, the very weeds," as *The Home Book of the Picturesque* described.[60] "The modern ideal is the Picturesque," the *Atlantic Monthly* art critic J. E. Cabot already recognized in 1864, the year before war's end, because it is a "beauty not detachable, belonging to the picture, to the composition, not to the component parts. It has no favorite; it is violated alike by the systematic glorification and the systematic depreciation of particular forms. . . . The picturesque has its root in the mind's craving for totality."[61]

No wonder the Berkshires and towns like North Adams were so crucial. They contained all the marks of history—of land and landscape weighted with the nation's past, of the coming and establishment of industry and the emergence of a new kind of large market economy, of labor and violent labor strife, and of the continuing conflicts between waves of immigrants and natives. They had ruin by the wagonload, but not of the sort brought about by cannons and torches, but rather of the seemingly more palatable, more answerable kind brought about by the passage of time and the fading of an earlier agricultural and colonial way of life. And they had their marvelous Taconic and Hoosac mountains that stood untroubled by the "tireless flow and ebb of life and labor" and "the turmoil and trouble and disaster" of the world around them, as Bryant understood.[62] The mountains absorbed history impassively, and at any rate, they were eminently pictorial. "History begins at home," Gladden wrote of North Adams, by which he meant that it was better to view the nation's frenetic, chaotic, lacerating movements from "one town from all its hilltops."[63]

How these debates facilitated or hampered local professors' efforts to photograph the land *they* lived in was clear (to say nothing of how the national investment in the Berkshires might have energized or enervated them). As the *Atlantic Monthly* critic declared to photographers, the camera was an unthinking eye before the landscape in the sense that it had no ability to discriminate between objects; it captured all that was before it, without organizing or prioritizing them. The pictures it gave were "too full and too empty," meaning they were too stuffed with indiscriminate details

and too empty of overall resolution.[64] The stereoview was potentially an even worse culprit in the sense that, with its ability to provide a three-dimensional effect, it picked out and accentuated all kinds of separate objects as if they occupied special places in the field of vision. The palpable "in front of" and "directly behind" quality offered of objects in spatial relationships worked against resolution; it was hard to give the stereoview something more integrated, more stitched together, than the jarring sense of a series of disconnected, overlapping planes. Of course viewers like Holmes loved that effect but only to the point where it did not break down into visual anarchy, a flurry of objects all competing for attention. Photographers should strive not simply for legibility, as *Humphrey's* sought, but for a means of picturing that subordinated parts to a whole and that, importantly, framed the incidents of history with the overwhelming sense of place. Make use of the mountains, find the grove, look for the tall pines, include the mingled vegetation, even the mangy weeds would do. Life and labor, trouble and disaster— all the teeming energy and all the potentially unruly details needed a pictorial order based on land. The underlying reasons for doing so were hardly disguised. "Is it not that the place seems set apart from the working-day world of selfish and warring interests? that here all manner of men, for once, lay aside their sordid occupations and their vulgar standards, to come together on the ground of a common humanity?"[65]

❦

While the picture of the Chinese against the south wall did not instigate a full-scale reassessment of the photographer's practice, it jarred it enough to permit among some practitioners a consciousness of their habits and roles in producing representations. To repeat the general claim, the relation between the great warring elements of, on the one hand, a post–Civil War industry coalescing around large factories and, on the other, the revaluation of land during the scarred, rehabilitating, and hopeful years of Reconstruction was raised for inspection. They were raised in the photograph in such a way that their juxtaposition provoked a sense of their awkwardness together. It did not help that in the photograph both elements were

reduced to ciphers, industry condensed to the exterior of Calvin Sampson's factory (how he must have loved that!) and land to a manicured, grassy lawn. But perhaps that reduction made them all the more jigsaw-like, ready to be fitted properly. It certainly did not help that in between them, in the crease, as it were, stood the newly arrived Chinese, whose very presence did not conform to any local understanding of what a sitter should be. Their incomprehensibility and interruption figured in the overall sense of awkwardness; in fact their interruption seemed to embody it and bring it about. If only there were some way of resolving the picture, of making it fit the habits the guidebooks and art critics were suggesting their readers cultivate, of naturalizing the view and giving it a totality. If only the strange juxtaposition of the picture's major subjects could be reorganized or reconceptualized in such a way as to give them a "beauty not detachable," a coherency not torn asunder by its component parts. If only there could be fashioned a whole and recognizable image. If only, that is, the photograph on the south wall of the factory could be transformed into the picturesque.

What the photographers soon saw in the picture of the Chinese was an opening or encouragement to rethink their habits with the view. Whereas once the view developed in dialogue with the engineer's understanding and resulted in pictures searching for graphic clarity, registrations of progress, and the like, it soon came into dialogue with the post–Civil War era's formulation of the picturesque. Indeed, the call to root the incidents of recent history in the impassiveness of landscape is nowhere answered in North Adams photography—that is, until the Chinese arrived. There was suddenly, in 1871, an attention to precisely the feelings of the picturesque as outlined by men like Bryant, Gladden, and Cabot. If the call was to see history from "all its hilltops," Ward obliged, literally, climbing Robinson's Hill to Witt's Ledge and getting a picture of the town (fig. 2.33), making sure to include the railroad tracks where the Chinese had arrived, the lower fork of the river where factories set up their huge water-powered engines, the Wilson House in the middle distance where Sampson took his residence, the workers' houses in the lower right and upper left where hundreds of French Canadians and factory operatives had settled in, and

FIGURE 2.33

Left
Henry Ward, untitled
photograph (no. 794,
"North Adams and
Vicinity"), ca. 1871

FIGURE 2.34

Right
William Hurd and
William Smith, *View of
North Adams Village*
(no. 261, "Views of
North Adams and
Vicinity" series), ca.
1872

in the distant background, the shadowy form of Hoosac Mountain.
They all seemed so charming from a distance. The sordid occupa-
tions and vulgar standards, the brutal strikes and intense acrimony
between the various factions in town hardly seemed to matter. Not
to be outdone, Hurd and Smith climbed the same hill, set their camera
several hundred yards south, and tried their own view (fig. 2.34). We
can measure their position by noting the same dome-capped temple
tower that appears on the right side of Ward's photograph. And they
tried yet another, this time bringing to fruition all the special features
called for by advocates of the picturesque (fig. 2.35). They included a
sitter regarding the view, perched on a rock, his boots planted in the
grassy slope, his hands clasped around his knee in relaxation, his head
cocked in thoughtful contemplation; he surveyed the land and, at the
same time, was firmly rooted in it. From his vantage, the bustling in-
dustrial town nestled snugly into place and was transformed into an
image. He could, if he chose, just barely make out Sampson's big box
of a factory at the far left. Or he might choose not to. The factory's
place within the environs did not stand out; whatever went on inside,
it was simply part of the scenery. The picturesque had its ideal viewer
who demonstrated for his audience the proper, meditated regard
and interpretation of a view. Even children could learn it (fig. 2.36).
(Typical of Hurd's increasingly irrational bent to outperform his for-
mer partner, in 1872 he bought a parcel of land on Robinson Hill in

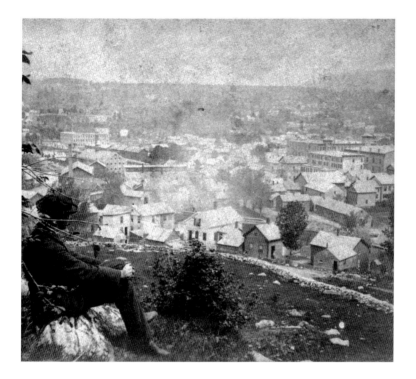

FIGURE 2.35
William Hurd and
William Smith, *View of
North Adams Village*
(no. 261, "Views of
North Adams and
Vicinity" series), ca.
1872

an attempt to monopolize the most amenable vantage point, the deed
declaring that the seller, who owned the surrounding property, "will
not erect any building, nor suffer any to be erected immediately in
front of said lot to obstruct the view."[66] Of course he wouldn't; the
picturesque was too precious.)

❦

With the exception of Ward's picture of the Chinese in front of
the factory (figs. 1.35 and 1.36), taken some time around 1875, the
Chinese never again stood before the factories, the streets, the hills,
or any indeed other locale in the environs, probably much to
everyone's relief. But their presence—their pressure—on the pho-
tographer's practice did not go away. Sampson's demand for cartes
de visites and an image archive of his workers meant that the Chi-
nese kept showing up at the studios. The money was welcome, but
all the same it must have been a continuing challenge to figure
them, even in the more controlled studio space. There was no doubt

FIGURE 2.36
William Hurd, *View of North Adams* (unnumbered, "Views of North Adams and Vicinity" series), ca. 1873. (Courtesy of the Freel Library, Massachusetts College of the Liberal Arts.)

a comic element to these studio visits, photographers and sitters not speaking the same language, nodding happily at each other in utter incomprehension, communicating through hand gestures about how the session should proceed, having different understandings of the purposes of portraiture and offering equally different ideas about pose and comportment, all the while trying to attain civility during the dance around the head brace. But the comedy had a serious aspect. To what "figural nature" should the Chinese adhere? What kind of expressiveness made the most sense, and how should it be lodged in the body? What was the middle ground between formula and uniqueness when, from the photographer's point of view, the Chinese were either too formulaic, in that they belonged to stereotype, or too unique, in that they were so unlike anyone else in town?

Having to answer these many questions was temporarily postponed in 1870, when the Chinese first visited the studios at Sampson's behest. Later that year, Ward (and then Hurd soon after—he was nothing if not attentive to his ex-partner's innovations) introduced the latest fad in portraiture, the "Rembrandt" style, characterized as a bust-length portrait highlighted by a sharply angled side-lighting.[67] The dark side of the sitter's face was outlined against a light background, the light side against a dark background, all of it

achieved by a movable light source and reflecting screens. The style was in homage to, and no doubt capitalized on the fame of, the great Dutch painter, though as the photography historians Heinz and Bridget Henisch quip, "[W]hether Rembrandt himself would have regarded it as a compliment remains in doubt."[68] There were simply so many bad examples floating about and claiming inspiration from him. Lighting was still an extraordinarily tricky aspect to control—it was the bane of Hurd and Ward's practice in the Excelsior Gallery—and movable lighting only compounded the problems. Yet, it provided a ready-made, ultrafashionable template to use on the Chinese sitters when they first visited the studios (figs. 1.28 and 1.29). It is also the reason the first portraits of them were bust-length, as opposed to the far more common full-length portraits that had characterized all of Hurd and Ward's previous studio work. The side lighting was not nearly as dramatic as some New York photographers were attempting, and the effect of a complex inner life that the best Rembrandts offered was nowhere to be found. But the new style avoided the whole problem of bodily expressiveness, gestures, comportment, the fluid movements of arms and legs—in short, the figural natures of the Chinese.

Damn if the Chinese did not keep returning to the studio! They seemed to come *of their own volition*, not just once or twice but over and over. When they returned, however, they did not want the Rembrandt picture that resulted from their first sessions, no matter how fashionable it seemed around town; they opted for the full-length portrait. The choice would eventually become a sore subject among photographers throughout the country; their clients didn't want to pay full price for a half-portrait, they complained sardonically. But that characterization of the sitters' literalness and parsimony did not really explain the Chinese motives.

The important point here is that, with the wish for more portraits, the question of Chinese figural natures could not but come to the fore. Rather than rely on the photographers to decide what those natures should be (the fancy Rembrandt style clearly did not appeal to them), the Chinese took matters into their own hands (fig. 4.14). They broke all the tasteful bounds of the professor's craft, splaying their legs unnaturally (the guidebooks, remember,

had recommended that they "must be perfectly natural and easy"), wrenching their ankles and feet ("In the position of the feet the first thing to be observed is, to avoid their being placed far apart, or put into constrained attitudes"); puffing their chests to an extreme ("Stiffness, or want of ease, whether relating to the chest, arms, or hands, is under all circumstances to be avoided"); leaning so far forward that their shoulders thrust back and their bodies sat bolt upright ("[T]he axis of the plane in which the shoulders lie shall not be parallel with the inclination of the head, which prevents the picture from appearing broad and disagreeably harsh"); stiffening elbows and fingers; holding objects that drew undue attention.[69] The list of improprieties went on and on. They brought props and costumes that the photographers could not furnish; they placed or held the knickknacks as they wished; they wore the costumes in a manner only they understood; they orchestrated the sittings as they pleased.

What Hurd and Ward thought of all this primping is hard to say; they certainly did not ask any of their other sitters to strike remotely similar poses. The two acquiesced in the zany portraits—the money was too needed—and besides, if one of them refused, the Chinese simply went to the other, heaven forbid, or even elsewhere. Although Hurd seems to have gotten a large portion of the Chinese business, the men had no special loyalty to him, and he surely knew it. I imagine he must have sighed and shrugged his shoulders when the men showed up with even stranger props. Their visits to the studio, the bags of knickknacks and clothes in tow, became regular. While the Chinese never appeared in any more stereoviews, with the important exception of Sampson's second commission, their regular presence in front of the carte de visite camera continued to represent a challenge, an interference in the photographers' normal habits.

❧

The Panic of 1873 hit everyone hard; the photographers were no exception. Two others had tried starting studios in the early 1870s; they were simply squashed by the brutish economy, each lasting less than a year. Hurd had somehow gotten rid of Smith by early

1873—the archives don't suggest how—and tried to elevate his two sons in the business, once again becoming "Hurd and Sons." But it was all downhill from there. Bad investments in all that property and the heavy loans were catching up to him and, combined with the Panic, stretching his studio to a breaking point. He hung on for a couple more years, but by 1875 prospects were bleak.

That year, events took a turn for the worse for Ward as well. His wife Julia, always sickly, died, leaving him to raise two young daughters alone. Since the demise of the Excelsior Gallery in 1870, competition between Hurd and Ward had been fierce, sometimes obtaining the quality of a nasty, bitter sibling rivalry. They seemed to enjoy inflicting wounds. Their divisiveness had opened a space in the local practice of photography, in that it made them both receptive to, or at least willing to try to work through, what they saw in the Chinese against the south wall. One might have expected that with tragedy and very harsh economic times the two men might bury the hatchet. But it was exactly the opposite.

The year 1875 should have been joyous by local standards. The Hoosac Tunnel, nearly twenty-five hard years in the making (it had taken 195 lives and countless limbs, not to mention $17 million), was finally completed.[70] The first engine passed through in February, the first freight train in April, the first passenger train in October. The town took them as occasions for a yearlong party. Early that year, Hurd published a photograph of West Portal showing the surface stones nearly smoothed into place and the remaining debris on the slopes ready to be cleared (fig. 2.37). It was an image of great expectations, the massive doors being opened by the engineers, as if the tunnel was being readied for the long-awaited business. Hurd had always advertised himself as following the Hoosac's progress and hitching his studio's future to the tunnel's. Although business was very rocky—the credit reports declaring not long after that Hurd was "not making much more than a living" and warning creditors that they should accept only cash from him—he was in a sense proclaiming his own expectations.[71] That year, as if in rebuff of Hurd's claims, Ward issued a photograph he and Hurd had made many years before, in 1868, when they were still partners (fig. 2.38). It, too, showed the West Portal, mostly in a state of disarray. Locals

would have easily pointed to the brick house at the upper right, the twin derricks so essential for hoisting the heavy loads, the six layers of lining on the mouth. If they had been given the date, they might have even been able to recite how far the heading had reached by the time of the photograph. Yet, as in the photograph of Walter Shanly and his family from roughly the same period, I would wager that most would have missed or simply dismissed as irrelevant the figures surrounding the gaping mouth. Except Hurd. There, standing on the very apex of the tunnel opening, arms folded in a posture of utter self-confidence, Henry Ward stared straight down the barrel of the camera.

However Hurd interpreted the gesture—a comeuppance, a derision, a sardonic laugh, a challenge being sent to him—he was soon on the rampage. He bought Lucius Hurd's old studio in South Adams, hoping to expand the business and make good on his expectations.[72] Lucius Hurd had left many years before; sales had been very poor. It didn't get any better in William Hurd's hands. The new mortgage on top of all the others and the feeble business at not just one but now both of his galleries simply crippled him. After nearly a decade of struggle as a Berkshire professor, he soon skipped town for Nevada, never to return, hoping to escape the hordes of creditors.[73]

The shamble of Hurd's business fell to his oldest son, twenty-two-year-old Ernest, who picked up the pieces and kept the practice going. He was roughly the same age as many of the Chinese, and he ended up taking some of their most compelling portraits (fig. 4.36). Old William Hurd never got a chance to see those strange results of what he helped to start.

Figure 2.37
Facing page, top
William Hurd, *West Portal, Hoosac Tunnel*, 1875. Courtesy of the State Library of Massachusetts.

Figure 2.38
Facing page, bottom
William Hurd and Henry Ward, *Hoosac Tunnel, West End*, 1868. (Courtesy of the State Library of Massachusetts.)

THREE

<center>✛</center>

What the Crispins Saw

The View: With the Chinese arranged against the south wall of the shoe factory—the men spread against the brickwork and, in the stereoscope's odd way of conjuring spatial relations, looking like they had been potted there—the Crispins confronted visual, almost tangible evidence that they had been rudely displaced. The picture was a flaunting by the shoe manufacturer of his victory. He had gotten the better of them, and their efforts to dictate the terms of factory work came to this. The photo declared that, for their troubles, they were now unemployed and their prospects of returning to work in the factory and providing for their families considerably reduced. Feeling at once helpless, enraged, frustrated, and provoked, the Crispins also confronted their commitment to staying in New England. It would have been easy to pack their bags and search for jobs elsewhere, for some of them even return to French Canada and a farming life. The border was less than a day's ride away; it had been crossed so many times in the efforts to find work that making another trip would have been routine and raised no heartbeats. Instead, many chose to stay; and in that decision they went from being wanderers in the industrial landscape to settlers, migrants looking for seasonal work to immigrants (or some identity equally complex, as this chapter suggests), and augmented the process of becoming an American working class. What that meant—"becoming an American working class"—was not always clear to them. The idea of it was made all the more fraught and perhaps even a bit less appealing than might have been the case because of the truculence, bad manners, and exclusionary tactics of the national labor organizations, to which the French Canadians had a strained attachment, and because of their own investment in some notion of "home." But they

made choices to acclimate and adapt to their social, political, and economic environs, even if those environs offered no determinate place for them in Reconstruction America and even if the lure of returning home remained. They also left us several remarkable photographs attesting to the unevenness, contradictions, and experimental nature of the process.

Although Quebec in the late 1850s and early 1860s was over-whelmingly rural—more than 80 percent of its population was still living on farms—the province was hardly the sort of place where a French Canadian farmer thrived. The difficulties came from both political and economic pressures. In the political sphere, the farmer had always found British rule suffocating and degrading, but events over the previous two decades, when the British government simply refused to recognize Francophone interests, had proven to him that he was officially a second-class citizen. In 1834, Louis-Joseph Papineau and his supporters had presented *Les Quartre-Vingt-Douze Résolutions* (The 92 Resolutions) on behalf of the landed Quebecois, asking the British government to affirm the rights of French speakers of Canada and uphold Quebec civil law, the Catholic Church, and the ancient seigneurial system. The proposal was soundly rejected, and its most enthusiastic supporters had warrants put out for their arrest. British refusal lit a fire under a growing separatist movement in the countryside. The years that followed were characterized by skirmishes between French-speaking rebels, nearly all of the recruits from the farms, and English-speaking troops. Throughout the late 1830s, French and English clashed up and down the Saint Lawrence and throughout the Richelieu Valley just east of Montreal. The *patriote* rebels had organized enough of the farmers into a resistance group to score small victories over the more professional British troops, the biggest and most promising victory in the small town of Saint-Denis in 1837. But these proved short-lived in the face of massive British reinforcements and ammunitions. A month later in the northern *patriote* village of Saint-Benoît, British troops overran rebel barricades, looted the town, and burned it to the ground. In Saint-Denis, the British returned

two years later, crushed the farmers, put that town to the torch as well, and arrested and eventually hanged a dozen of the rebels on charges of treason. The early small victories on the part of the French transformed by the turn of the decade into humiliating defeats. Papineau and his supporters were forced into exile in the United States. Martial law was proclaimed; the Canadian constitution was suspended; and the most militant *patriotes* court-martialed and either hanged or banished to Australian penal colonies. By 1841, with the farming countryside ravaged, many villages reduced to ashes, and the separatist movement dealt too many losses on the battlefields and in the courtrooms, the rebel farmers were in no position to fight a British decree that joined Quebec and the French-speaking territories of Lower Canada with English-speaking Upper Canada, the union between the two in effect putting an official stamp on the *non*-recognition of French Canadian self-rule.[1] In 1867, the entire province was linked by the British North America Act to New Brunswick, Nova Scotia, and Ontario, placing all of Quebec under a central English-speaking authority based in Ottawa and deeding all political power to a highly centralized federal government.

While the farmer's dignity, sense of political belonging, and understanding of fair treatment from authorities were tested, his wallet was stretched thin. Wheat, the staple crop of Quebec, had been so intensively cultivated to try to meet British demand over the previous decade that it had begun tapping out the once-rich soil. An attack of wheat midge and wheat rust made the shrinking harvests even smaller. Produce from the agribusinesses in the American Midwest flooded the British market and pushed the hardscrabble French Canadians to the fringes of the economy. Until 1854 and the signing of a Reciprocity Treaty with the United States, tariffs prevented them from shipping their goods south of the border. Some of the farmers turned to peas and potatoes, but those crops in the 1850s put them outside of the larger markets. Disconnected, those farmers in effect returned to subsistence farming, producing a limited supply for a very local market, often just for the immediate family. With no easy way to sell off any surplus crops (if they had any) and no extra income to buy the new mechanical equipment

and improve the land, the Francophone farmers were trapped in a stagnant agriculture seemingly out of the eighteenth century. Although most Quebecois were overwhelmingly dependent on a farming economy—the cottage industries that characterized the American antebellum countryside had not yet taken hold in Quebec, and the forest industry was increasingly the domain of large companies—by the middle of the nineteenth century they were losing ground to the American corporations and losing touch with the burgeoning international markets. An official report from 1850 painted a dismal picture. While the fields were arable, the whole region suffered because, as the assessors declared, its farmers were backward in their farming techniques and completely unprepared to revitalize and tap the land's potential and extend Quebec's agricultural and economic reach. The farms suffered from "want of an appropriate rotation of crops . . . want or bad application of manures . . . want of attention given to the meadows, and the production of vegetables . . . [and a] scarcity of improved agricultural implements."[2] A photograph from the late 1850s tried to suggest the efforts at improvements by farmers (fig. 3.1). A gigantic tree stump remover hovers over the land, its cranks and pulleys hoisting a mass of broken, unearthed tree for all to see. The prodigious effort has brought out not only the farmers at left but also the smartly dressed men at right, as if such a technological feat were a village event. But land clearance proceeded at a snail's pace, the tripod contraption and its crazy tangle of rope providing as much evidence for the cumbersome, almost primitive nature of the clearing process as for the singular successes. So many inefficient contrivances, basic wants, and scarcities pushed the farmers into bankruptcy. The inheritance expected by eldest sons went instead to banks and the British government.

For the least successful farmers, life was a struggle for survival. They barely kept their heads above the poverty line and sometimes sank below it and became part of the floating population of indigents. In harsh times, families with no grains in storage had to buy their food, sometimes from the marginally better-off farmers who lived side by side in the old plots of the seigneurial system. Those with modest means got a little richer; the poor got much poorer.

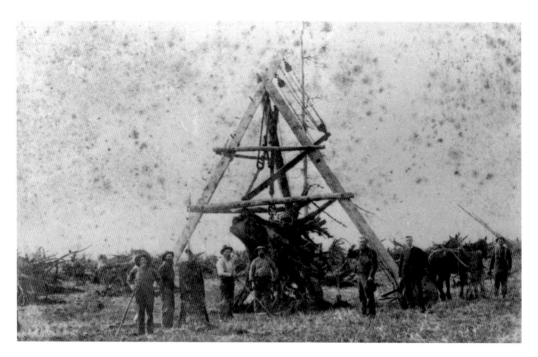

FIGURE 3.1
Unknown
photographer, *Stumping
Machine*, ca. 1860.
(Courtesy of the
Archives of Ontario.)

The near destitute survived by their rural wits, hiring themselves
out as farmhands, picking up the backbreaking jobs that even their
poor neighbors didn't want (including removing the seemingly
ubiquitous stumps), begging, stealing, smuggling, doing whatever
they could to hang onto the small patch of land inherited from
their parents, often without success. They became like the emaci-
ated peasants who lived in early modern Europe, malnourished
(eating meat once or twice a year), prone to disease, scratching the
earth from dawn to dusk, roaming from one old seigneurial tract
to another as part of the flotsam of a wrecked economy. The social
and economic imbalances led to jealousies and rivalries, sometimes
bloodshed. Penny-pinching farmers who held their neighbors in
debt were despised almost as much as the seigneur, the tax collec-
tor, or the hated British official. What the cultural historian Robert
Darnton says of French peasants of the Old Regime is as true for
their younger cousins across the Atlantic, that the farming commu-
nity, embattled from without and within, "was no happy and har-
monious *Gemeinschaft*."[3]

It is no surprise that when recruiting agents from American factories traipsed across the border looking for new hands, Quebec's farmers leaped at the chance. Between 1850 and 1870, more than 250,000 farmers, about a third of the population, moved south.[4] The exodus was dramatic, felt in every town and village. Despite the fact that Quebec was having a hard time feeding its population or that the Catholic parishes and church councils were earning a nice cut in American dollars from the recruiters, the mass movement caused a palpable level of alarm and feeling of doom and gloom among the remaining Quebecois, already feeling oppressed by British rule and squeezed out by an English commercial class. The emigration was the "great haemorrhage" and portended, as Antoine Labelle, curé of Saint-Jérôme, feared, the absolute "graveyard of the race."[5] In the villages, new songs were sung and poems recited warning not only of the death of a people but also of the travails across the border. "Où allez-vous?" a popular song asked. "Dans les Ètats," the audience replied. "Vous courez après le misère. Virez de bord, n'y allez donc pas!"[6] But the fears of an ethnic apocalypse and even greater poverty abroad could not stem the tide. The conditions at home seemed to inure the French Canadians to the risks and hardships on the road. The poor men and women had a reputation for taking the lowest-paying jobs, acclimating themselves to the most minimal standards of living, and traveling by the most modest means. With cheap manpower seemingly everywhere north of the border, New England's factory owners and managers happily welcomed them and soon dubbed them (ironically, given events in North Adams) the "Chinese of the Eastern States." Most of the farmers-turned–industrial laborers headed for the southern New England and upstate New York mill towns; some went to work on the Erie and Champlain canal networks.

Many of the French Canadians who left for Woonsocket in Rhode Island, Lowell and Fall River in eastern Massachusetts, Chicopee and Holyoke in the western part of the state, and Cohoes in New York (just across the border from North Adams) took their whole families.[7] They transformed these towns into suddenly thickly populated, French-speaking communities. Sometimes husbands, wives, and children entered the factories as one; in those

cases farming families became industrial laborers almost overnight, trading the ax and spade for the spindle and loom in a radical transformation of their daily lives. But that wholesale relocation and transformation was never entirely the case, either in the coastal mill towns or especially in North Adams. Perhaps it was the relative proximity of the northern Berkshires to the border. Perhaps it was the connection of waterways from the Saint Lawrence River to the Richelieu in southern Quebec to Lake Champlain in Vermont and down through a series of tributaries to the Hoosic River that made North Adams seem within easy reach (it was a difficult but passable route, although winter crossings were usually out of the question and the trains had to be used). Perhaps it was the uncertain conditions in which workers could expect to live; the stingy Sampson offered no housing or amenities, in contrast to the owners of the Slater-style mill towns in Woonsocket and Fall River who offered factory bungalows and tenements as part of the lure. Whatever the many reasons, the French Canadians at first did not view North Adams as a place to resettle entire families. Young men arrived alone, most of them probably the second and third sons of impoverished farming families, many leaving young wives and children behind.[8]

This was not an unusual scenario. At least as early as the 1830s, parts of Maine, New Hampshire, and Vermont had served as places for seasonal work for French Canadians, a migrant workforce that baled hay and cut wood in the autumns and returned home with a few coins in their pockets or a few supplies in their knapsacks to help their families face the cold winters. The thick, forested region of the entire northeast quadrant of the continent made their skills felling trees transferable from place to place. There was talk of regular work in Montana, Idaho, and even the Klondike whenever the men wanted it.[9] The itinerant woodcutter was so common that he became a stock type in the photography studios (fig. 3.2), where photographers kept piles of wood and handsaws as props for the sitters. In our example, by the great Montreal photographer William Notman, a woodcutter to the right is shown just having arrived at a job site, only to find that another has beaten him to the punch, made short work of all the cordwood, and is already relaxing with a

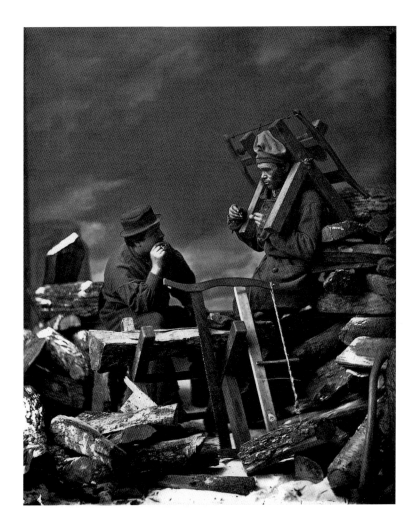

FIGURE 3.2
William Notman,
*Canadian woodcutters,
Montreal, QC*, 1866.
I-25240. (Courtesy of
the McCord Museum,
Montreal.)

pipe. The roaming woodcutters scratched for jobs everywhere, and seemed ubiquitous, not to say photogenic.

The young men arriving in North Adams at first understood the town as a seasonal locale, albeit in the factory, and viewed their incomes as part of an effort to augment the household economies back home. Some may have continued chopping wood and baling hay during the months when they were not pegging shoes for the American manufactories. Others may have made North Adams the very southern terminus of a well-traveled route between Quebec

and western Massachusetts, picking up jobs along the way in Vermont, maybe stopping in Burlington for a spell when the barges came in and needed loading or when the laborers were flush with a little spending money. The vacuum left by New England men off at the battlefront during the Civil War made all kinds of patched-together jobs available for the Quebecois. The rhythm of Berkshire shoe manufacturing, in which the hired help tended to be temporarily let go in the slow months of December and January, fit neatly into the already established patterns of migrants and poor farmers living by their wits and allowed them to dovetail shoemaking with other kinds of work. Whatever the mixed-and-matched employment, the working life of the young French Canadian shoemaker was as wide and varied as the path he traced back and forth across the border. The farming situation in Quebec, though grim, still held much of his attention. Maybe if he earned enough wages in the factory he could pay back part of the note on the farm; or maybe he could put some dollars toward the purchase of better mechanical contraptions to make land clearance more efficient and the fields yield more bountiful crops; or maybe he just simply wanted extra spending money because the margins of profit from wheat or potatoes were too slim for anything more than covering daily necessities. But in any case, neither North Adams nor the shoe factory had a permanent hold on him.

The migrant period lasted for much of the late nineteenth century, though the numbers of migrants going back and forth were most evident in the years between 1860 and 1880—that is, from the beginnings of the Civil War and the increased need for help in the North Adams shoe manufactories at one end, the arrival of the Chinese in the middle, and their eventual departure at the other end. The years between 1867 and 1870, coincident with Sampson's rise as a dominant shoe manufacturer, marked an important turning point in the pace and quality of movement. The fluid lives among these French Canadians in North Adams meant they had a different kind of attachment to a notion of "home" than many other foreign workers who resettled more quickly and permanently in other New England mill towns. For our purposes, because of that difference, the residue of those concerns in Quebec

recounted above—the difficulties of living under British rule; the harsh, localized, and divisive nature of Quebecois subsistence farming; and the anxious sense that a race was somehow passing away in the "great haemorrhage" and those remaining in (and returning to) Quebec were responsible for its continuation—eventually brought about a peculiar kind of identity among North Adams's new transnationals and informed how they understood the Chinese in front of Sampson's factory. We may call it a diasporic identity and elaborate its contours in the pages that follow. This will require that we pursue several related stories as they bear on a diasporic sensibility: the cultivation of "wandering" and "displacement" as themes, the nature of the French Canadians' tentative settlement in a new country and the quality of the resistance they faced, and the formation of a working-class consciousness side by side with an ongoing sensitivity for the farm.

⁜

Organized and often violent militancy had always seemed a part of the French Canadian farmers' repertoire, as the widespread *patriote* conflicts with the British suggest. But there is a curious and persistent thread in American antebellum writings about the Francophone farmers that downplayed that. Rather, they were viewed as romantic victims—noble, constant, principled, and almost helpless in the face of British oppression. Possibly the earliest statement of this view was Longfellow's epic poem *Evangeline: A Tale of Acadie*. Written in the 1840s in the aftermath of the failed *patriote* rebellion and published in Boston in 1847, the poem reinterpreted a history of French Canadian loss and displacement. Despite its epic ambition (perhaps because of it) the poem has not worn well over the years. Many modern readers would agree with the sentiment offered by the literary critic Christopher Benfey, who asks, "Who now reads those bosky American epics [like] 'Evangeline' . . . except for laughs?"[10] Yet it was in its own day wildly popular, its lumbering melodrama, lofty sentiment, and nearly impenetrable meter somehow irresistible to its contemporaries; and it made Longfellow the most famous poet in America. Longfellow based the poem on the Acadians, French farmers who had settled in the

salt marshes of the eastern coast of Canada and who, throughout the revolutionary era when their lands were being fought over by the French and British, maintained a fierce loyalty to Catholicism and the French language.[11] By the mid–eighteenth century, they counted some fourteen thousand, far outnumbering English-speaking settlers in the region. In the 1750s, with eastern Canada finally under British control, the English decided to break up and deport their recalcitrant Acadian subjects to the far reaches of the empire and replace them with loyalist Protestants. The French colonists dug in, made pacts with local Native American tribes, and fought back. The effort to remove them proved onerous. British troops torched villages, wrecked farms, killed livestock, destroyed dikes, and swamped the carefully cultivated marshes; but they could not intimidate enough of the farmers into leaving.[12] At one point, the redcoats were reduced to dragging individual farmers onto any ships that happened to be anchored and sending them off to wherever the captains were headed. Although many Acadians were relocated in groups, stories circulated of gruesome beach scenes where husbands and wives were torn from each other's arms and put on ships pointing in opposite directions, the couples destined never to meet again. In this manner, the British rid themselves of about a third of the coastal French.

The Acadian history of dispersal and displacement was largely forgotten—it seemed a regional story of ethnic tribalism and yet another of the many examples of British hubris and miscalculation in North America—until Longfellow revived it. In verse, he condensed the larger history of colonial conflict into a story of a husband and wife, Gabriel and Evangeline, who are separated on the Acadian beach and each exiled to distant parts of the continent. For twenty years, Evangeline wanders roads and fields in search of Gabriel, traveling through Acadian (Cajun) Louisiana, the Ozarks, Nebraska, the Shawnee camps in the Great Plains, even as far west as Oregon—a mad, improbable, and for Longfellow's contemporaries compellingly *Odyssey*-like journey on the western frontier. Husband and wife somehow trace each other's steps across the vast landscape and tragically miss each other on several occasions. Finally, old and gray, Evangeline finds Gabriel in

a Philadelphia charity hospital dying of cholera. He lives long enough to recognize her, "and Evangeline, kneeling beside him, / Kissed his dying lips, and laid his head on her bosom." The years of fruitless wandering yields a fleeting reunion, but rather than take it as an occasion to rail at a brutal and draconian displacement or lament a life spent in painful and nearly unfulfilled longing, Longfellow proffers Christian and feminine sentiment: "And, as she pressed once more the lifeless head to her bosom, / Meekly she bowed her own, and murmured, 'Father I thank / thee!'"[13] Scattered far from home, the Acadians find redemption—a kind of communal meaning in their dispersal—in constancy and charity. ("Eureka!" John Greenleaf Whittier declared in the abolitionist paper *National Era*. "Here, then, we have it at last! An American poem."[14] The irony of that claim—that a figure living in the diaspora was the basis for American feeling—seems to have been ignored. The critics were almost unanimous in their ecstasy. No less than Hawthorne concurred, identifying loss as giving rise to nationalist sentiment, "a pathos illuminated with beauty," a story of tragic separation "nowhere dismal or despondent" but instead glowing "with the purest sunshine where we might least expect it, on the pauper's death-bed.")[15]

Although the stuff of grand poetic license, *Evangeline* quickly took on the quality of history, and while hardly anyone had called himself an Acadian in generations (it did, however, result in a generation of daughters named Evangeline), the poem prompted stories of a long-lost people finally found and was cited as a precedent for the more generalized sufferings of contemporary Catholics and French speakers.[16] Of course the history of Quebec's *patriote* French was hardly the same as that of the displaced Acadians (though many Acadians—as many as eight thousand—had relocated to Quebec during the British expulsion).[17] And there was a huge difference between mobility, as the Quebecois economy demanded of its poor farmers looking for work, and wandering, the fate of lonely, separated Evangeline, though the two kinds of movement got regularly confused. But the rough parallels between the two stories, especially as Longfellow had conjured the boundlessly Christian heroine, were apparently obvious, both stories seemingly gripped with the horrors

of ethnic cleansing, the willful survival of a devalued people (in the farms, along the frontier, in the factories), and an intensely regional identity under imperial British rule, all aspects of an emerging French Canadian patrimony.

We can measure how the sentiments expressed in *Evangeline* rippled through the people of industrializing New England and the Canadian borderlands and how they provided a rough sort of identity for and about the long-suffering French Canadians. First of all, *Evangeline* reached a large Lower Canadian readership almost immediately. In 1853, the poem was translated into French, and to wild acclaim; it was the first of many editions. In the following years it was excerpted in primary school textbooks, the cover pages for composition books, and taught as an essential part of the melodrama of French Canadian history. By 1864 it became the basis for key portions of a college curriculum in New Brunswick. Throughout 1867, the entire lugubrious poem was published over the course of weeks in a new, self-described Acadian newspaper, *Le Moniteur Acadien*, as if to connect daily events with a presiding story of cultural origins. Such was its continuing popularity that *L'Evangeline* soon adorned the masthead of a second French Canadian newspaper. It did not seem to matter that Longfellow had concocted the heroine's name from Greek, not Acadian, Quebecois, or even French, sources. In all these, the poem became attached to a lingering separatist sensibility and gave new poetical meaning to an old phrase, *la survivance*, the preservation of the Catholic faith and the French language.

Second, the Evangeline myth, which illustrated the rupture of an agricultural life, helped to solidify a connection only then being made between French Canadian culture and the life and lands associated with the old farms. Despite the fact that both Quebec City and Montreal were as cosmopolitan as any cities in all of Canada; that their harbors and markets were as congested as any in New England and their buildings tall enough that one could use them as panoramic vantage points, as photographers happily showed (fig. 3.3); that their cities were becoming overcrowded, and their working-class artisans, including countless shoemakers, were squeezed into narrow streets and bustling neighborhoods (fig. 3.4, notice the

Figure 3.3

William Notman, *Montreal, looking east from tower of Notre Dame Church, QC*, 1859. View—7055.0. (Courtesy of the McCord Museum, Montreal.)

boot sign above); that their art exhibitions took on the look and feel of the great European salons (fig. 3.5); that their emerging, increasingly educated bourgeois began to fancy themselves on a par with their American counterparts, as a loony composite photograph of an imagined football match between McGill and Harvard suggests (fig. 3.6); or that the entire region's future depended on modernizing—technologically, economically, demographically—Lower Canada began to root itself in an agricultural image. "To understand the national life of Lower Canada," a guidebook on French Canadian character declared, "you must go among the *habitans*." And if the word had no precise English equivalent, the guidebook made clear what it meant, a "*cultivateur* or farmer . . . the dweller in the land . . . nothing more forcibly expresses both the

FIGURE 3.4
L. P. Vallee, *Break-Neck
Steps*, ca. 1870

origin and nature . . . of the French Canadian."[18] A closer look at
the paintings in figure 3.5 might suggest the ubiquity of the rural
idea not only among the guidebook writers but also the artistic and
moneyed. A whole generation of Quebecois painters made their
reputations on landscapes and rustic genre scenes.

 The reasons for the agricultural identity are sufficiently clear. In
their struggles against an English commercial class that had taken hold
of the Canadian government and in their efforts to forge an inde-
pendent French-speaking nation, French Canadian religious and po-
litical leaders elevated its generations of poor farmers—the heart of
Francophone Catholicism—to the status of a national culture. It led
to new histories about the people of the countryside, new rural guises
for the photography studios, new appraisals of colonial settlement

patterns, and the like. The ancient seigneurial organization of the
land, which attempted to structure how the early farmers elbowed
with each other to make use of water from the Saint Lawrence (the
land parceled like fingers reaching out to the river), was like a foun-
dational map. The whole region grew out of that basic seigneurial
template, so it was argued, and took its identity from it. An awareness
of the cultivated, parceled, Catholic land was, as another observer de-
clared, the "dawning of a Quebecois nation."[19]

Such a rabid connection between nationalism and the old farming life and lands gave photographers prowling about the countryside and decked out with wet plates and portable darkrooms all sorts of easy opportunities. We might take a famous, slightly later photograph by the Notman studio to be typical (fig. 3.7). Urban and rural are juxtaposed, but unequally. Montreal, the jewel city of the province, is reduced to a few spires, a mix of ghostly shapes, a thin line that is indistinguishable from other forms that make up the horizon. The long skyline hovers like a mirage in the background, in contrast to the boldly massed forms of the farmers and horses bringing hay to market. The wintry conditions, the frozen Saint Lawrence, the snowdrifts and ice clumps—these do not stop or deter the rhythms of agriculture; they are simply aspects of it, in

the enduring and hardscrabble manner of French Canadian farm-
ing. How amenable and tractable the land and its farmers seemed
for photographers who sought ways to resolve or make sense of the
coming of modernity! No matter how expansive or rapid the
changes, the urban could always be imagined to take shape as back-
drop because there was a long-standing, methodical, and substantial
way of life with which to compare it. Photography could court
these kinds of arguments and allegories because a national mythos
about the old farms was settling into place.

Third, the Evangeline myth allowed French Canadians to de-
fine themselves not only against the commercial and oppressive
English but also the dominant nation south of the border in which
hundreds of thousands of their countrymen were suddenly reset-
tling. Although the border could have been blurred by so much
crossing and the cultures along it could be imagined to be hybrid
and wholly impure, *Evangeline* helped to reinscribe the differences.
This happened in many ways, but perhaps the most insistent, cer-
tainly the most aggressive and pugnacious, was laying guilt at New
England's doorstep for past injustices. The Acadian expulsion was
"a stain from which Massachusetts . . . cannot claim to be free," the
lawyer and *Evangeline* enthusiast Adams Archibald declared. "It was a
Massachusetts governor who devised the scheme. It was the soldiers
of Massachusetts that drove the French from the encroachments on
our territory. . . . It was Massachusetts officers, and Massachusetts
soldiers, who carried out the decree of expulsion at the heart and
centre of the . . . settlements. . . . It was Massachusetts vessels, char-
tered from Massachusetts merchants, officered and manned by
Massachusetts captains and crews, that carried the poor Acadians
into exile." Whether the charges were warranted—there is ample
evidence to suggest otherwise; often the Massachusetts colony sim-
ply refused to accept the Acadians on British transports—it seemed
ironic to even the skeptical observers of the Evangeline story that
some ballyhooed, long-winded New England poet was reaping the
benefits of telling the tale of French Canadian displacement, since
"it is clear . . . that if there be any escutcheon smirched by the
transaction, it is specially that of the country and home of the
poet."[20] The larger point, of course, was that "our territory" and

the besmirched "country and home of the poet" were made distinct. Guilt and innocence, victimizer and victimized—these were valuable tools in the hardening of identities.

And fourth, Evangeline prompted an entire tourist industry that relied on the perpetuation of her foundational suffering and, further, the appearance of a descendant people and set of places that kept alive the wandering and exiled heroine. Indeed, it was not just Francophone supporters north of the border who were taken by the Evangeline phenomenon, which helped to make *la survivance* poetical, historical, and educational and the French Canadian identity agricultural. American tourists also could not resist. In 1855 a regular steamship service began operation in Boston providing tours of ancient Acadia (the "Land of Evangeline," as it soon became called). The dollars poured north; the towns set themselves up to receive them. By the early 1860s the route was dotted, as the historian John Mack Faragher quips, with "Evangeline tearooms and Gabriel gift shops."[21] (The myth and industry are intact; today one can still find in Grand Pré, the Nova Scotia town propitiously named in Longfellow's poem, an Evangeline Beach, an Evangeline Trail, an Evangeline Expulsion Site, an Evangeline Motel, an Evangeline Camping Resort, an enormous bronze Evangeline sculpture, and countless postcards and T-shirts with her sculpted image. The town is only one of many keeping the French Canadian heroine vivid.)

✛

Obviously useful, the Evangeline characterization of the French Canadians was an important thread in a wider fabric of representations. Yet, no matter how interestingly colorful (or fanciful or weirdly melodramatic) it may now seem, it would be inaccurate to say it outshined the others. The tours along the coast were imbibed by a decidedly American leisure class, which did not represent a majority opinion concerning the huge influx of workers from the north. From the point of view of Yankee North Adams, the odd people pouring across the border were wanderers, true, but also said to be drunkards, burglars, and "rowdies." They were uneducated and deceitful, and when caught lying or breaking laws, "they

scrabble together what few things they have, and move away to some other places where they are unknown"—like gypsies escaping their responsibility and punishment.[22] When sixty-five French Canadians arrived in town in 1863, they were dismissed as "contemptible corner loafers" with a "loose state of morals."[23] At times, the characterizations of them rivaled those reserved for the Irish, the usual targets among nativists for charges of disorderliness and the "curse of the dram shops."[24] But the Evangeline effect persisted; the themes related to displacement from the ancient land offered a new kind of cultural currency, especially among an important constituency of French Canadians who found themselves in Massachusetts, the country and home of the Evangeline poet. In a studio photograph (fig. 3.8) taken by William Hurd, a young man stares directly, if a little uneasily, at the camera. There is nothing terribly unusual about the portrait. The pose is eminently conventional; the body's weight is distributed in a rough *contrapposto*. Even the ubiquitous stand for the neck brace can be spotted behind the man's right leg, an attempt to keep him still during the long exposure. (It did not do its job properly; notice the blurriness from movement around the eyes and left jowl.) The young man has donned his Sunday best for the occasion, the vest all shiny and the tie knotted just so. He is identified as "Gagnon," a typical surname for the French Canadians crossing the border. And there is another key feature of identification. On the back of the carte de visite, next to the photographer's imprint, is an elegantly handwritten word: "Acadie."

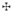

The French Canadians crossed the border to find and make a decent living—that much is abundantly clear. Unlike Evangeline, they did not wander in the picturesque frontier but traveled with a sense of purpose through the industrial landscape. Compared to the miseries of a near-indigent farming life, living for extended periods in the overcrowded New England tenements and toiling in the mills were often worthwhile trade-offs. The days tending the looms or spindles were numbingly long, true, and the wages provided little more than subsistence, and sometimes less. But the

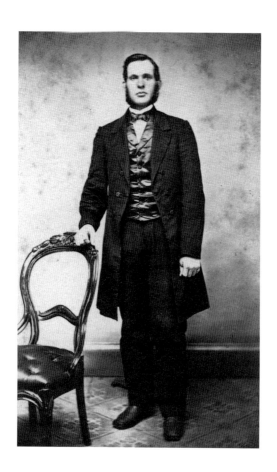

FIGURE 3.8
William Hurd, untitled
photograph, ca. 1866

majority of French Canadians were marginally better off than they
were in the fields. Some received pay for the first time in their
lives.[25] Along with the sheer massing of so many workers in the
mills and tenements, this sense of obtaining means, however mini-
mal, brought about a shift in the social relations among the former
Quebecois farmers. As we have seen, in Quebec farmers com-
bined and fractured in almost equal measure, at once identifying
with each other over their Francophone heritage and their sense
of persecution under the British, and also disputing with each
other, sometimes bitterly and violently, over the inequities and
limited resources in a meager agricultural economy. Harmonious
at a large political level, fractious at the small economic level;
showing broad interest and narrow self-interest—the survival of

the old French seigneurial system within a British colony encouraged such apparent contradictions. Community relations were structured within that spectrum. In the English-speaking New England mill towns, the sense of an inherited Francophone social identity survived, even magnified; but the economic disputes, when they took place, changed dramatically. They did not usually pit workers against each other but rather against capital and management. Far from fissuring or dispersing the French Canadians, as some in Quebec feared, the mill experience tended to collectivize them, providing not only a ready-made community in the sheer numbers who were gathered together but also giving the various workers a shared cultural *and* economic interest.

This claim for a collective sensibility among the French Canadians contradicts the usual claim for them offered by their Yankee contemporaries.[26] The idea of a bedraggled, hopelessly fractious people was elaborated in all sorts of invidious characterizations. The workers from across the border were selfish, penurious, and untrustworthy; they had no loyalty to anything larger than individual gain; they squabbled relentlessly with each other; they were so preoccupied with hoarding what little they earned that they could not act communally and cared nothing for the welfare for their own children; they had no desire to put down proper roots. Of course these descriptions were the usual fare for foreigners taking up residence in the Northeast (the Chinese got versions of them out West, the Mexicans in the Southwest) but what is significant—and not wholly surprising—is the vehemence with which they were offered of the French Canadians, not only from the xenophobic or nativist townspeople but also from labor's most sympathetic supporters. Read, for example, the single description of French Canadians that appeared in the report by the Massachusetts Bureau of Statistics and Labor, details from which I have already quoted.

> With some exceptions the Canadian French are the Chinese of the Eastern States. They care nothing for our institutions, civil, political, or educational. They do not come to make a home among us, to dwell with us as citizens, and so become a part of us; but their purpose is merely to sojourn a few

years as aliens, touching us only at a single point, that of work, and when they have gathered out of us what will satisfy their ends, to get them away to whence they came, and bestow it there. They are a horde of industrial invaders, not a stream of stable settlers. Voting, with all that it implies, they care nothing about. Rarely does one of them become naturalized. They will not send their children to school if they can help it, but endeavor to crowd them into the mills at the earliest possible age. To do this they deceive about the age of their children with brazen effrontery. . . . To earn all they can by no matter how many hours of toil, to live in the most beggarly way out of their earnings they may spend as little for living as possible, and to carry out of the country what they can thus save: this is the aim of the Canadian French in our factory districts.[27]

They work endlessly, they live beggarly, they send their children to the factory. How easy it was to ascribe to the French Canadian personality the conditions imposed on them by American industry. How convenient it was to forget the role and promises of recruiting agents and the mad rhythms inside the factories. Of all the bile and displaced responsibility, the most telling was the simple declaration: "their purpose is merely to sojourn."

Beginning roughly in 1867 and in contrast to the official state findings, the evidence for a large, generous, tenuously stable community and communal sensibility among the workers was everywhere. To combat the mindless effects of the factory, the French Canadians, like nearly all foreign workers who arrived in the Northeast, initiated and maintained a wide spectrum of social and cultural institutions to bring life to the few hours they had off: fire brigades, church groups, musical bands, fraternal clubs, pubs, music and dance halls, cockfights and revivalist meetings, a Young Men's Catholic Literary Association in nearby Cohoes, a French newspaper defiantly called *Le Patriote* in Burlington, another equally defiant in Cohoes called *La Patrie Nouvelle*, and on and on.[28] Vulgar songs got composed extolling the naughty pleasures of sinning, breaking the rules of the Catholic priests in the new French

Canadian parishes, or simply remarking on the more lenient aspects of New England–style French Catholicism ("Les curés du États, ils nous conduis'nt mieux qu'ca," one of them went, "ils nous font des veillées, c'est pour nous fair' danser").[29] Of course all these social and cultural extravagances, even the silly French ditties, could be chalked up as further evidence of an insular and resistant foreignness, traces of a stubborn *la survivance* mentality, rather than also being attempts to cope as an alienated community in the New England mill towns. But for our purposes the larger point is that these were all signs of new social relations among the former Quebecois farmers as they found each other as a working class in American industry. This is not to say they were blessedly free of feuds and rivalries; there were plenty of complaints about favoritism, the rankling air of superiority worn by some, the impossible jealousies of others. Nor is it to deny the greater fluidity between the old farmlands and the new factories for the Quebecois, a mobility that was in practice impossible for other foreigners, the Irish especially. But in general, the old village relations that had once characterized the farming countryside were being replaced by something entirely new, not homegrown in Quebec but grafted on foreign, urban soil—a collective resolve, often based on social and cultural pursuits, to accommodate and withstand the rigors of industrial life. Despite the fact that the Bureau of Statistics and Labor could not conceive the French Canadians as anything more than miserly, rootless, and hopelessly unassimilable—in essence, unsuited for the needs of organized labor—the people from across the border were in their own way being proletarianized.

<p style="text-align:center">✙</p>

There is a temptation to consider the French Canadian formation of local lodges of the Knights of St. Crispin separately from the more obviously language-based social and cultural institutions described above, but that would be a mistake. Although easily the clearest sign of a new economic consciousness and cohesiveness among the former farmers, the Crispin lodge, especially as the old medieval shoemakers guild had been revived and developed during

and immediately after the July Monarchy in France, possessed an important social as well as economic dimension. Whatever else it might connote, shoemaking also possessed a "delightful princely and entertaining history," according to the Crispins.[30] They concocted plays and colorful stock characters, not only of Crispin and Crispianus, the saints who gave the order its name, but of entirely new figures like John the Frenchman, whose many adventures revolved around a "Shooe-maker's Glory" (fellowship and fortune) and trysts with his many fair customers (usually a mayor's or banker's wife). The earnest pursuit (or fabrication) of medieval stories, poems, sayings, and songs—all of them available in the mother tongue—surely appealed to the French speakers. Even the crazy blanket-tossing initiation rite must have been a social experience, if nothing else. At some fundamental convivial level, then, the local Crispin lodges must have been on a par with the music and dance halls, the drinking clubs and corner pubs—places to gather, swap gossip and stories about the farms and factories, contrive tall tales about crossing the border or hazing the British, and sing the new drinking songs that put to melody both homesickness and American opportunity.

Of course the lodges were based on a trade, too, and developed in relation to a specific kind of industry and manufactory so dismissive of its workers, so jaundiced in its view of the interchangeable nature of cheap labor, that it forced the shoemakers to organize. In the manufacturer's logic, one worker was as good as another; and the cheaper the wage, the better, for after all, even a hardscrabble farmer could learn how to operate the stitching machines. In that industrial climate, the goals of the lodges were clear: above all to monopolize the skills needed to run the new machines, and to maintain a closed shop and keep "green hands" from entering their workspace and devaluing their work. There was the sense among some contemporaries (Calvin Sampson among them) that the Crispin lodges were resistant to new technology—romantic primitives unable to fathom the coming of modernity—and that they organized simply to prevent or retard the transformation of shoemaking from the artisan's craft to the industrialist's assembly. But this was the manufacturer's typical lament (if only he could get

more machines!) and not at all characteristic of North Adams shoe-makers' attitudes. Besides, hardly any of them made more than an occasional shoe prior to leaving the Canadian farms, and they had no long-standing devotion to the hands-on, leather-to-finished craft of the cobbler. For most of them, their introduction to the trade in North Adams took place when machines had already begun to structure most of the processes in the manufacture of shoes. This is not to suggest they were either lackadaisical or un-skilled when it came to the art of making shoes. But it is to suggest that, quite in contrast to the sense of them offered by Sampson, the Crispins were sober about the ubiquity of machinery and their economic prudence to master and monopolize it.

Unfortunately, very little evidence remains of precisely how the mix of social conviviality and a modern artisanal sensibility took place or, when the time came, how the social ground of the lodges gave way to or, better, was put in fertile relation to their political and more violent aspects. But we can make some educated guesses about its nature. The French Canadians represented a different kind of worker than the one so defended (and celebrated) by the official labor bureaus and statisticians, which is to say that the French-speaking lodges of the Order of the Knights of St. Crispin were a receptacle for a cultural and economic combativeness built on dias-poric experiences across the border, the Quebecois *survivance* de-mand developed around midcentury, and the old *patriote* sensibility as it had been cultivated since the 1840s. Rather than preventing them from becoming an organized working class, their experiences as embattled farmers in the diaspora facilitated their ability to col-lectivize and understand that social and cultural identities were in-herently political.

We should therefore keep that mixture of the social and eco-nomic alive and build into our account the social and cultural ce-menting that helped to underwrite working-class organization and protest. There were practical reasons in the French Canadian case. They were clearly a decided minority within the larger brother-hood of Knights and needed to rely on each other and the few other French-speaking lodges, a more intense bonding over lan-guage and cultural inheritance than might have been the case for

most organizing laborers. Indeed, although the French dominated the North Adams lodge, the national Order was overwhelmingly English and Irish, and defiantly English speaking. Perhaps this was the reason why the officials at the Bureau of Statistics and Labor, the state organization prompted into being by Crispin agitation and dedicated to labor's interests, could not be more generous with the French Canadians, seeing in them only a cabal of babbling foreigners, rapacious competitors, and plundering sojourners. With the exception of North Adams and several small lodges in the western and central parts of the state, the eastern lodges, by far the more numerous and holding the majority of the state's Knights, had very few French speakers.

Like the bureau, historians have taken this discrepancy in the overall membership to mean the French Canadians were congenitally resistant to organization. Rather than potential Crispins, they were characterized (beset, limited, plagued) by the itinerancy and migrancy that we observed above. Or, as the special agent for the Bureau of Labor and early historian of the Order put it, they "worked at the lowest wages because they could return to their fishing and farming when the 'season' was over"; and because they increased the New England labor supply so dramatically during the manufacturing months, "they prevented the journeymen from forcing wages up at the only time of the year when they were in a position to enforce their demands."[31] In that logic, the French Canadians were, fundamentally, backwoods farmers who interfered with the coalescing and economic clout of a proper industrial working class. Of course, the bureau's special agent was not entirely wrong. The French Canadians did have greater mobility across the border and many more opportunities for retreat than others had. The farms still were vivid aspects of their lives; and as we have seen, nearly every factory worker began his or her life as a farmer and could easily return to the fields whenever the circumstances demanded. But he was utterly wrong in his sense of their resistance to organization. To repeat, far from making them unsuitable for becoming proletarians, the farming cultures and all the social and political meanings attached to them made the French Canadians, as they found themselves in the industrial towns, eminently prepared

to collectivize and agitate for their needs. Acadie and Crispin were not so far apart.

<center>⊹</center>

One thing is certain: by 1870 the French Canadians had organized the pegging rooms in all the shoe factories in North Adams. When Sampson refused to accept their demand for a closed shop and when he refused to pay them a decent wage (or at least one in proportion to his profits), they all went out on strike. For nearly a month in late spring 1870, the protesting Crispins shut down every shoe manufactory in town.

<center>⊹</center>

While the Crispins surely understood what displaying the Chinese against the south wall signaled—namely, that their efforts to dictate the terms of work had resulted in their being replaced by green-hand foreigners, shut out of the shoe factory, and stripped of their means of providing for themselves and their families—they were certainly not alone. The photograph's meaning was available for all to see, especially the attentive caricaturists. A few weeks later, *Punchinello* published *Yan-ki vs. Yan-kee* (fig. 3.9), putting the matter bluntly. The Chinese swarm across the shoemaker's dinner table, taking his bread and cake, pulling a patty from his daughter's hands, even stealing his pet dog. A Chinese off to the left rips apart a "trade prices" document, suggesting any demand on the part of shoemakers to fix wages to profits no longer mattered to manufacturers. The reason was simple: another Chinese off to the right has taken to the workbench and makes shoes. One way to read the cartoon is as a ploy to stoke native workers' anxieties; although the English-speaking Crispin lodges were not directly involved in the North Adams dispute, their future well-being was no less put at risk by the threat of imported labor. But another way to read it is as a contest that pitted the two *non*-nativist constituencies against each other. The cartoon's title is telling in this regard, since it is unclear who was who (was "Yan-ki" French or Chinese?). They were both foreign labor—accented, hyphenated, each fighting to become working Americans in a New England economy. Of

course, completely missing but everywhere implied in the carica-
ture is the real "Yankee," the shoe manufacturer himself.

Bruised by the Chinese appearance, the French Canadian
Crispins almost immediately responded. Of course there were the
expected schoolyard pranks; one shoemaker scaled Sampson's
fence and scrawled "No Scabs or Rats Admitted Here" on the
factory wall (one wonders if it was the south wall; the evidence
does not say).[32] There was simple thuggery; some of the Chinese
were beaten when they attempted to walk through town during
their time off. Others had buckets of dirty water poured on
them.[33] There were attempts at intimidation of the shoe manufac-
turer himself; Sampson was sent threats, the factory put in danger
of "being blown up or set on fire."[34] And there was a good bit of
loud moaning; the Crispins held a mass rally in the center of
town, invited Samuel Cummings, the national leader, to speak,
and bellyached about Sampson, whose name they shuddered to
say because they "did not wish to pollute [their] lips with it of-
tener than possible."[35] Needless to say, none of these bad manners
helped their cause among the shoe manufacturers or nativist
townspeople, and in general the Crispins responded with more
sophisticated strategies, though most of them may strike us as as-
tonishingly contradictory.

The first was to go back to work at the other factories just a
week after the Chinese had arrived. Given the presence of the
Chinese in Sampson's bottoming room, they went back under a
black cloud, but the circumstances were even worse than that. A
journalist for the *Transcript* happily listed them: "The suspension of
work in the other shoe factories caused by this event, has ended
and work has been resumed. Parker Bros., Cady Bros., Millard and
Whitman and E. R. and N. L. Millard offered their old hands work
at a reduction of ten per cent, but this was not accepted. They then
resolved to employ new help and so many of the old as chose to
accept the new terms, and on Tuesday commenced work."[36] All
the names of North Adams's shoe factories were carefully spelled
out, making clear that manufacturing had combined its might to
confront the Crispins in unison, determine an across-the-board
wage (and cut), and follow through on the threat to turn to "new

help" if the union (not the manufacturers) did not yield. As if to punctuate the fresh resolve of the shoe manufacturers and the precarious position of shoemakers who remained out, the *Transcript* concluded that Parker, Cady, Whitman, and all the others "expect to be able to procure fresh hands and in the end to be as well supplied as before."

Why did the Crispins return? Had the presence of the Chinese—and the potential for more "new help"—so rattled them? One answer is the simple need to fill their plates; the caricaturist for *Punchinello* had gotten that right. There is no surviving evidence to suggest how the North Adams Crispins maintained themselves during those long weeks of striking, but if they were in good standing as a lodge and adhered to the policies of the Order, they could have expected to draw from the national fund six dollars a week for a man, two dollars for his wife, and one dollar for each child under twelve, a minimal yet passable wage for a strikebreaker living on grievance funds.[37] The problem was that there had been so many strikes between 1868 and 1870—shoemakers going on strike and drawing grievance money in New York, Philadelphia, Boston, Baltimore, Rochester, Albany, Newark, Worcester, New Haven, Chicago, Milwaukee, Lynn (several times), and on and on, in all more than thirty—that the national chest was depleted. The year 1869 was an especially active one for shoemakers. A strike that year in Chicago had drawn nearly $36,000 alone (more than $23,000 was still owed by the national Order a year later); and a prolonged walkout in Worcester, lasting for months, would eventually cost $175,000.[38] In April, only partway through the striking season, the grand lodge pledged more than $20,000 to striking shoemakers in New England that it could not pay. Those lodges not on strike were tapped to send money to the national chest to help sustain the lodges officially out, but the policy, so key to the might of a national umbrella organization, led to a good deal of resentment on the part of working Crispins, who saw their hard-earned money being sent elsewhere. Some refused to pay; the grand Knights could not force them. At the national meeting in April 1870, the Crispin William McLaughlin lamented that the "greatest obstacle that the International Grand Lodge has had was

that some of the locals were perfectly indifferent with regard to the payment of the international and grievance taxes."[39]

A good guess is that a majority of North Adams shoemakers had no more money to sustain their strike and no help from the national Order. (It did not help that so many of the other lodges out on strike were Irish and English; what little available money surely was not distributed evenly.) Some were forced back to the factory to put food on the table; their decision must have caused spleen among the more principled. No wonder Samuel Cummings was so quick to the scene in North Adams; in addition to berating Sampson, he was trying to keep the lodge from splintering or collapsing. Only a few shoemakers, who had stored up enough food or money or had income from the mixed-and-matched jobs along the Quebec-Massachusetts corridor, could weather the storm a bit longer.

In addition to going back to work, the Crispins kindled a larger discussion on the East Coast about labor's relationship to the Chinese, a discussion that had been raging for years on the West Coast. They gathered all of North Adams's unions together in late June, just two weeks after the Chinese had arrived, assembling at the Wilson House (of all places, the heart of the nouveau riche), and putting the "Chinese question"—what to do about them—in the context of the larger labor movement. Although the papers were barred from covering the union meeting—all they could report was that a "Labor Reform Meeting will be held . . . to consider and discuss, among other things, the Chinese question"—there is sufficient evidence to suggest what took place.[40] The union men had discussed the wholesale exclusion of the Chinese and agreed to put the subject up for national debate. Some may have wanted exclusion outright; others, it is clear, began to parse the distinction between immigrant and coolie labor (the venerable and useful distinction among manufacturers, as we have seen) and finesse the question; and still others, themselves recent arrivals in the country, wanted no part of exclusion. The positions played out in a whole sequence of meetings and rallies afterward among unionists in Albany, Boston, Chicago, New York, Rochester, and Troy.[41] The summer was rife with heated debate as labor tried to feel its

Figure 3.9
Unknown illustrator,
Yan-ki vs. Yan-kee, 1870

Figure 3.10
Unknown illustrator,
The New Pandora's Box,
1870

way toward a proper stance regarding the Chinese. By August, the positions had hardened. At the National Labor Union meeting in Cincinnati, the Crispins introduced a resolution to establish a separate labor party to bring their platform to national elections—in effect, to put their views to the ballot box. What did they want voted on? They pushed through a new official Union stance, that the old Burlingame Treaty between the United States and China—the treaty that had made provisions for the free flow of Chinese labor across the Pacific—be completely abrogated and the Chinese, having suddenly penetrated east of the Mississippi, be excluded from the country entirely.[42]

The illustrators for *Punchinello* knew what was brewing. Just a week after it published *Yan-ki vs. Yan-kee* (fig. 3.9), the journal published *The New Pandora's Box* (fig. 3.10). Unlike the earlier drawing where the Yankee remained offstage, in this a portly shoe

manufacturer, all jowls and sideburns and a vest stretched too tight, is brought on to square off with a brawny (more squarely native) Crispin. Where the earlier may have pitted two kinds of foreign laborers fighting over a meal (and, implicitly, a claim to the American economy), this suggests that at least one of the combatants, the Chinese, was doing the bidding of the manufacturer, who springs his mad jack-in-the-box in the face of the shoemaker. And in contrast to the earlier picture, in which the Crispin is surprised at having his meal (and livelihood and leverage over the manufacturer) taken from him, this shoemaker remains unimpressed because, as the caption suggests, he has found the ballot box and is preparing to make it his rebuttal.

<center>⁘</center>

Crispins scrawling graffiti on the factory walls, sending threats to the shoe manufacturer, flogging the young Chinese, feeling the pangs of hunger and going back to the pegging machines, fomenting boisterous rallies and calling for national attention to their plight, debating behind closed doors among themselves and with other laboring men, and resolving to take their case to the electorate—there was a rough logic to the shoemakers' activities, but also, it must be admitted, a good bit of flailing as well. The Crispins were searching for a way to respond and only slowly came to one that seemed reasonable and defensible. I earlier suggested their responses were contradictory, and perhaps that is most apparent in their dealings with the Chinese. In addition to beating them and to kindling legislation for their complete exclusion, the Crispins also tried to organize them—it is still astonishing to contemplate, given the shoemakers' other behaviors—imploring them to join the lodge or form their own.

The evidence for *how* the Crispins approached the Chinese is lamentably nonexistent. It must have been difficult for them to communicate, given the huge language barrier between the two groups of shoemakers. Perhaps even more difficult, how would the Crispins broker the delicate subject of organizing the young men for the purpose of striking in a trade they had only recently learned and against a man they had only recently met? One can imagine

the comic misunderstandings and also the unspoken suspicions on the part of the Chinese, whose experience of the Crispins consisted of being greeted by them at the train station with sticks and guns, assaulted on the streets, and now recruited for a cause that asked them to travesty a contract they had recently signed in good faith.[43] The references in the papers about the Crispin efforts are fleeting; the journalists did not want to contemplate any more than necessary the possibility of an Oriental Crispin lodge. In any event, it did not seem likely. "Chinese lodges and strikes will come in due time," *The Nation* reported with anticipation, and also some relief because "the prospect appears to be not immediately flattering at North Adams."[44]

Sampson's building of a fence around the factory and sequestering of the Chinese in the bunkroom had the effect of quarantining the men from labor agitation, making Crispin efforts at organizing the Chinese even more of a task. With only slivers of evidence, my guess is that they came under the guise of "missionaries" who arrived in the factory each Sunday to teach the Chinese the rudiments of English (how the French taught English is a nightmare in itself, how Sampson didn't recognize the deception is astonishing, though many of the would-be missionaries seem to have been Crispin daughters), convert them to Christianity, and educate them in collective bargaining and the power of the strike—Jesus and Marx by turns, cultivating Christians and proletarians all at once. Whatever the circumstances of their contact, they failed miserably, but the teaching was not lost. The education in the ABC's of unionism brought forth a certain level of political savvy among the Chinese. In 1873, when Sampson discharged eight of the men, the rest went on strike to have them returned. Later that year, when the terms of the original contracts were up, the men bargained hard for wage increases and, probably unique in the annals of working-class agitation, more storage space for Chinese-grown (as opposed to American-grown) rice. In 1876, five of the Chinese shoemakers, flushed with political insight, began to draw up guidelines for a new Chinese republic, based on the principles of democratic organization and the one-body, one-vote logic. The proposal became fodder for the caricaturists as far away as

California (fig. 3.11), who imagined that the July 4 celebrations would, in the future, no longer be the province of the working citizens of America but instead an occasion to celebrate an even newer republic, the parade a collection of mixed-and-matched peoples calling for independence—all this taking place, of course, during the much-anticipated centennial of the Yankee country. Although the Crispins may have preached to the young shoemakers, maybe even enlightened them politically, they found absolutely no foothold among them. For all kinds of reasons, they were and remained adversaries.

✝

At one obvious level, the Crispins saw in the Chinese a class of competitors—competitors for their jobs, yes, but also competitors and instigators for their claims to belonging. (In picturing two groups of foreigners at an adversarial remove from "Yankee"—the absent-presence, the desired state of grace, the one who possesses

uncontested rights—the illustrator of *Yan-ki vs. Yan-kee* may have been on to something.) I earlier suggested that such an identity or way of naming this complex sense of belonging might be understood by way of current theories about diaspora. Diaspora, the dispersion or scattering of a people, has several key features of particular relevance to the French Canadians in North Adams. It connotes not only a history of dispersal (whether forced or voluntary), but also a strongly held memory (or set of myths) about the homeland from which its people have been scattered; a difficult relationship with the new country (the "belief [that the people] are not—and perhaps cannot be—fully accepted by their host country," as William Safran writes); a desire for an eventual return, however distant, but in the meantime a commitment to the maintenance or maybe even the restoration of a homeland and its downtrodden people; and a sense of community with others, often living in quite separate places, who are kept in contact with each other by some important homeland circulation (of goods, money, photographs, perhaps even just a bit of gossipy news).[45] It differs from exile insofar as exiled persons are prevented from returning home, destined because of legal or political obstacles to remain forever outside the land of their dreams. Indeed, for the exile, the continuous experience of loss is much more intensely constitutive of identity. There was nothing that absolutely kept the French Canadians from returning; in fact quite the opposite, most of the townspeople would have preferred that they went home. The border was completely porous, as the migrants up and down the Quebec-Massachusetts corridor knew well. But the idea of return—to home, but perhaps more importantly to a condition of ethnic solidarity and cultural richness and to a place and time (usually mythologized out of all proportion) where the benefits and privileges of citizenship were simply assumed—helped give form to the community living on an alien soil.

The Crispins did not pack their bags and return to Canada. It must have been tempting; the old farms were still there, the old community, no matter how embattled under the 1867 British North America Act, must have seemed familiar and comforting. A popular song made them dream of a future there. "C'est là

l'endroit d' ma naissance," it reminded the French Canadians, "Là où que j' suis toujours resté. Nous achèt'rons une terre qui nous sera parfaite en beauté."[46] Instead, they chose to stay, and in doing so augmented the condition of living in the diaspora. The presence of the Chinese had somehow activated in the Crispins, who were everywhere reminded of "l'endroit d' ma naissance" and their responsibility to *la survivance*, an awareness that they were committed to North Adams as well and made them recognize that they had multiple attachments, as all diasporics do. In this sense, the diasporic identity was shaped not only by a transnational sensibility and network but also in response to another foreign workforce claiming a place on the host land. It was formed relationally and characterized a way of framing one's relationship to local constituencies and circumstances and a means of communal survival— and community making—amidst Others.

If questions about "belonging"—about what it meant and how it was secured—were posed to the Crispins, I am not sure they would have had as concise a response as postcolonial theory now offers, though the salient features of diaspora would have peppered their answers. The word *belonging* courted but did not necessarily connote "citizenship," and at any rate that word was so elastic and everywhere being tossed about with equal measures of envy and scorn in Reconstruction America. However, the very idea of being able to claim inalienable rights—to work, to provide for their families, to reap the benefits of those who are entitled—sat at its core. It was tinged with the experience (and exacerbated by the Evangeline myth) of oppression under the British, of having been second-class citizens whose rights were trampled and unrecognized and whose lands had been and were continuing to be confiscated, by loyalist Protestants before and the usurious banks more recently. It was inflected by the knowledge that a core population had been sent wandering—the "great haemorrhage," as the curé of Saint-Jérôme had called the exodus—in an effort to find a decent living wage, leaving the survival of a Francophone Quebecois identity seemingly in doubt. And it was prompted by the Chinese poised against the south wall. How those large social and cultural experiences structured the Crispin efforts to belong in North

Adams is still to be fathomed. Several remarkable photographs provide important clues.

✛

In late June 1870, only a few weeks after the Chinese arrived in North Adams, thirty-one Crispins purchased and began operation of a worker-owned shoe factory, a commune to compete directly with Sampson.[47] The name for such a commune was "cooperative" (the socialist inflection lessened) and was much in the news. Short of dismantling industrial capitalism, which only the most fervent or delusional radical envisioned, the cooperative was seen by many as a good compromise and an antidote—maybe the only kind—for the embattled laborers to use. Capital is "too subtle and fugacious a thing," the editor for *The Nation* proclaimed, and the shoemakers "have but one means of protecting themselves against its tyranny, and that is, becoming capitalists themselves and co-operating." Neither the strikes nor the violence throughout 1869 and 1870 had brought manufacturers to their knees, everyone understood. "It is becoming clearer and clearer every day that this [the cooperative] is the only road out of [the shoemakers'] difficulties," *The Nation* concluded.[48] The national Order of the Crispins agreed and encouraged as many lodges as possible to begin their own shops, decreeing after a spate of unsuccessful strikes in 1869 that "co-operation [is] a proper and efficient remedy for . . . the evils of the present iniquitous system of wages."[49] The North Adams Crispins were not the first group of shoemakers to form a cooperative; French Canadians had already done so in February 1869 in St. John's, New Brunswick. They were followed in March by shoemakers in Stoughton, Massachusetts; in June by shoemakers in North Bridgewater, Massachusetts; and soon by men in New York, Brooklyn, Baltimore—in all, between thirty and forty new shops nationwide by midyear.[50] A few years later, cooperatives dotted the entire Northeast, from Newark and Philadelphia to portions of southern New Hampshire and Maine. The North Adams Co-operative Shoe Company, as it was called, was followed in town by another just a few months later in September 1870, led by William Vial, a former lead shoemaker at Sampson's, and a third—it turned

out to be stillborn ("we mention no names," the *Transcript* reported with relief)—shortly after that.[51]

The first North Adams cooperative was a small enterprise, its ability to compete tested from the start. The Crispins could afford only six sewing machines and a single pegging machine, compared to thirty-five sewing and three pegging at Sampson's, and twenty-six sewing, three pegging, and even three new heeling machines at Millard's. At top speed, working day and night, they produced a hundred cases of shoes a month; Sampson produced over four hundred, Millard over four hundred, the Cady Brothers over three hundred, among several other top-flight factories.[52] The disadvantages apparently did not diminish the Crispins' feistiness. Whether feeling more competitive than other lodges, more rancorous, or perhaps having fewer building options open to them, they settled on a spot only a hundred yards uphill from Sampson's manufactory, putting themselves in open view of their former boss. It must have seemed an amazingly brazen act.

Equally brazen, the cooperative Crispins had a picture made of themselves soon after opening their doors, as if they too were going to pronounce in visual terms their stake in the new economy (fig. I.4). Although they numbered only thirty-one (they appear mostly in the back row and off to the left), they saw fit to include the other men and women they had to hire to fill out the berths, bringing their mass to a size roughly comparable to the Chinese workers at Sampson's, competing with them not only in the manufacture of shoes but also in the sheer mass of bodies. We should be struck by other details that were in dialogue with those in the first picture of the Chinese. Although the cooperative was housed in a "smaller wooden shop," as the *Transcript* reported, the Crispins had decided to set themselves against a large brick wall.[53] A closer look reveals the façade was not just some convenient factory face in North Adams but in fact the north wall of Sampson's, literally the opposite side of the one in the picture of the Chinese. It was a deliberate, pugnacious, provocative gesture, not to say an indication of stealth and wiliness. One can only imagine how they managed getting inside and pulling off the picture. In the photograph's logic, the Crispins pour out of Sampson's back door; men crowd

the steps, pushing the rest of the men and women off to the right, three and four deep. Some chairs or benches must have been hastily set up in order to allow the shoemakers in the back to stand high enough to be seen. The arrangement is orderly, even meticulous. The lineup against the plain exterior, the reduction of the factory to windows and walls, the care of the mass of people not to overflow the limits of the lens, to crowd in such a way so as to touch but not trespass the picture's borders—in all these, the Crispins had looked closely at the competition and responded point by point. Initiated by Sampson, an argument proposed by the camera was being taken up in earnest by his former shoemakers, and it is tempting to read the claims of *this* photograph in the context of the conditions that brought about the first. The outpouring of men from the open door and the streaming of men and women along the north wall are signs of an exodus, as if the factory once belonged to these people—once their vocational home—and, with the Chinese on the other side, as if they were being booted out the back. One of the men at the left descends from the lowest step to the bare ground, hat in hand, jacket and vest buttoned tight, as if he were leaving the factory.

Contrast the Crispin photograph to a roughly contemporaneous picture of another shoe factory (fig. 3.12), also owned and operated by labor, but this one several hours by carriage northeast in Henniker, New Hampshire. There, the shoemakers saw no reason to amass themselves in numbers greater than their lodge membership. Nor did they see their factory as mere backdrop but instead something to articulate in its full width and height. Of course it was a smaller factory, and the camera could be set at a distance to capture its full dimensions without losing a sense of the men. But the whole logic of the picture is different. Whereas the North Adams shoemakers regard themselves as the structuring agents for the camera's gaze, defining what and how the photographer should control the field of vision, in the Henniker photograph it is the building that determines the photographer's strategies. It sits roughly in the middle of the pictorial space, bordered on all sides by an equal amount of air and ground, light and shade. The big tree off to the side provides a way to measure the factory's scale and does more to set off

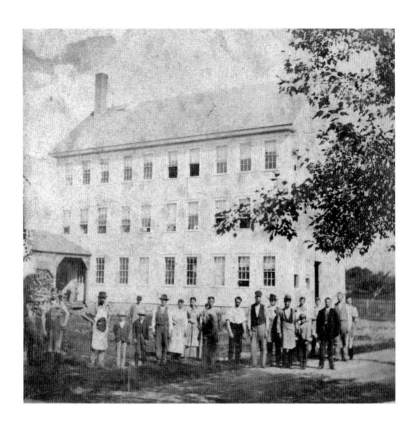

FIGURE 3.12

Unknown
photographer, *Shoe
Factory, Henniker, N.H.*,
ca. 1870

and highlight the façade than it serves to frame the workers. The men compete for attention with the building behind and the tree to the side. They are part of, not independent from, the factory they front.

The North Adams Crispins were no less devoted to their cooperative factory, no less understanding of the centrality it held in their lives and the risks they took to buy and run it. But the rhetoric of their group portraiture was built out of a review of the competition's, the terms of self and identity waged against those related aspects of visual culture already in circulation. Under these terms, the presence of the Chinese in photography, and also their very real presence in the refurbished, hybrid bunkroom, suggested to the Crispins that Chinese shoemakers were not only workers who had displaced them but a community being transplanted to American soil, not only laborers from a foreign land but a kind of integrated,

domestic family inside the factory, and had to be replied to in kind. To answer, the Crispins schlepped to Sampson's again. They were challenged to see themselves as belonging, and they interpreted this to mean seeing themselves as a large community in a complicated relationship with the shoe manufactory where they had their beginnings and with the foreign shoemakers who were replacing them. On the north wall, their backs symbolically to the Chinese on the south wall and their numbers being pushed out the door, they staked a claim in North Adams not through simple opposition or indifference but through a difficult and knowing embrace of what the competition stood for and through an argument that their place in industry could not be so easily dismissed, their community would not be dismantled and wither away. Some of the women wear their Sunday best; the young girls wear their bonnets and hats; the bustles rumple and flap in the wind. It seemed the display most comparable to the cotton jackets, flat-brimmed hats, and soft slippers on the other side of the factory.

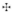

Just as the Chinese shoemakers went to the photography studios, the Crispins started going too. Unlike the Chinese, who may have initially found those sessions to be an extension of Sampson's long reach and viewed their portraits as mediated by his patronage, the Crispins took it as an opportunity to lay claim to a different kind of identity, closer to an artisan's sense of self derived from a craft. It is a curious identification, since few of the Crispins had actually been cobblers in the old sense of the trade. But because it became the stock type by which industrial shoemakers still got identified, as an illustration by Thomas Nast made clear (fig. 3.13), and because it fed so neatly into the enthusiastic recall of the medieval artisan, as the French so loved, the cobbler was happily enlisted to help characterize the Crispins' devotion to skill. In a tintype portrait, a shoemaker has brought the instruments of the old trade to the photographer's studio (fig. 3.14). A toolkit is placed carefully off to the side. A shoe, its sole turned upward for repair, sits on his lap. The sitter wears the simple apron of a shoemaker, like the kind used by shoe repairers everywhere throughout the Berkshires, as later pic-

Figure 3.13

Thomas Nast, *The Martyrdom of St. Crispin*, 1870

tures attest (fig. 3.15). The upper flap on his apron sags, the result of years of being pressed upon by his chin and neck. The shoemaker's fingers hold the thread and needle to stitch the leather strips together; his head and shoulders droop slightly to give him better advantage over his work, one leg forward to balance the sole, the other back to brace his weight, the elbows splayed at a light angle so to manage the sharp needle and thick thread properly. It is a position this man claims to have assumed many times before and can take up again instantly, even in the artificial environs of the studio. Sometimes called occupational portraits, these pictures make the photographer's fancy screens in the background appear more ludicrous than is normally the case. The Victorian wallpaper belongs to someone else, the middle-class parlor fantasy of a tropical paradise far removed from the conditions of labor.

In contrast to the coif and coiffeur of the Chinese portraits, this shoemaker insists upon the cobbler's work clothes, daily habits, and long facility with tools as the proper markers of an identity. And in this sense, he is less a shoemaker, as it was being practiced in the new manufactories, and more like a medieval Crispin cobbler, an artisan of long-standing and singular skill, whose kind of labor and identity predates those permitted by the newfangled, steam-powered machines. The portrait is an argument for the endurance

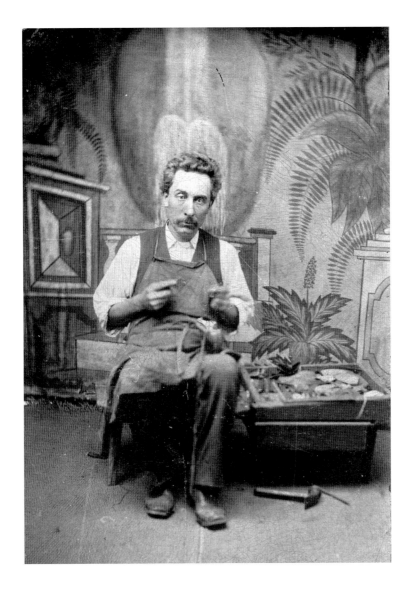

FIGURE 3.14
Unknown
photographer, *Cobbler*,
ca. 1870

of a craftsmen's integrity and the values inscribed in it, values
worth recovering and proclaiming during a moment of its immi-
nent erasure, when craft became mechanized and the Chinese and
other green hands could learn shoemaking right off the train. He
clings to (or fabricates) this identity when he and his brethren in
the Crispin lodge are hardly earning a living in the way that is

FIGURE 3.15

Left
Unknown
photographer, *Shoe
Repair Shop*, ca. 1872

FIGURE 3.16

Right
Unknown
photographer, *Leather
Workers*, ca. 1870

pictured here. The portrait is a conjuring of a preindustrial aura, even as the sitter, once back in the cooperative factory, must necessarily put himself on different competitive ground. In a sense, the lack of fit between conjuring the cobbler's old skills and the reality of the new factory, where steam power had taken firm hold of the industry and transformed the nature of labor, is mirrored in the portrait itself, where the hand-sewing shoemaker seems a cutout from another place and set like a specimen in a world that does not belong to him.

Or take another studio portrait (fig. 3.16). Instead of bringing the old cobbler's materials to the studio, the Crispins in this carte de visite have donned the waist-tied thick aprons they used in the leather-cutting process. Unlike the large shoe manufactories in town, which had buyers to handle the purchase of raw materials, the cooperative had to send its cutters to buy the bundles of leather. The *Transcript* found this worth remarking on—the cutters as buyers? how ludicrous, the papers thought—and speculated that it represented mismanagement and even anarchy inside the shop.

The shoemakers must not have enough work in the factory to keep their cutters busy, they determined, and sent them unwisely on the road; they did not install proper supervision of financial tasks and efficient division of labor, "no one to command and none to obey."[54] The credit reports were even more dubious about the workingmen's abilities to divine the intricacies of buying raw materials and handling the finances. "[W]e have our doubts as to their financial ability," they warned everyone who was selling to them, and "don't advise long credits nor larger ones."[55] The Crispins were forced into being businessmen—that was the devil's bargain of the cooperative—but as the photograph declares, that fact did not obscure or diminish their essential claim to being skilled, hands-on shoemakers who, through collective effort, wanted to take control of their livelihood. Unlike Sampson, who could not make shoes himself (and would not have thought cobbling such a valuable skill to proclaim, except when it suited the illustrators), the Crispins were workers in the berths and businessmen on the road, wearing leather aprons and silk top hats, raggedy edges and crisply fastened vests. They cut their own leather, and yes, they bought it too; and in the process bonded over those many routines. A hand extends to touch a colleague's shoulder, the shoes nearly graze each other, the bodies turn conversationally inward—this was the Crispin brotherhood of making shoes, the photograph insists.

Or take, finally, a stereoview (fig. 3.17) of children at the Notre Dame du Sacré-Coeur Sunday school, a parish and school begun by the French Canadians in 1871. Census records and the flurry of activity in the town registry indicate that French Canadian women and children began arriving in town in much larger numbers starting in 1870; the cooperatives probably needed all the help they could get.[56] The image of the children seems designed to counter the characterizations offered of how French Canadians treated their children in other New England towns. "They will not send their children to school," we will recall the Massachusetts Bureau of Statistics and Labor reporting.[57] In North Adams, the children are bundled warmly, with shawls and mittens, hoods and hats (one is even dressed as a sprightly gendarme), evidence that they are well

cared for. And their schooling is not haphazardly offered but strictly of the French Canadians' choosing—Catholic, Francophone, and internally communal. No Bible classes with missionaries, no weekly English language lessons as the Chinese were encountering—the Crispins had other ideas about acclimating their young and maintaining their cultural origins, and wanted that advanced in a picture. (The kind of schooling offered at Notre Dame du Sacré-Coeur would not last long. Bilingual education began to dominate the Catholic schools beginning in the early 1880s, though not without controversy among the diasporic French Canadians. In 1882 in nearby Cohoes, just across the New York state line, Ferdinand Gagnon had to bully his "would-be Canadians" who "denounce our [bilingual] schools as being disloyal." They relented, grudgingly.)[58]

☩

The cooperatives struggled along for a number of years. The effort required to succeed was prodigious. In November 1870, normally

the beginning of the winter slow period when most manufacturers began to lay off their workers and shut down the machines for two months, the Crispin cooperatives remained open, trying to squeeze out all the pennies from the tight market.[59] (Of the big manufacturers, only Sampson stayed open; he had huge new contracts to fill.) The same thing happened the next year and the one following. While most of the manufactories gave their machines a rest and put them up for yearly maintenance, the cooperatives kept their six or seven stitching and single pegging machines chugging for three years straight. Although they boasted to the local papers in early 1871 that their businesses were "in prosperous condition, having all the orders [we] can fill and being free of debt," they were having difficulty penetrating the lucrative Boston markets.[60] It surely did not help when Sampson combined with other shoe manufacturers to pressure the state's wholesalers into refusing Crispin-made goods.[61] After the autumn of 1873—the beginning of the Panic of 1873—there was no hope of success; the nation's economy went into a tailspin, and massive unemployment ruled throughout the Northeast, eliminating the market for any sort of luxury item like the dainty shoes being pumped out of North Adams. But even before then, the cooperatives were in danger, since they were always on tenuous footing and deeply susceptible to even the tiniest shifts in the market. A single lost order or an unpaid bill, a refusal of credit or the demand that a debt be paid immediately could set them back. They began to close one by one. The closings were slow deaths, the men departing the cooperatives in twos and threes and leaving their remaining brethren to try to keep the hope alive with increasingly smaller numbers of hands. The shops struggled along in a nearly comatose state for weeks on end, the membership slowly leaving and yet shoes still trickling out from the machines in smaller and smaller bundles. Even the North Adams Co-operative, the first and largest and most militant of the bunch, could not keep its membership intact. "Look out for a smash up," the credit reports warned their creditors, because "the best men have left the concern."[62] The prognosis was accurate. In March 1873, the North Adams Co-operative shut its doors and advertised the small wooden factory building on Brooklyn Street for rent.[63]

As if to drive the wound of failure deeper, Sampson quickly declared to the papers that while other manufactories were closing he was refurnishing his office "in a very elegant and tasty manner" and, oh yes, "putting a new boiler, suitable for driving a 40-horsepower engine."[64] Later that year, the North Adams Crispin lodge, like nearly all the lodges throughout New England, quietly folded.

<div align="center">✛</div>

Developments among the French Canadians between 1869, when they first organized as Crispins, and 1873, when their union collapsed, had been animated by their demand for the right to economic survival. But as this chapter has been proposing from the beginning, that demand was facilitated and accompanied by another kind, more closely aligned with the survival of a cultural identity, *le survivance*, and made all the more resilient by both demands being combined and waged in the diaspora. Of course that cultural identity was an ideological deposit, as much a product of the needs of Quebecois nationalism, during a time when French speakers were endeavoring to keep alive a separatist movement, as it was constitutive of the social bonds among the former farmers. But in New England it was nonetheless useful in helping the French Canadians make the shift from cultural politics to class politics and, in the long run, from being migrants moving back and forth across the border to becoming immigrants with economic and political commitments in North Adams. What they saw in the photograph of the Chinese against the south wall was, ultimately, the challenge to settle, to plot themselves as their parents had done in the old parcels along the Saint Lawrence, and become something like an American working class.

The decades after the Civil War comprised the great age of working-class formation, to which the French Canadians throughout the industrializing Northeast contributed. A key aspect of that larger story is how various workingmen from across the immigrant spectrum solidified as both a white working class and proper citizens and how that solidifying was brokered through their repeated efforts to position themselves against unorganized, nonwhite laborers, especially the Chinese—against an "indispensable enemy," as

the historian Alexander Saxton once described them.[65] In that negotiation, white working-class consciousness obtained economically, politically, and socially through an oppositional, sometimes violent, form of race relations.[66] Its most concrete political embodiment appeared in 1877 with the founding in San Francisco of the secret, working-class Order of the Caucasians, whose "bounden and solemn duty" was to "pursue and injure" the Chinese and agitate for their exclusion.[67] Through the efforts of the Caucasians and groups like them, whiteness and class mixed, fortifying each other, a kind of alchemy that resulted in a means for immigrants to claim rights in the public sphere and, eventually, citizenship. The French Canadians would eventually pursue that route.

The situation in 1870s North Adams between the French Canadians and Chinese would seem an early example of that larger story, but we ought to be mindful of an enormous gray area, a historical moment when the path to citizenship was for many nominally "white" immigrants not easy to discern or follow. The French Canadians were, after all, the "Chinese of the Eastern States," caricatured by the same invidious features of penury, babble, mindless efficiency, and rootless sojourn normally offered about the Chinese. And they were hardly "white"—they did not even make it into the spectrum of variegated whiteness proposed in an 1877 series of *Harper's* articles concerned with ethnographic differences among the "white races"—and were usually considered by the representatives of labor to be no better or sometimes even worse than the horde of Chinese threatening to come across country.[68] Sampson certainly came to think so. Of course the French Canadians went some way toward becoming more aligned with the Irish and English by becoming an activist Crispin lodge and helping to generate a prolabor and anti-Chinese platform in national politics. But as the ungenerous, niggardly reports from the Bureau of Statistics and Labor and the special agent for the Bureau of Labor suggest, they could be accommodated in an image of labor only to a point. In a bizarre way, the features that we have identified and valued as enabling their entry into class politics—their *survivance* inheritance and collective attachment to the spirit, if not the sufferings of Acadie—were the same ones that kept them consistently construed as other, as unassimilated,

unassimilable, and even racialized. They were nonwhite laborers hoping to gain a foothold in a white working-class polity.

At least one of the old Crispins seems to have understood that odd bind. In 1877, the same year the national magazines like *Harper's* hazarded to their readers the proposition that whiteness was plural and existed on a variegated spectrum, William Vial, the same French Canadian shoemaker who once worked for Sampson and later joined with others to open a cooperative, visited the photographer's studio. He went as neither a skilled cobbler nor a brotherly leather worker, as others before him had chosen to present themselves. Instead, he went in blackface (fig. 3.18). It is an astonishing self-image. In the picture's rhetoric, the French Canadian shoemaker has racialized himself in the most popular and theatrical manner of the day. The effect, however, was that he was neither securely white nor black but somewhere ambiguously and comically in-between.[69] What is most apparent is that the effort to stake out that uncertain place is left showing. The disguise was everywhere poorly fitting, the corking on the hands and face and the head topped by a woolly wig—all these accessories to skin and hair having been arrestingly applied. And in a sense, that blatant application was apropos, since Vial, like the rest of the French Canadian Crispins, was between the two kinds of large racial identities permitted in post–Civil War America, both of them uncertainly attached, both of them adhering to him only with difficulty. In his blackface guise, Vial summoned all the humbling clichés afforded by the masquerade. He was part buffoon, part Uncle Tom, part Jumping Jim Crow, and part obsequious servant in an imaginary minstrel show. His goofy, wide-eyed smile and shoe-tapping rhythm were part of the act, as if he were playing to the attentions of others. But importantly he was also a shoemaker, as the large work boot, purposefully tilted up for our inspection, insists. In its upright angle, the shoe's bottom is easier to see. The photographer has made it the point of the camera's clearest focus; the rest of the field of vision is slightly blurred. From our vantage, we see that the pegs connecting the heel to the sole are rung tightly and evenly around the outside edge, evidence of a good pegging job and of the fact that Vial, as Sampson knew, was a bottomer of considerable skill. How important a claim that must have seemed

FIGURE 3.18
Unknown
photographer, *William Vial*, 1877

when the previous years had shown the shoemaker how little his skills seemed to matter to the manufacturer.

In addition to the crisp application of the pegs, someone has neatly written on the shoe's underside the number "18," an indication of the enormous shoe size but also, I like to believe, given the odd, abbreviated, half-proffered slash between the "1" and the "8," that it was equally meant as "one-eighth." It was a sly reference to the common belief that blackness was signaled by a one-eighth

rule, that a person of mixed blood was in the eyes of officialdom a black man if one-eighth of his blood were black—that he was an octoroon, as those in French America called him. In that year, 1877, Reconstruction officially ended, and federal troops began leaving the South. That year, too, with Southern politicians left to their own devices, the one-eighth rule and local Jim Crow laws began to go into effect in nearly all the former slaveholding states, in essence reinstating the social inequality of the antebellum South. Almost twenty years later, the court case between Homer Plessy, a shoemaker and one-eighth black man, and the Massachusetts lawyer John Howard Ferguson made those regional practices into federal law.

The picture everywhere suggests Vial's historical consciousness and his sense of himself as being caught in a web of racial and class politics being spun by others. Both he and the other French Canadians, along with the Chinese, were brought to American industry when the economy, once dependent on black slave labor, needed to find cheap bodies to run the machines. "If negro emancipation has turned out so rich a blessing," the *New York Herald* asked, "why should not a new nigger be gladly welcomed?"[70] But despite the glib equation between Southern slave labor and the new Northern factory hands, the *Herald's* writer had gotten the particular mixture of labor and race all wrong. The French Canadians and Chinese were not black, not even incrementally, and could never claim the emancipation theoretically offered to the former slaves by law. And they were definitely not white, and so had few places available to them in the working-class political imagination except as sojourning foreigners. They were pitted against each other, but from the perspective of 1877 the winner was uncertain and, besides, had no more security or chance of stable livelihood than the loser. That would change in five years, with the passage of the 1882 Immigration Act that excluded the Chinese from the country. From that point the French Canadians could begin to parlay more successfully *le survivance* into whiteness, as opposed to the previous effort to animate it into class, and they could finally answer the challenge of belonging posed to them by the Chinese arrayed in front of Sampson's.

FOUR

※

What the Chinese Saw

The View: How odd it must have been for the Chinese to see themselves pictured as a group, as Sampson and the photographer had assembled them. Prior to squeezing together in the emigrant cars and traveling en masse across the country, they had never been gathered or conceived of themselves as one. It was likely that in the cars many of the men had met for the first time. Rumbling along the rails for two weeks, they certainly got to know each other and learned they had some things in common. They were all young, separated by an ocean from ancestors, parents, and siblings, bitten by the bug to travel (or at least amenable to it), and charged with making money. But their different surnames, so important in how the Chinese organized their senses of self and belonging, and their noticeable variations in dialect, equally important in identifying and distinguishing travelers, also made them aware that they had come from entirely different villages in Guangdong, with distinct family histories and clan allegiances. Yet, as the photograph seemed to announce, the men were a single body and given a crude collective identity. They were momentarily construed together as "Chinese," though the name did not sufficiently describe how embattled such a thing was in Qing China. The locals in North Adams seemed to see a mass of like men, not the family or village differences or the tentative, sometimes conflicted relationships the men were only then developing but instead referring to them as one. They were men from the West, the railroads proclaimed; strikebreakers or scabs, the angry shoemakers spat; untutored souls, the zealous missionaries pronounced as they made their Bibles ready; or competitive labor, the manufacturers rejoiced.

This alien recognition—the weird sense that photographs provide an odd, almost out-of-body experience and fantastic identification; the

gap between how a sitter sees himself and how photographs (or other viewers of them) can suggest something radically different—is today a commonplace and usually causes nothing more than a pause among the casual observers of pictures. But the newness and strangeness of that fracturing was still palpable in the 1870s, the testing of oneself against the proposals offered by the camera still able to produce anxiety, curiosity, and, paradoxically, pleasure. For these and other reasons, it led the Chinese to experiment with photographs—they have left us an enormous trove of carte de visite and tintype portraits, perhaps the most comprehensive of any early group of Chinese—and measure the dispositions and claims for community that Sampson's stereoview of them against the south wall seemed to cultivate. The experiments in front of the camera, which lasted for nearly the entire time they lived in North Adams, took on a pathos and urgency when, as Reconstruction drew to a close and exclusion became more and more likely, others in the country were happy to tell the Chinese, in total, how foreign and unwanted they were.

The trip from San Francisco to North Adams was at least the third hard journey for each of the Chinese men. The first leg was the relatively brief journey by wagon, punt, or more often a two- or three-day walk from the backwater villages in the Pearl River Delta of Guangdong Province to one of the major port cities along China's southeastern coast, usually Hong Kong but sometimes Canton or Macao, occasionally Shanghai. The photographers often found the men's arrival photogenic (fig. 4.1). The typical traveler was a young man, who might have been the oldest but was more likely the second or third son of peasants. It was a journey he may have made before when he had accompanied his father or brothers to bring goods to market or to gather items that were simply unavailable in the rural environs. But this trip was different. He was sent off to earn a wage (and to be one less mouth to feed) and send money home to help the family meet and sustain its competence.

Overwhelmingly a farming region, the Pearl River Delta was often troubled by a fragile economy, the low ebbs and flows of hand

FIGURE 4.1
Unknown
photographer, *In the
Harbor of Hong Kong,
China*, n.d. (Courtesy
of the Library of
Congress.)

farming, and the difficulties of feeding its ever-increasing peasant
population. Ever since the early 1820s, and probably before, its
farmers had sent its sons abroad to look for work. They went to
Chinese cities, sometimes the northern frontier, including places as
inhospitable as Siberia, or occasionally to Singapore, all in an effort
to augment the farming purse. Although migrant work began as a
passing or stop-gap measure to see families through rough times, as
the generations passed, it became a staple aspect of the family's ef-
forts to survive. By midcentury the Pearl River Chinese created as
energetic and continuous a migrant society as was found in all of
China.[1] The more the sons, the more extensive and diverse the mi-
grant network could be. With children spread across Asia, the patri-
arch of the family had a large economic strategy. One of the sons
would find profit, maybe all of them. Over time, the migrant pat-
terns became predictable, the money trail dictating where peasants
traveled. Sons followed paths laid down by uncles; younger brothers

followed older ones. Sometimes the habits became so specific as to give rise to comedy: a son might make a yearly trip to one of the northern cities, which he came to know well; he might never venture to a neighboring town just a few kilometers away in Guangdong and could not give even the crudest description of it. The length of the men's time abroad varied, but no matter how long, even a lifetime, they remained connected to the family, their efforts and remittances always geared toward keeping their family solvent and the small plot of land and the ancestral village intact.

The year 1841 marked an important shift in the migrant patterns. That year, China officially ceded Hong Kong to the British, transforming that port city into a gateway to the West. The effect on the Pearl River Delta was dramatic. Almost immediately its sons began jumping on board large ships in search of work in the many places where the British traveled, some going as far away as Peru and Cuba.[2] The opportunities for work expanded, but so did the need. The village economies were beginning to feel the trade deficit as a result of the midcentury Opium Wars, when U.S. and British merchants, brandishing a commodity the Chinese did not want but came to *need*, simply foisted opium onto an entire population, brought about mass addiction, and drained the country of its marketable merchandise.[3] The eventual demand for the drug by millions of addicts, willing to trade almost anything for the opium chests, quickly stripped the land of its goods and left the already wobbling economy on the verge of collapse. It did not help that the entire Guangdong province rarely received the beneficence of Qing administrators in the north, who profited enormously from the southern ports but generally viewed the region's peasants as nothing more worthy than a subject people and rarely sent assistance their way. The Pearl River Delta's sons were being sent off in even greater numbers and to greater distances.

We might compare the condition of the Chinese peasants in Guangdong to that of the French Canadian farmers in Quebec. Both Lower Canada and Guangdong relied heavily on fragile agricultural economies, and by midcentury both suffered from their having gone sour. While factories and a vibrant global trade based on high industry began to remake parts of a national economy (more

aggressively in British Canada than in Qing China), they did not penetrate very far into the traditionally peasant regions, leaving them to lag further and further behind the peoples and areas touched more aggressively by industrial capitalism. In the lag, a nearly feudal countryside remained alive in the midst of the coming of mercantile and entrepreneurial modernity. This did not mean that either the French or the Chinese were untouched by that large economy; but it did mean that they participated in it as laborers working far away from the old family parcels. They did not expect that industry would suddenly appear, transform the countryside, and somehow save them, or that the family farms would become anything other than farms, passed from one generation to the next. By sending their sons abroad, the peasants were attempting to have two seemingly incompatible things at once, to gain a piece of the global economy and yet preserve a very local, ancient possession. For the Chinese, as for the French Canadians, the call of home and land could be heard wherever in the modern world they went.

While there were similarities between the two peoples in their relation to industry and the global flows of labor, there were also key differences. Quebec's farmers often left their homes as families; Guangdong sent only its sons. After American factories began the heavy recruiting campaigns in the late 1850s and early 1860s, Quebec's farmers went looking for work specifically in New England industries; during roughly those same years many of Guangdong's sons went searching to strike it rich in the rush for precious metals and ores in California and Australia, and went to the factories only after their quick-rich schemes proved illusory. Among other things, these differences added up to the distinct histories of movement and settlement, of attachment to bounded industrial communities (more in the case of the French, less for the Chinese), and of the obligations to family and kin.

※

Coupled with the contrast between how the peasant populations found and entered industry, there were important distinctions in how they understood the "home" they were leaving. Where the French Canadians developed an intense regional identity, structured

by their sense of being oppressed by British rule and organized around various interpretations of *le survivance*, the Guangdong Chinese developed a much more conflicted sense of what it meant to be Chinese. Although the villagers of the Pearl River Delta shared more or less the same climate, developed the same hardscrabble farming techniques, grew similar crops, had access to the same ports and markets, they often seemed like they lived on isolated plots of land with no connections between them. The countless distinctions between flatlanders, hill people, aboriginals, and boat people were honed to a fine point. Those who lived in the Kaiping hills were uncouth bumpkins and spoke an irksome guttural language, so the Zhongshan lowlanders said; their speech, by contrast, was cosmopolitan and beautifully mellifluous. The Hakka women didn't bind their feet, so everyone else in the delta said, and were unkempt and blindingly ugly, not to mention untrustworthy and uncivilized; the Hakka countered by saying they were congenitally more civilized than the rest of the delta's many jealous populations, having originally come from the north centuries before and maintaining through all the generations a truer level of Chinese cultural orthodoxy.[4] Among the many markers of difference between the populations, dialect mattered most. There were hundreds of tiny villages stuffed into the nine counties in the delta and seemingly even more speech variations. Zhongshan had three nearly unintelligible languages that even the county's own officials had a hard time deciphering. It's no wonder that migrants abroad were so attuned to the dialects and village origins of their coworkers; back home, those things told him a world of important distinctions.

The rivalries and jealousies between the various inhabitants of the Pearl River Delta did not remain at the level of bad manners but instead often led to pitched battles. For example, between the early 1850s and early 1870s, the period of greatest Guangdong migration to the United States, the Hakka and *bendi*, or natives (the official gazetteers regularly referred to the Hakka as "guests"; although they had arrived in the Zhongshan lowlands from the mountainous Jiaying prefecture some six hundred years earlier, they could not shake the singular denunciation of being "not native") fought a prolonged war, marked by bloodshed and land-grabbing

that seemed to encompass the province's entire southern coast.[5] The Hakka claimed they were ultra-Chinese, trumpeted rituals to announce it, and proceeded to raze the villages of those who disputed them. The *bendi* declared themselves not Chinese at all, cared little for those who thought a Chinese identity worth proclaiming, spat on all the Hakka's meretricious symbols, and fought back. The villagers in neighboring Xinhui regarded them both as grotesque, chest-thumping, unwanted interlopers in the region. The war resulted in the eventual losers, the Hakka, being forced into a tiny, newly constructed parcel at the very southern tip of Taishan county to live like a quarantined colony. Many refused to relocate and left for the migrant trail. Their old lands were gobbled up. The splenetic arguments between victors and defeated continued.

But if the Pearl Delta Chinese were on the whole more fractured than the Quebecois French, they still maintained a regional identity in the face of Qing oppressions. That identity found its clearest expression in the elaboration (or fabrication) of a Han Chinese culture and history. In that formulation, most Guangdong Chinese were Han and thus were the "true" Chinese, not the corrupted and foreign Qing—invaders from the north who had taken control of the country—dating their origins to the ancient Han dynasty, at its height nearly two thousands earlier. In the crucial realm of culture, the Han, so it was argued, were still living and available as a means of identification for the long-suffering southern peasants. The argument had a level of legitimacy. The remnants of Han had always enjoyed a place at the center of Qing officialdom. Although Qing rulers, ever since the successful Manchu invasion of China in the seventeenth century, had placed social and cultural barriers between themselves and their subject people (for example, forbidding intermarriage, attempting to keep the highest realms of education and court administration in the hands of its own people, creating in principle a strict division between intellectual and manual pursuits and relegating all manual labor to the native populations, and so on), they understood that keeping control of such a huge, dispersed people required adopting and adapting to various aspects of an older Han society and culture. Among the most embraced were Confucian philosophy and civil service,

temple rituals and religious practices, and literati painting, calligraphy, and literature. The continuation produced an extraordinary flourishing in the arts and, through the elaborate referencing and cross-referencing to pre-Qing cultures, sustained an almost unbroken link to ancient forms of expression. In these various ways, a living Han Chinese culture—hybrid and politicized, to be sure—could be said to exist within the most elevated levels of society.

The enthusiasm for Han stoked a radical and belligerent sensibility in Guangdong. Whereas French agitation and resistance took their most violent turn in the *patriote* rebellions in midcentury, the Guangdong Han took theirs in the frighteningly bloody, protracted Taiping Rebellion, which lasted for nearly twenty years beginning in 1850. Led by a Guangdong peasant, a rebel army surged northward and attempted to overthrow the Qing, its rampage bringing about bloodshed on a massive scale. Where thousands died in the Canadian conflicts, some twenty to thirty million died in the Chinese. Although finally squelched, the Taipings gave undeniable evidence for an imperial and imposed monarchy on its last rickety legs and claimed ownership of the supposedly authentic Chinese culture at the heart of the royal court.

The emergence of further Guangdong political radicalism over the last half of the century, the dissolution and eventual toppling of the Qing, the efforts at Han legitimization through the formulation and embrace of ethnic symbols, and the push for a new nationalism are enormous topics, but for our purposes this combination of a radicalizing, awakening south and weakening, moribund north produced a peculiar sense of "home," laced with nationalist fervor, for the young southern peasants leaving the family farms and heading to the ports. The overall ambience is best characterized by a phrase coined by Qing administrators in their efforts to maintain their tenuous hold on power: "self-strengthening." In its simplest form, it meant a greater openness to Western technology, industry, thought, and language; and paradoxically a greater entrenchment of aspects of Confucianism, in particular the cultivation of an ethical sensibility dedicated to the welfare of the common person. In contrast to the West's anarchy, selfishness, and individualism, the Confucian *jen*—humanness and all the selfless virtues associated with it—would provide a unity of purpose to a crumbling nation, so it

was hoped. Although formulated as an official and reformist creed by the Qing, self-strengthening never really took hold in court; it was, however, taken to heart by Taiping radicals and pervaded the cultural, social, and political rhetoric taking root in the Han Chinese south. Self-strengthening was available as a creed to fortify peasants as they hit the migrant trail.

<p style="text-align:center">❁</p>

Once in Hong Kong or Macao, the young Chinese peasant began the second leg of his journey, hooking on with a company that could pay his way on a clipper or steamship headed to "Golden Mountain" or "First City," the common names for California and San Francisco. He usually needed to wait a few days, sometimes a couple of weeks, for his ship to pull anchor and head out to sea. During the weeks of waiting, he might get lucky and land a temporary job sweeping floors or clearing trash, but most often he was idle and relied on his country sense, any friends, perhaps the work companies to furnish him a cot and meals. The shipping companies that gave passage to the migrant workers were by then already well-oiled machines. Where once migrant patterns were family or village affairs—sons following uncles along well-trod routes, villagers vouching for others, word of mouth taking on as much importance as official communiqués—by the late 1850s the big companies had taken over and turned it into a lucrative business, as a slightly later photograph of the bustling Shanghai Bund tried to show (fig. 4.2). There were literally thousands of these companies, each devoted to trafficking people, goods, and money between China and the West. Some provided dormitories, medical exams, and if necessary false papers and advances for the bribes and countless surcharges. Others advertised for work companies and matched peasants with jobs (though it is unlikely Sampson's men found the shoe factory in this manner). The experience already began to teach the young peasant how to survive in a bustling urban space. In a sense, being alone in port might have been the first time he had a small measure of freedom to make his own way.

If the journey to the port was trying, the long trip across the Pacific was much worse, a grueling affair that, with bad weather,

FIGURE 4.2
Unknown
photographer, *Shanghai
Bund*, n.d. (Courtesy of
the Library of
Congress.)

could last months. If he was fortunate, he spent time each day on
deck, breathing the sea air and getting a dose of sun (not that this
was always pleasant—"I ate wind and tasted waves," a passenger
later wrote with no fondness for the trip).[6] Most of his days were
probably spent in the crowded holds where he met others who, in

❀ CHAPTER FOUR

Figure 4.3
Unknown illustrator,
*Chinese Emigration to
America—Sketch on
Board the Pacific Mail
Steamship "Alaska,"*
1876

their youthfulness and rural origins, were not unlike him. There
are no surviving accounts by the Chinese to tell us what the daily
life in the holds was like in this early period of travel, but we may
surmise that it was filled with equal measures of anticipation and
boredom and new social relations built around the passing of both
courtesies and suspicions among peasant strangers. While the Chi-
nese left no description, American observers filled the void, pro-
viding a stream of reports and images to those on the mainland
awaiting the Chinese arrival. Although the ships were overcrowded
and the men stuffed in every nook and cranny below deck, an il-
lustrator for *Harper's Weekly* tried to convey something like a
leisurely camp life on board (fig. 4.3), where the men's daily lives
were imagined to belong to a pastoral (their feet needed no shoes
in such a happy abode) and seemed best characterized by the shar-
ing of bowls of rice over a campfire. How the wooden floor of the
deck could withstand such a fire was a problem this illustrator did
not worry over (and anyway the fire could be partially hidden by
the men's chummy circle); he has even included strips and planks
of wood in the foreground ready to be used to stoke the blaze. A
steamship officer to the left gestures towards the men, as if reveal-
ing to his companion the Chinese in their most typical, communal

behaviors. The ubiquitous laundry basket is tossed off to the side (the men are apparently too hungry to tend to their chores and hygiene). The poor cook (if that is the man in the apron) is confronted with a ravenous cargo. When not voraciously eating, the men were imagined as being instructed by a missionary's Bible study—the peasants were already on the road to conversion—as another illustrator for *Harper's Weekly* suggested (fig. 4.4).

Whatever tentative bonds may have formed in the bowels of the steamships, when the men reached San Francisco they usually dispersed and immediately confronted an even more complicated social economy. A stone's throw from the docks, San Francisco's Chinatown was a labyrinthine world, where since the early 1850s the Chinese had organized themselves into a dizzying array of associations. Some were based on shared dialects, surnames, or villages of origin; others on ritual oaths based on mythical ancestors; and still others on the simple bunks that friends and fellow laborers shared. The associations ranged from informal to formal, the most elaborate usually developing officers, maintaining meeting halls, asking for dues, even writing a charter. While they were officially self-help and mutual aid societies, the migrant's profit motive was never far from their purpose, as they happily declared in their official creeds. "The purpose of forming [this group] is to maintain a friendly relationship among our countrymen," one of the associations proclaimed, "and to accumulate wealth through proper business methods."[7] Taking stock of their tiny memberships and needing strength in numbers, some associations even joined forces and in a formal way linked men with different surnames—sons from villages all over Chiqi and Taishan brought together, for example—a bonding that was simply unimaginable in the Pearl River Delta.

Overlapping those mixed and matched associations, though not consonant with them, the myriad work companies demanded allegiances and, at the least, repayment for any advances and the costs of shipping the men. And in between the many associations and work companies, the tongs—part fraternity, part criminal subculture—cut across village, dialect, and surname divisions to offer the men various forms of employment (often black market), entertainment (illegal), and protection in a foreign city. In a sense, the social mixture and

FIGURE 4.4

Top left
Felix Regamy, *Sunday Service on Board a Pacific Mail Steamship*, 1877

FIGURE 4.5

Right
Unknown photographer, untitled photograph, ca. 1862

FIGURE 4.6

Bottom left
Unknown photographer, *Chinese Fishing Village— Monterey*, n.d. (Courtesy of the Library of Congress.)

mission of the tongs, as they gathered adherents in a manner completely opposite to those found in the peasant villages where family bonds held powerful sway, marked the increasing confusion of the more orthodox terms of community as the men moved further and further from their ancestral homes. Within limits, especially those demanded by any contracts they had signed, the men could align themselves as they pleased. Of course the many associations called upon the men to remember their filial, financial, and moral responsibilities; and they were shrewd in applying peer pressure and threatening ostracism. They knew how to spread gossip back in the villages and cause disrespect or loss of face. The larger the association, the more monopoly it had on a certain cross-section of the migrant community, the greater sway it had in the villages, and the harder the Chinese traveler found it to ignore its pleas. But if the men were shrewd and wanted to afford themselves the greatest opportunities to

provide for the families, they chose as many allegiances as they could—a far cry from the intense cultivation of ethnic allegiances and the equally intense phobias for others back home.

For most of the Chinese arriving in San Francisco in these early years, the journey did not end there. If the mines and rivers were still yielding precious metals, the men headed east for a several days' journey across the bay and Central Valley to the mining camps in the Sierra foothills. If the mines had been played out and the small farms needed pickers, they headed south along the peninsula to Santa Clara and the vegetables fields or north to Napa and Sonoma and the grapevines (fig. 4.5). (Our photograph might be the earliest to picture a Chinese man on the Napa farms.) If the fisheries needed more hands to prepare the nets and lines, they left for the Monterey shoreline, where photographers captured them at work, or imagined them inhabiting, alternately, makeshift tents or stilted huts not unlike those found in the Pearl River Delta (fig. 4.6).[8] Sometimes they went to the big canneries along the Oregon coast (fig. 4.7). And as we know, at least seventy-five men thought another two-week journey by train to a shoe factory in North Adams was a worthwhile undertaking. For many of them, it was almost certainly the first time they traveled by rail.

<div align="center">❁</div>

Because the young men were probably the very first Chinese in history to pass through huge swaths of the country, they could be called travelers and explorers and likened in a very general way to other intrepid adventurers in the nineteenth century. Yet in the usual American stories about cross-country or frontier expedition they are never mentioned. Their journey did not seem to match the epic character usually ascribed to those others during the great age of American survey and movement, and did not seem characterized by even the most rudimentary features associated with "discovery." The men traveled eastward, as opposed to the more usual westward direction of, say, the great teams led by Clarence King or John C. Fremont; they moved toward civilization instead of away from it. They rode in emigrant cars on newly laid track, not on horseback or mule or in covered wagons along barely

Figure 4.7
Unknown
photographer,
*Butchering Salmon—
Interior of a Canning
Establishment, Astoria,
Oregon, USA* (no. 227,
Keystone View
Company series), n.d.

marked trails. They made no conscious effort to record their brave
journey or narrate their dramas, as opposed to, say, Fremont, who
wrote glibly and voluminously about his long adventures, or the
photographers Timothy O'Sullivan, William Henry Jackson, or
Carleton Watkins, who set up their big glass plate cameras at every
turn. Only four years before the Chinese trekked eastward, Watkins
had climbed into Yosemite and had the wherewithal to name one
of his photographs *First View of the Yosemite Valley from the Mariposa
Trail,* forever linking it with the insatiable national demand for eye-
witness discovery and rapture, documenting and enshrining the
virginal moment when his camera's glass plate had impressed upon
it the view that the photographer first saw. It did not really matter
that he had actually seen many sites in the valley previously and
taken many pictures of them. Unlike Watkins, the Chinese seemed

to display no particular consciousness about the historical signifi-
cance of their venture or the pristine moments of their viewing
the country; they saw no reason to document or commemorate any
of them. Given their quarantine in the cars, it's unclear whether they
caught sight of most of the natural scenery or the many wonders al-
ready being popularly singled out along the route. And besides, they
ventured not through the untrammeled, untamed wilderness in the
name of discovery but instead to a well-settled New England town,
with bunks and jobs waiting for them. They wouldn't have gone
otherwise. Although in recent years the grand nature of westward
exploration has been debunked as so much nationalist myth, and the
less-than-heroic commercial and political motivations underwriting
these hard efforts have become clear (to say nothing of the violent
encounters between peoples and the eventual destruction of cul-
tures that these explorations helped to effect), the Chinese adven-
ture seemed so plainly commercial in nature, so nakedly without
scientific, topographic, or geological concerns, so directed toward
the needs of early industry, that it hardly seemed to fall in the same
category of a people's adventurous movement and discovery.[9] Al-
though no less historically significant, this was a different kind of
travel and discovery, more related to the needs of migrants.

One general picture of the Chinese man as he left his family and
journeyed further and further from his ancestral home—on foot,
by wagon, on a steamship, by rail—is of an individual confronted
with increasingly newer forms of Western modernity. The most tan-
gible signs of that modernity were the fancy new modes of steam-
powered travel, each step of the journey seemingly facilitated by
ever more recent innovations. In a sense, the long trip by emigrant
car to North Adams was the pinnacle of that flight into modernity,
since the transcontinental connection—and all that it represented,
including the advent of standardized time, whole new towns and
cities sprouting along the route devoted to shipping and receiving
goods for market, a culture being built on speed and efficiency, and
so on—had been completed only a year earlier in 1869, when the
last rail spike had been driven in Promontory Point, Utah.[10]

Another picture of that same man is of an individual forging a new path along an array of paths in the migrant trail. To see him from the point of view of the Pearl River Delta, he was pursuing one of the many options open to him in his quest to sustain the village, provide for his family, honor his parents, and worship his ancestors. Some of the men may well have expected North Adams to become a favored destination for other villagers looking for work, as perhaps Sampson's hiring of new men in 1871, 1873, and 1874 might have suggested to them. Work at the shoe factory would replace or augment the regular jobs in Shanghai, Fujian, Singapore, or, heaven forbid, Siberia. The town was certainly more picturesque.

But a third, perhaps composite picture sees him confronting the conflicts between the push into modernity and the call to preserve the family. We can feel the force of that conflict on the way in which his movement eastward made good on, but also put pressure on, his understanding of "self-strengthening," that curious midcentury nationalist mix of an obligation to Confucian ideals and an openness to Western modernity. He certainly set out on his travels with several well-understood communal sensibilities and responsibilities. He belonged to family and clan and, through the creed of Confucianism and the daily habits in a peasant family's life, had been taught the sacred nature of that kinship. His journey across the Pacific was predicated on the promise to send any income back home; and if his travels lasted years, a decade, maybe even a lifetime, he understood that he was expected to return. As an extreme testament to that understanding, he stipulated in his contract with the Chinese companies that, should he die on the road, his bones would be sent home for burial in the family plot. In addition to the more local allegiances, the political and economic circumstances in southern China brought about a vibrant regional rhetoric, in which the investment in Han, especially as it was augmented by the Taiping Rebellion and its aftermath, provided a heady mix of ethnic and political allegiance. Sometimes this larger sense of Han brought anger, given the peasant's experiences in the delta. The villagers from Zhongshan or Taishan were making such a hullabaloo about true Chinese-ness that it was easy to become fed up with all the talk about origins and authenticity. Sometimes it gave sustenance to his

sense of familial loyalties. His commitment to family and clan could easily be cemented by the belief that, as a breathing Han Chinese, he held within his ancestry and seed the reservoir of a nation's true origins. At any rate, if he were asked what kind of blood ran through his veins, he had ample ways to answer the question; but in most cases the answer was on some continuum with the goals of family and region. It was not easy for him to conceive of himself outside them.

With each new stage of the journey, those seemingly instinctive and inviolable sensibilities were raised for inspection. The experiences in a foreign land and with a foreign people were disorienting enough. But as we have briefly seen, the self-consciousness was also brought about by the ways the Chinese men confronted *each other*. Chinese social arrangements in the port cities, on the steamships, and in the United States were designed not primarily as unaltered imports of the old village societies and peasant relations in the delta but as points along a migration network. The many associations were hybrid affairs. On the one hand, they offered connection to the villages, wrote and received letters for the illiterate, and raised money for all kinds of village needs, like establishing schools, paying off a debt, rebuilding a crumbling hall, fortifying an old stone wall around the fields, even moving families when thugs came around.[11] On the other hand, they offered strategies to cope with the political, economic, and social realities of a foreign and often hostile West. They were mutual aid societies in confronting non-Chinese, especially the difficult labor unions. They acted as supply lines, artisan's guilds, legal representatives, social clubs, gambling tables, even cemetery societies. The bigger ones regulated trade, set and stabilized prices, arbitrated disputes, even monopolized a craft. To survive, the Chinese man attached himself here and there, joined this or that association, set up a bunk in this town or moved to the next one, each decision strongly (though not solely) influenced by the desire to afford himself the greatest economic opportunities. Whatever his original dreams (of hitting it rich and returning a prince, of pursuing his family's well-being), because of the uneven mesh of Chinese associations, Western opportunities, and the global market, he was becoming not only an independent contractor in a modern economy, selling his physical labor wherever he found a living wage, but also a more

cosmopolitan Chinese, mixing with others in a manner that none of his siblings or parents back home would ever condone. Some of the men could even imagine a different future for themselves.

Take the case of Charlie Sing, who became the foreman of the Chinese heading to North Adams. Born Chung Tang Sing in the Kaiping hills in Guangdong in 1847, he was sent packing at about ten years old to help deliver the family from its poverty.[12] (He later claimed he was descended from royalty—a fib to his children—but in all probability his parents, Chung Hou Hah and Chung Moo Ten, were typical delta farmers.)[13] Arriving in San Francisco in 1858 or 1859, he stayed a month in Chinatown, orienting himself to that odd, hybrid quarter, and then he quickly left for Weaverville, California, a gold-mining town on the north edge of the Central Valley, where he spent eight years. By the time Sing reached Weaverville, the mines had been played out; its most notable feature for the remaining Chinese was an extraordinarily modest but much-celebrated joss house. (It was repeatedly burned down by those who wanted the Chinese gone, and, in the continual efforts to rebuild it, gained a measure of folklore around it.) Sing must have survived by working odd jobs in the small shops; there were few other prospects. He then crossed the Sierra and settled in Virginia City, Nevada, for another year or two, hoping to strike in the mines there. But that city had a powerful miner's union, which prevented the Chinese from any sort of panning or digging and consigned them to the typical leftover fare as servants, laundry workers, day laborers, even shoemakers, as an illustrator for *Harper's Weekly* popularized (fig. 4.8). What associations he joined is unknown, but they must have been diverse, given what was available. By 1869, with very little to show for a decade of ambulation and work, Sing was back in San Francisco, picking up jobs in and around Chinatown for a year before signing on for North Adams. He had by then picked up enough English to serve as a translator, some rough skills living hand-to-mouth in a modern economy, and a range of experiences living among and bargaining with both the Chinese of different backgrounds and the non-Chinese—in all, an accumulation of knowledge that gave him the sense that he could serve as a work foreman.

FIGURE 4.8
W. A. Rogers, *Chinese
Quarters, Virginia City,
Nevada,* 1877

Sing's movements were typical, his travels up and down the bor-
der between California and Nevada dictated by the routes other
Chinese had taken and the small communities and temples they
had established, and also by the lure of possible riches. The dream of
discovering precious minerals quickly gave way to the hard reality

of menial labor that Sing, like most Chinese peasants, knew all too well. Although his return to San Francisco might be interpreted as reentry into Chinatown—its comforts, its intensely vibrant and also complicated social life—it was also an admission that there were no more extravagant strikes to be found. Another means of living needed pursuing, and the city offered the greatest opportunities. But through it all, something changed in Sing. Although he had been sent on the road precisely to make some money, in the many wanderings the original terms by which he understood his responsibilities and belonging began to recede to a distant shore. Returning to San Francisco was in no way a prelude to returning to China or even keeping in touch with home. The expectation that he set sail for Kaiping to visit, take a wife, father a child (a son, preferably), resettle, if only temporarily—all these the key signs of his blood attachment, the promise to honor his kin—that faded too. Instead he moved east. He would eventually marry a woman from Virginia and settle permanently in the States. When asked later in his life by an immigration officer whether he had ever returned to China, Sing replied simply and resolutely, "Never."[14]

No doubt there were many Chinese who took their kinship and ethnic obligations to their graves. The pleas for devotion were the family's and the associations' stock-in-trade. But the larger point is that when the Chinese arrived in North Adams and stood before the south wall, they were hardly a single body. They were intensely conscious of, but hardly unified in, their attachment to "home," whatever that word might have signaled to each of them. They were aware of but not uniform in their understanding of the meanings attached to "Han Chinese." They knew well the responsibilities of migrants traveling so far from their ancestral villages. And they knew how migration itself put them in unorthodox situations. But how all these influences got sorted, clarified, and prioritized in the actual experiences of the migrant trail and Western modernity was individual.

※

And yet, despite the uneven and competing senses of self and the differing means by which the men described their limited attachment

to or distance from each other, the photograph gave them the look of belonging together. The frontal dispositions, join of arms, the touch of shoulder to shoulder, the evenness of shade and sheen across the visual field—all these details gave off an image of intimacy and uniformity, a cohesiveness and a sense of shared possession (of space, of each other, of Chinese-ness) that existed nowhere so strongly as in the fiction of the photograph. The repetition of shapes in the background—the brick and the rhythm of windows—only added to the effect of sameness. To repeat the original claim, the felt difference between the image of self in the picture and the sense of self before it was an early example of the alienated recognition so common in histories of photography. Among the Chinese, there was probably some level of wonder and also discomfort at the gap, a split between the distinctions and pulls they each felt and the fantasy of wholeness they saw. Of course there were terms available to understand what they saw—Han Chinese, migrants on the road, dutiful sons, villagers from the Pearl River Delta— but the problem, as we have seen, was none of those terms had definite meaning or agreed upon value and were not, in most cases, a means of assigning unfettered, uncontested collectivity. It surely did not help that many in north China began calling the Pearl River Delta migrants looking for work "foreigners' dogs" and "Guangdong sluts."[15] They lapped at the white man's feet and did his bidding, so it was said. They gave their bodies to the highest bidder. They embarrassed their parents and disrespected their ancestors. They were false Chinese.

One thing is clear: what the Chinese saw did not paralyze them. The photograph was somehow provocative and enchanting, and they decided to test their images over and over.

<div align="center">❈</div>

The relationship of the initial Chinese cartes de visites to the south wall stereoview was like parts to a whole, at least from the shoe manufacturer's point of view. The Chinese sat for individual photographs whose purpose was less to declare and mark the differences between the men than to provide a more thorough compendium of his new workers for whom he now had a large paternal responsibility. That

the portraits quickly found their way into an album meant that the young men pictured in them were just as quickly returned to an overall assemblage that gave them their identity. To the Chinese, the initial portraits must have seemed of a piece with the overall demands of the great manufacturer. They posed in the studio at his request, however whimsical it may have seemed, because it came from the man on whom their livelihoods depended.

But what a Pandora's box! The young shoemakers soon began to return to the photographer on their own—not just once or twice but repeatedly, year after year, for almost the entire time they spent in North Adams. Something else was drawing them to the studio beyond merely satiating a passing curiosity. It was a costly determination on their part because it was no small outlay of cash to sit before the lens. The men earned roughly ninety cents a day; a portrait sitting cost twice that, and a tintype sometimes more. At first they returned with the same formal attire in which they had previously dressed and sat for bust-length portraits, as before (figs. 4.9 and 4.10). But increasingly, they began to see other possibilities in how they could represent themselves. The many props began to be thought of usefully and constructively. Bodies began to nestle in chairs, elbows found their way to tabletops (figs. 4.11 and 4.12). Screens began to appear behind, frilly tassels nearby. The North Adams photographers owned neither props remotely Chinese nor knickknacks that could be called Orientalist; so the men brought teapots and teacups, fans and porcelain vases (fig. 4.13). As if to accentuate the props they had brought, the men began to hold them up to the camera's eye, at once simulating a friendly gesture to an imaginary friend but also, simply, acknowledging the things that were theirs and the items they wanted photographed (fig. 4.14).

It would be easy for us to interpret these many pictures as nothing more than local examples of the typical portraiture during Reconstruction America, when people flocked to the studios in droves and photographers expanded their businesses to accommodate them. In most cities and big towns, the successful studios got more spacious, the processing and waiting rooms multiplied, the props diversified. For the countless patrons, the studio's closets began to fill with costumes of all sorts, giving each sitter the

Figure 4.9
William Hurd and
William Smith, untitled
photograph, ca. 1871.
(Private collection.)

chance to outfit him- or herself in the latest fashions, however un-
affordable or remote from their normal dress this coat or that
shawl might have been. The sitters followed suit and learned to
play along. They braced themselves against fake columns, placed
their hands on books they had never read, held parasols they had
never used, stood before temples they had never seen. The critics
laughed at the pretensions, alternately amused and horrified by
such overt fantasies and thin deceptions. The most successful busi-
nesses stockpiled background scenery pictured on canvas—an out-
door scene here, a library scene there—and learned to titillate and
lure a photography-minded crowd with ever more outlandish en-
virons in which to be pictured. William Hurd and Henry Ward, as
we have observed, were especially aggressive in promoting their

FIGURE 4.10
William Hurd and
William Smith, untitled
photograph, ca. 1871.
(Private collection.)

up-to-date studios. All these many developments were evidence of a fast-growing industry and a critical mass of people urging it on.

The millions of cartes de visites that resulted from these countless sessions are often understood as evidence less of individuals attempting to take control of their representation than of the false impression of agency offered by the picture industry and, despite the ever increasing props and finery, the limited and harshly constricted means by which any kind of self-imaging was even possible. But that verdict has always seemed too grim and gives up too quickly on the ways the sitters and the complicated relations among them helped to drive the industry from below. The North Adams studios enabled the Chinese shoemakers in these early years of the industry a means to distinguish themselves. Furthermore, the effort at differentiation was aimed not only at the image of unanimity proposed of them by others but also at the distinctions they felt toward each other.

FIGURE 4.11

Lucius Hurd, *Chung Ley*, 1870. (Private collection.)

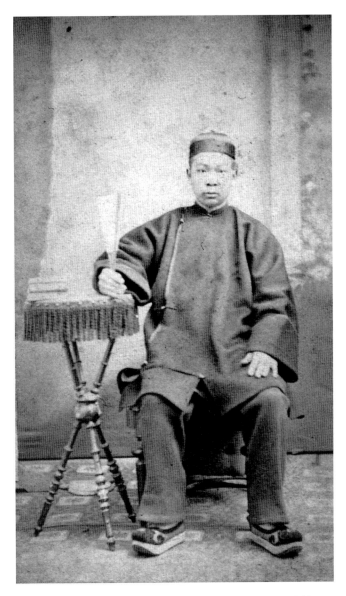

FIGURE 4.12
Lucius Hurd, *Hin Quan
Lay*, 1870. (Private
collection.)

❊

The distinctions got manifested early and involved the enterprising and English-speaking Charlie Sing. He was in a sense a lightning rod because, all by himself, he functioned like a Chinese migrant association. He acted as go-between for Sampson and the

FIGURE 4.14
Eli Gokay, *Sing Ah Ham*, 1877. (Private collection.)

Chinese shoemakers, received and distributed the wages for the young men in his charge, paid any bills they had incurred, made orders from the markets for them, and for the illiterate wrote their letters and read their mail. He bought gifts on their behalf and represented them, as best he could, to the shoe manufacturer and

townspeople. He knew that small courtesies worked best to ameliorate tensions and ingratiate the men among the locals and worked hard at providing them. In December 1872, for example, he cajoled the shoemakers into buying big turkeys ("the best they had" in the local butcher shop, the *Transcript* was surprised and happy to report) as Christmas gifts not only for Sampson and George Chase (Sampson's chief officer) but all the local ministers, the local judges, the county clerk, the key Crispins in the shoe cooperatives (including William Vial [fig. 3.18]), and a handful of other important foremen in the shoe factory—in all, twenty-two key figures around town.[16] It was a shrewd gesture, but all the same it must have cost the men a small fortune. They had made similar gifts of "plump turkeys," as *Scribner's* reported, for Thanksgiving 1870, again for Christmas 1873 and 1874, each time the list of recipients comprising a particularly useful group of townspeople to have as friends.[17]

Although the funds for these gestures were drawn from the entire group, Sing seemed to reap the greatest benefits, becoming in the eyes of merchants and manufacturers a foreman worthy of the name and a foreigner on his way to citizenship. Read the following description offered of him by a reporter for the *Boston Advertiser*:

> This young man is a living example of the elastic capability of his race. . . . He keeps the most complicated accounts with entire ease, and carries on a very extensive correspondence with the other side of the world. He rules his little flock with pleasant words and a constant smile, and never has any trouble. He attends to their commissariat, and keeps the run of the market. He seems entirely content with his $60 a month and his rice and tea diet. He already knows every detail of practical shoemaking, and can show his men the right way whenever they make a blunder. He is as unassuming as the President, and was never known to be in a hurry.[18]

The image of the peasant-turned-president—the elastic, malleable Chinese man transformed not into a mindless, robotic imitator, as the labor unions warned, but into a proper American—was as effusive as one could have imagined.

But the signs that all the men in Sing's little flock were not in agreement with his leadership, however pleasant and unassuming it may have seemed to others, were soon apparent. He made more money than the rest, even though he worked at the berths less. He had full control over their "complicated accounts" and could finagle them whenever he wanted. We can imagine the concerns. Was he deserving of that much privilege, favor, and trust? After all, he seemed to many of the men that he was too quickly relinquishing Chinese habits in favor of alien ones, as an early photograph might suggest (fig. 4.15). Gone were the queue, the traditional costume, the modest cap. He had taken to broad lapels and a starched shirt, grown his hair, and was combing it most curiously. So smartly dressed, he was rumored to be courting a white woman. When in 1871 one of the men opined his concerns—we do not know the precise nature of his complaint, but it must have been sharp—he was promptly dismissed. (He returned two years later to visit, trumping the successes he had enjoyed in the interim in a needle factory in nearby Springfield. "Ah think he smartee," the *Transcript* reported one of the men saying of his former coworker, "but he do not smart at all."[19] Those flaunting their triumphs in the face of Sing's flock ran the risk of censure.)

Among the sharpest examples of Sing's tenuous hold were those that dramatized the differences in how the men viewed their burial obligations. When one of the men died after a long illness in August 1872, the men went into a tizzy, not only because they had lost one of their coworkers but also because they did not know how to handle the body.[20] Though Quain Tung Tuck was not a Christian, Sing, who by then had become a Methodist, got the pastor of the local Methodist church (one of the many who got turkeys) to conduct ceremonies and the burial in the local cemetery. The Buddhists among the men balked, carried out their own competing ceremony, and demanded that the burial be accompanied by a procession, with loud banging and clanging, more in keeping with village precedents. Such rituals were hugely important. They had long-standing claims on the Chinese sensibility, seeming to provide a means of controlling and responding to a world always in the midst of change. Following the choreography

FIGURE 4.15
Henry Ward, *Charlie Sing*, ca. 1873. (Private collection.)

precisely—there were countless manuals detailing all the proper forms—was equally important. Correct ceremonial procedures "provide the means by which to resolve what is doubtful," the Chinese *Book of Rites* declared, "clarify what is abstruse, receive the spirits, examine regulations, and distinguish humanness from righteousness."[21] Indeed, "[To run] a state without ritual would be as if to plow a field without a plowshare." In burial, a successful ritual was a "properly performed one."[22] Charlie Sing's call to the Methodist pastor was tantamount to introducing anarchy in the order of things.

The debacle surrounding poor Quain Tung Tuck led the men to engage in a heated discussion about what to do next time. The evidence is scant, but we can imagine the points of contention. Should they send the body home immediately, as every Chinese man understood was required? Should they store it over the winter and decide what to do after consulting with family? Should they bury it nearby (with proper rituals) and exhume it later? The debate lasted over a month until Sing, exhausted by all the controversy,

finally intervened, bought a lot in the local cemetery in October, and established North Adams as the final resting place.[23] The local paper applauded, declaring that the "Chinaman can be persuaded neither to make his home nor to find his grave in a region where he has been treated like a dog; but he has no more objections than other human beings to spending his days and leaving his bones in a town where he is treated like a man."[24] The traditionalists among the Chinese groaned. The same tensions arose in February 1873, when Chain Kow died, and July 1874, when Hing Wing Shing died.[25] By 1875, it was clear that the three who had already been buried in the local cemetery were unlikely to be exhumed and sent across the Pacific. It got the traditionalists even more hot and bothered. When Ching Yat Bing died in January 1876, they demanded that his body not be buried in the ground (it was probably too frozen for that anyway) but in a vault for temporary keeping.[26] When Chung Wing Dong died in May 1877, they made it clear that his remains, although buried locally, "would eventually be removed to China."[27]

Perhaps those debates help us make sense of the portrait of Sing Ah Ham (fig. 4.14). At twenty-six when he arrived in North Adams in 1870, he was one of the older recruits. Nothing is known of his life before his arrival, but to judge by the photograph, he was familiar enough with the conventions of Chinese portraiture to want to follow its lead. This cut at least two ways. First of all, he ennobled himself by mimicking the portraits of Chinese aristocrats (Qing but also, importantly, pre-Qing), splaying his legs in the manner of high portraiture (fig. 4.16), a posture that accentuated the wide heft and bulk of his body and the magnificence of his presence. Toying with the card format, testing his body against the arcs, rectangles, and ovals made by the borders and measuring what might be lost or gained by cropping here and there—these were part of the effort at mimicry too. One format made him seem larger (fig. 4.17), his knees and elbows pushing hard against the cardboard frame, as if he overflowed the lens and studio space. What severe presence, befitting a mandarin! But second, and more closely tied to the debates raging among the Chinese, he aligned himself with the typical conventions of funeral portraiture, declaring that

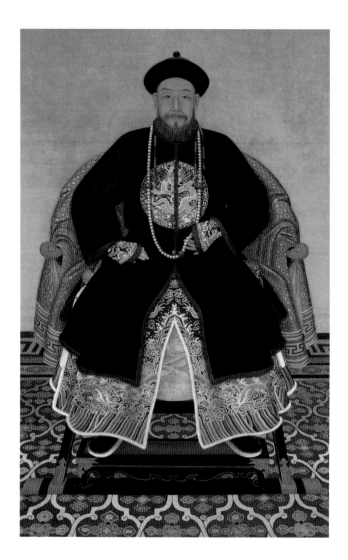

his image was best formulated in dialogue with those reserved for funerals and ancestor worship. In Qing China, it was common for pictures of the deceased to be prominently displayed during funeral processions, the images carried with the coffins and later placed in the ancestral shrine. The enshrined image served a dual purpose. It was the site of a family's worship, and it was the receptacle for the soul of the deceased. The more realistic the image—in the Chinese

FIGURE 4.17
Eli Gokay, *Sing Ah
Ham*, 1877. (Private
collection.)

interpretation of realism, the more squarely frontal, the more de-
scriptive of the deceased's bulky, physical presence—the better, so
as to conjure more vividly the ancestor in the hearts and minds of
his family and also, just as importantly, so as not to let the soul
know that it was being deceived by a mere picture. The portraits
had usually been painted, but with the introduction of the camera

in China in the late 1850s, photographs rapidly took their place and fit neatly into this long practice. They did not, however, alter the basic format. Although photographs potentially provided greater and more varied forms of verisimilitude, the splayed, frontal posture was maintained. The new studios in Hong Kong, Shanghai, and Canton continued old-style funeral portraiture and enjoyed a booming business.[28] No doubt Sing Ah Ham had seen his share of the many photographic examples.

The date of Sing Ah Ham's portrait is significant—1877, the year Chung Wing Dong died, when the traditionalists among the shoemakers, fed up with Christian burials, talk of heaven and the resurrection, and the white man's bleak cemetery, demanded that his remains be sent home. By that point, many of the Chinese had been living in North Adams for seven years. Any differences among the factions had grown more pronounced, the arguments about obligations and "home" periodically resuscitated with special force when the new recruits arrived in 1871, 1873, and 1874. Their beliefs and commitments needed testing and cultivating. Sing Ah Ham, one of the longtime shoemakers, still meticulously shaving his head in the manner of the humble, obedient Chinese man, was declaring his beliefs to his coworkers.

<p style="text-align:center">囍</p>

Sing Ah Ham was not the first of the Chinese shoemakers to emulate the conventional portrait style. Only months after their arrival in 1870, Chung Ley, about fifteen years old at the time (fig. 4.11), and Hin Quan Lay, about twenty-eight (fig. 4.12), traveled several miles to South Adams for a portrait sitting in the studio of Lucius Hurd. (Hurd probably could not believe his good luck. His business had been faltering for years, the bigger and more aggressive studios in North Adams taking away most of his clients, the trip to the comparatively small and rural South Adams seemingly too bothersome for most sitters in the region to make. The Chinese must have seemed like a boon. It would not last; they were among his last clients. By the end of the year, with business coming to a near halt, he packed his bags and left town to open up shop in New York. Bad luck followed him; the new studio would burn down a year later.)[29]

Chung Ley and Hin Quan Lay had been familiar enough with ancestor and aristocratic portraits to try to arrange themselves appropriately, though in comparison to the pose struck by Sing Ah Ham, they seem to observe the old conventions less rigidly. Notice how Sing Ah Ham took greater care to twist his ankles, the heels of each foot turned inward and nearly touching, and causing the knees to push out at harsher, more pointed angles. The contorted pose was an effort to emphasize his lower body's breadth and give the camera a more unimpeded view to all the parts of his legs and feet. The wrenched ankle was no doubt uncomfortable, yet he maintained it with a calmness and serenity. Whether the greater laxity in the poses of Chung Ley and Hin Quan Lay is the result of their discomfort with the studio environs and the photographer's practices, or the lesser degree to which they consciously adhered to precedent, or Hurd's unfamiliarity with the precise gestures they were trying to capture is hard to tell—probably all three. Nonetheless, in the small South Adams studio, the young men hazarded the severe, official countenance, with very mixed results.

Try they did, but not with the same intent as Sing Ah Ham. To judge by the inscription on the back of Hin Quan Lay's card, at least one of the people he gave his picture to was Cora Fisher, a young North Adams girl who came on Sundays to the factory to help teach the Chinese the rudiments of English and Christianity. Though the successes of those Sunday teachings were measured (some of the peasants-turned-shoemakers could hardly read and write Chinese, let alone English), the young men's encounters with the townsfolk were among the most intimate and regular that they had and must have meant enough to them that they replied to the efforts of the North Adams locals in kind. Chung Ley holds his hymnal as if to acknowledge the object that brought Chinese and non-Chinese together, and Hin Quan Lay keeps his two-volume set close by on the tabletop. The small acts—of photographs made with their teachers in mind, of gestures of acknowledgment and salutation within them—might remind us of the 1870 *Scribner's* report, cited briefly in a previous chapter, which remarked on the tenor of the Sunday meetings. "The attachment between the scholars and their teachers is in many cases noteworthy," *Scribner's* observed with

surprise and pleasure. "Not only is this manifested in little acts of kindness, and such trifling gifts as they are able to make—fans, coins, and multitudes of little trinkets—but sometimes their feelings find expression in more substantial manner."[30] Something more than a coin or trinket, the portraits were gifts of a more personal kind, in which the Chinese dressed in the most formal, respectful manner they knew. "Generally, a Celestial will not attend the school unless assured that his teacher will be present," the reporter for *Scribner's* continued. "From some convenient nook in the sleeping room, or elsewhere, he watches the door until the familiar form appears, when with a glide and scramble he hurries into the accustomed seat, and is waiting with boyish eagerness for the commencement of his exercises." We watch for and remember your form, the photographs seem to say, keep these so as not to forget ours.

The cartes de visites were made in multiples, a single session in the studio yielding six or eight pictures (sometimes more, though there is no evidence that the North Adams photographers had that kind of expanded technology), each sheet of cartes providing for the Chinese shoemaker enough photographs to send to several different recipients. A picture for Cora Fisher could double as one for father and mother. Look at me, the sitters says when his photograph arrived at the Guangdong village, I am alive and doing well. I honor you and our ancestors. The display of a formal self worked especially well in conveying that greeting. Or it could just as easily have been sent to a lady friend as a kind of well-wishing from a suitor. The men received pictures from afar (fig. 4.18), suggesting that their romantic and erotic interests were at least partly acknowledged, though by whom is hard to say. (Figure 4.18 is an example of mass-produced pictures of "great beauties"; the three women were not individuals the men knew personally, and are similar in type and function to the three goddesses in the Judgment of Paris.) At least one of the men received a picture of a single woman (fig. 4.19), though whether she was kin, friend, or pinup is unclear. The men also received pictures from Chinese men in San Francisco (at least one of the men received a photograph made in the studio of Lai Yong [fig. 4.20], the most prolific and successful of Chinatown's early Chinese-born photographers);

FIGURE 4.18
Unknown
photographer, untitled
photograph, n.d.
(Private collection.)

in Holyoke, a bustling paper mill town about a long morning's car-
riage ride south along the Connecticut River; and though there
are no surviving pictures to attest, probably in Hong Kong and
Shanghai as well. Pictures of all sorts circulated.

All of this energetic circulation of images produced a loose but defi-
nite visual culture, in which portraiture became the currency by
which the Chinese living abroad sent and received greetings. It was a
transnational culture, images freely crossing borders and paying no
heed to trade agreements or tariffs that burdened many other prod-
ucts crossing the Pacific in the 1870s, blessedly free of the restrictions
that put stoppers around a nation's ports, unhindered by national
markets and economies that increasingly began to regulate cultures
and cultural products. In the traffic of pictures, studio practices that

FIGURE 4.19
Unknown
photographer, untitled
photograph, n.d.
(Private collection.)

were developed locally got disseminated widely, creating in studios across the globe an expansive attentiveness to the subtlest innovations in portraiture. Local sitters and photographers who were savvy enough to pick up on the tiniest new details in the cartes de visites

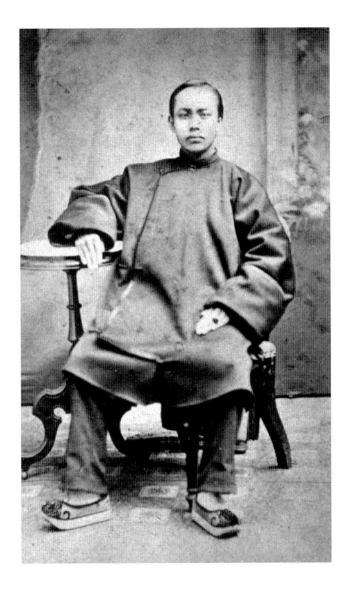

FIGURE 4.20
Lai Yong, *Ping H.*,
ca. 1873. (Private
collection.)

and tintypes made elsewhere found ways to incorporate them into
their own practices in town. The photographers tried the latest card
stock and back matter, for example, in the hopes of giving their
portraits a more elegant framing. They were especially on the look-
out for any new device to keep the sitters still for the long exposure
and yet avoid the telltale signs of restraint. For their part, the sitters

pointed to the latest fashions and echoed what they perceived as the latest hairdos and styles of dress and comportment issuing from the cosmopolitan centers. The shoemakers seemed especially eager to sit, spend their hard cash, and try out new poses and attitudes. It did not require too much prompting and sensitivity to get them into the studio (or perhaps only a tiny measure of sympathy, sensitivity, or even a bit of kindness to get them into this studio and not that one).

This enthusiastic call and response of images across the globe and this alertness among photographers and sitters to the minutiae in portraiture are aspects of the picture industry being driven from below. Photographers kept their fingers on the pulse of their sitters, observing what seemed to enchant them, or at least to catch their eyes, and monitoring their tastes, or what could be gleaned about them from the pictures and circulation in which the men seemed to participate. Take the portrait of Ping H. (fig. 4.20), made in Lai Yong's San Francisco studio about 1873 and sent to a Chinese shoemaker, and how it rippled through North Adams. It seems a common enough portrait, the sitter wearing his finest tunic and shoes and striking a pose more or less in keeping with ancestor portraits. Compared to the early photographs of Chung Ley (fig. 4.11) and Hin Quan Lay (fig. 4.12), this one of Ping H. is most recognizable in the sitter's sporty haircut and big ring, in the hands holding nothing but instead kept stiff, the fingers tight and rigidly at attention, in the slight angle of the body, and in the unadorned table. However small these differences may seem in the comparison, they led to a fad among the North Adams Chinese, who picked up various elements of the formula and tried them on for size. Ping H.'s picture was, after all, made in San Francisco, the "first city," the cosmopolitan center for Chinese living in the United States, if there ever was one, and therefore a crucial center of fashion and self-styling to heed. In 1874 Dong Ah Heng (fig. 4.21) went to William Hurd's studio and took the combination of formal tunic, fancy haircut, and ring to heart. There was no such combination among the Chinese sitters before this. That same year, another shoemaker, whose name is unknown, went to Henry Ward's studio and got himself a ring and asked for the simpler wooden tabletop (fig. 4.22).

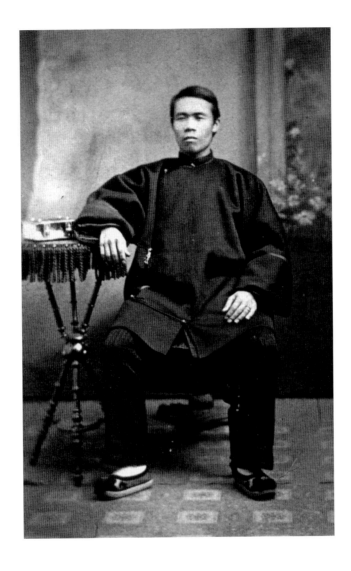

FIGURE 4.21
William Hurd, *Dong Ah Heng*, 1874. (Private collection.)

He made sure to keep his hands free of belongings, even emphasizing that choice by bringing a Chinese fan to the studio but putting it on the table and conspicuously folding it and laying it flat. Ward had only recently purchased the table (we spot the casters on its legs, a new innovation for him, making the table easier to roll in and out of sessions) and was no doubt pleased to have a customer who wanted to use it, even for so seemingly unremarkable a

FIGURE 4.22
Henry Ward, untitled
photograph, 1874.
(Private collection.)

gesture. (Compare it to the tabletop in Hurd's studio found soon
after [fig. 4.13]; the ex-partners were keeping up with each other
and the times.) By mid-decade, there were at least half a dozen
variations on Ping H.'s theme.

❦

What the Chinese saw in the photograph of themselves against the
south wall, then, had at first very little to do with how others in

North Adams wanted to see them. Instead of recognizing the assembly of men as comprising a whole (as Chinese, as shoemakers, as strikebreakers), they saw themselves full of distinctions in front of the camera. It's not quite accurate to say they saw themselves as "individuals," given their backgrounds in Confucianism, self-strengthening, and Han. And at any rate, the idea of individualism in an American context carried a potent set of associations that only partly characterized the Chinese sense of self. But some "distinctiveness" informed their view, a product of the different backgrounds of each of the villagers, their entrepreneurial experiences on the migrant trail, and the immersion in capitalism, which, yes, nurtured and rewarded individualism. As single and singular men amidst others, they pursued further their own investigations in the photographer's studio.

Whereas Sampson understood the cartes de visites of the Chinese as a refinement of an overall sense of their unity, amassing the individual portraits in an album that in the accumulation returned the Chinese to each other and to him, the Chinese understood their cartes de visites in more varying ways. The portraits were greeting and visiting cards, gifts to young girls and remembrances to family and friends, part of a social currency that extended across the country and even further across the Pacific. As products based on fashion and style, the portraits helped to drive an industry that in return promised the hypnotic pleasures and powers of self-representation. Photography's growth was made possible by the distinctiveness felt by each sitter and the heightened sensitivity to giving and receiving such personal expressions.

What pleasure it must have given the young Chinese to primp and pose, and then distribute the results! What importance a visit to the studio must have assumed. It surely made them conscious of their efforts. The men began increasingly to circulate the photographs with captions and names in a local language. Sometimes this was explicit, as in the calling cards that Chung Tick Way had made for himself (fig. 4.23). The photographers offered these non-photographic cards, like early business cards (though they were never as popular among patrons as the cartes de visites). For the Chinese to use these cards without portraits meant that they had

FIGURE 4.23

Left

Chung Tick Way calling card, ca. 1873. (Private collection.)

FIGURE 4.24

Right

Chung Thomas calling card, ca. 1873. (Private collection.)

to be familiar enough around town for the recipients to recognize them by name alone. As if in recognition of that familiarity, Chung Thomas preferred to have his card printed with the name he had begun to use (fig. 4.24), the strange but increasingly common amalgam of a Chinese surname and an adopted Christian name (no doubt developed during the many sessions of Bible study among the good missionaries). If for the portrait sitting the photographer used background screens to create a fantasy landscape, Chung Thomas opted for something like that on his calling card, asking for an Orientalist seascape become fabulous. A gigantic longboat, a cross between a Viking raider ship and a Mongolian junk, goes dashing across the sky, its oarsmen pulling its huge pot-bellied captain, a cross between the Qing emperor and the devil. They leap past clouds and gigantic dragonflies, heading, presumably, to some arcadia in the South Seas where Chung Thomas has already staked his card and laid claim to the land. The Manchu devil-emperor was beaten to the punch by a lowly shoemaker. Chung Thomas must have chuckled at the thought as he sent his card around town.

If in most sitters' hands, the small portrait photographs, originally developed as a pictorial parallel to the older visiting cards, lost their original function as a form of daily greeting and increasingly became objects to be framed for the parlor or inserted in the album, the Chinese restored them to their social function, circulating portraits as a means of address and salutation. Brought together with others far from home and quarantined in a makeshift

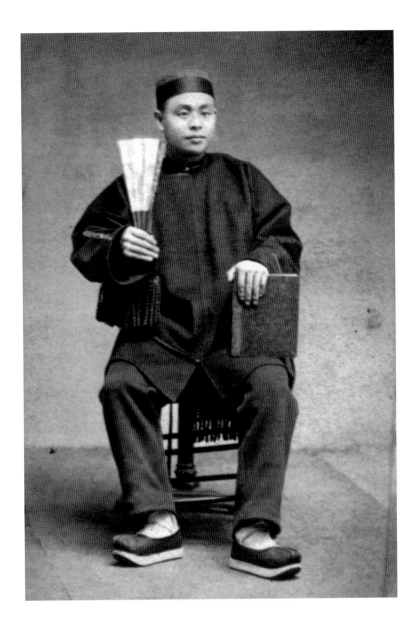

FIGURE 4.25
William Hurd and
William Smith, *Chung
Ah Bard*, ca. 1873.
(Private collection.)

Chinatown, the Chinese peasant sought the studio as a way to
fashion a self and play with the dispositions available to him. He
brought his best coat, sometimes an elegant prop, even the book
of English grammar he was studying (fig. 4.25), and declared this

to be his portrait and not that of the shoemaker or, worse, the strikebreaker. He gave that portrait to a friend or acquaintance to review the claims made in it. The French philosopher Louis Althusser once wrote that to acknowledge someone's wave of hello was to accept, over and above the greeting itself, that one belonged in the same ideological world and shared that world's pleasures and pains.[31] We can extend his observation to say that, in receiving the carte de visite of another, the Chinese man acknowledged that giver and receiver shared a place in this strange land, made room for each other, and acknowledged the preciousness of the photograph and hard-earned money that it required, and the fragile claims of the self that were waged through it.

There must have been enormous symbolic weight both in the exchanges and in the determinations that led up to them. But there was also certainly room for fun. In one portrait, the sitter's eyes have been painted blue, a quick and burlesque racializing of the Chinese man (fig. 4.26). But far from transforming him into a white man, the blue eyes suggest instead either the fantasy of whiteness or, more likely, the goofy and farcical pleasures of trying to pass. Or take this portrait of his colleague, who had gold leaf applied to highlight buttons and decorative slippers and a dollop of red to top the pompom on his hat (fig. 4.27). With crossed legs and a gesture of relaxation nowhere found in the iconography of the Pearl River Delta, it is the image of a North Adams dandy, Chinese-style: relaxed, urbane, and accessorized. The identity was wholly fabricated, of course, and intended for friends who understood the boldness and humor and perhaps even the absurd remoteness of any kind of dandyism from the reality of their daily lives.

In the face of the new economy during the 1870s, when the old outsourcing characteristic of the shoe industry was rapidly being replaced by the integrated new factory, the Crispins, who were being routinely shut out of that industry or had to enter it as a new kind of collective, preferred to picture themselves as the skilled cobbler, as artisans with a sense of self derived from long craft. In this, the Crispin portraits betray the French Canadians' difficult efforts in coming to terms with being an American working class, especially under the new terms set by industry, labor,

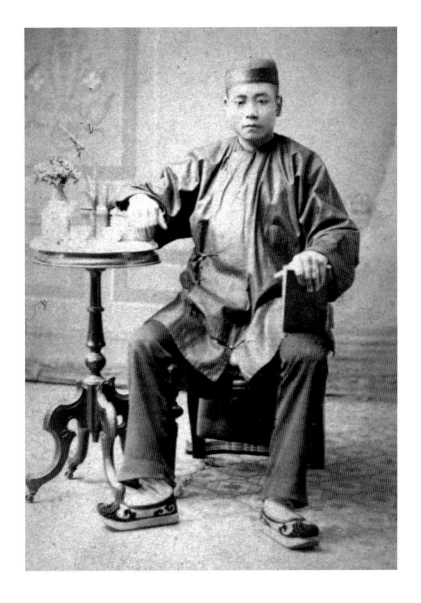

Figure 4.26
William Hurd, *Chung
Dong Bon*, ca. 1875.
(Private collection.)

immigration, and legislation. The Chinese, in contrast, preferred to
picture themselves as having no relationship to labor at all—in
fact, quite the opposite. They could be dandies in the making,
proudly showing off new coats and haircuts, wearing their new
boots and trousers (fig. 4.28), even swapping coats with each other,
no matter how badly they fit, because the old ones in their bunks

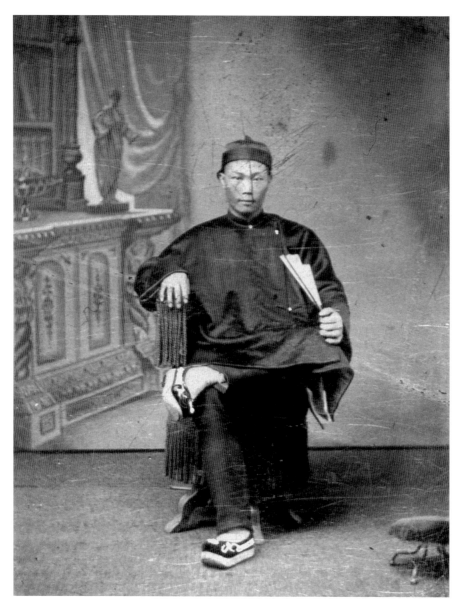

FIGURE 4.27

Henry Ward, untitled photograph, ca. 1874. (Private collection.)

did not have the right cut or sheen (fig. 4.29). The Chinese sitter's portrait was not merely concocted by the photographer's gaze— that much is clear—but essayed within it. The delicate touch of hand on silk, the fan lightly fingered, the sleeve pulled back and

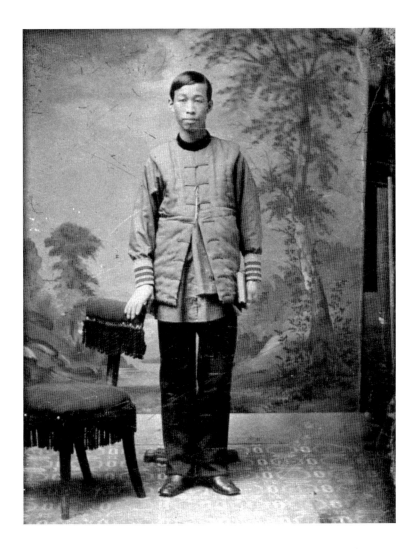

Figure 4.28
Henry Ward, untitled
photograph, ca. 1874.
(Private collection.)

tacked just so, the tassel tucked through the buttonhole to fall
along the pleat (fig. 4.30)—all these can be reevaluated for what
they might say about a usable and empowering sign language
within the studio. And if these simple attentions produced no
proper results, then another opportunity, just a payday or two
away, was easily available. A gold watch could replace the tassel, the
broad cloth replace the silk, the starched collar and pleated tie take
the place of the cut neckline (fig. 4.31).

FIGURE 4.29
Henry Ward, untitled
photograph, ca. 1874.
(Private collection.)

One might be tempted to call the transformation suggested in figures 4.30 and 4.31 or in figures 4.32 and 4.33 "before" and "after" images, as if there had been some Westernizing enlightenment in between the sequence of portraits or as if subaltern Chinese-ness had given way to bourgeois American-ness (to citizenize and Christianize the Chinese, as the manufacturers and missionaries never tired of saying). But that is too crude a gloss on the varieties of testing and displaying, the affects that could be elicited in the wide

Figure 4.30
Henry Ward, untitled
photograph, ca. 1874.
(Private collection.)

spectrum between playfulness and seriousness, and the sheer pleas-
ures (and risks) of performing an identity for another. At one level,
the studio seemed to permit free play and, along with the circula-
tion of the portraits, cultivated an awareness among the Chinese

F<small>IGURE</small> 4.31
Henry Ward, untitled
photograph, ca. 1876.
(Private collection.)

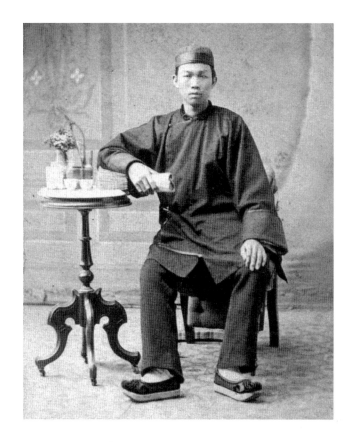

FIGURE 4.32
William Hurd, *Lue Gim Gong*, 1875. (Private collection.)

FIGURE 4.33
Ernest Hurd, *Lue Gim Gong*, 1876. (Private collection.)

that such visual and performing pleasure was expansive. What de-
light the Chinese man must have derived by trading one suit for
another (fig. 4.34) and, because of what the tintype surface enabled,
by scratching a ring on his finger when he simply wanted to own
one and show it off! What sense of entitlement or power he must
have felt when he held a photo album in his hand (fig. 4.35) and
knew that this was the kind of book meant to collect images he
gave and received and when he considered how such a collection
tallied only roughly, if at all, with the one composed by Sampson.

<div align="center">醤</div>

There is pathos and historicity in these portraits, best glimpsed when
we recall the responses to the Chinese by the various constituencies

FIGURE 4.35
William Hurd, *Ah Chong*, 1875. (Private collection.)

of manufacturing and labor, on the one hand, and the cultivation of socially and politically redolent Guangdong and Han sensibilities, on the other. Many of the men's efforts at self-representation were waged between these much larger forces that tried to provide ready-made identities for them. Those identities did not float in some abstract realm but were ever-present. The obligations to the Chinese

family were bred in their bones; and the sense of the men as a collective of shoemakers everywhere structured their daily habits inside the factory and the tenor of their relations with the townspeople outside of it.

The most violent signs of their falling prey to those pressures came in 1873. That year, the Chinese struck—an amazing development, given their normal indifference to labor union entreaties and their general resistance, as the individual cartes de visites suggest, to seeing themselves as an industrial working class. Perhaps even more astonishing, they struck not once but twice. The strikes were complicated affairs involving factions of Chinese, turbulence and rampage among them, arrests, time in jail, even threats of murder, and eventually banishment. The evidence for all of the details surrounding the strikes is incomplete, and at any rate the papers did not want to make too much of the news that the supposedly docile Chinese were acting more and more like other industrial factory workers, especially the hated Crispins; but enough remains to make some educated guesses at the tensions that brought the men to dissent and agitation. It started when a large group of the Chinese objected to Charlie Sing's leadership, especially his handling of their business affairs. Never entirely comfortable with Sing as undisputed foreman and yet initially needing him (and his English, his business savvy, his longer experience), the men's quiet frustrations came to a head during the negotiations for a new contract earlier that year when the original one of 1870 had expired. In their view, Sing had succumbed too quickly and easily to Sampson's new offers. (The negotiated contract does not survive, but with the closings of the competing shoe cooperatives and the sudden flood of unemployed labor and later that year the beginnings of the Panic of 1873 and the drubbing the shoe market was taking, as most markets were, it was probably as stingy in wages as those offered in the original 1870 contract and possibly much worse.) The ill-feelings were surely exacerbated when one of the original shoemakers, who had been dismissed in 1871 for voicing his dissent to Sing's leadership (the "smartee" needle manufactory worker mentioned briefly above), returned to town in late spring to brag about his successes elsewhere. Sampson tried to keep the brewing

disgruntlement in-house, declaring in June to the papers that nothing of interest was happening with the Chinese inside the factory ("We have yet to hear of any threatened strike among them," the *Transcript* reported, though its interest was clearly piqued by so unsolicited a declaration on the part of the shoe manufacturer).[32]

The quiet would not last. In August, led by Ah Coon, about a dozen men walked off the job. They took issue with both Sampson and Sing, targeting both the factory owner and one of their own as oppressors. Yet, because the men still lived in the factory, the walkout led to a bizarre daily scenario. The striking men refused to climb the stairs from their living quarters on the ground floor to the bottoming room on the second, preferring instead to hunker in their bunks and take up space in the dormitory while the workdays passed. They still ate and drank and communed with the men who continued to work, and still took advantage of the stipulation that Sampson supply them with room and partial board. The reporters did not quite know how to describe the situation, the strike not looking or feeling like the usual confrontation put on by shoemakers throughout the state. All they could conclude, probably with some befuddlement, was the Chinese strikers did not appear like the "more assuming and demonstrative workmen from other lands."[33] They did not resort to "pounding, beating, or threatening those who chose to work," meaning their fellow Chinese. There were no speeches or public forums, no calls for militancy or riot, no fisticuffs or bloodshed, at least not yet. But all the same, it was a walkout and must have caused turmoil in the ranks and for the shoe manufacturer. It was also an open challenge to Sing. The Crispins, struggling mightily to keep their last cooperatives open and failing horribly at the task, must have been struck by the irony. Some of the Chinese had finally learned the power of organization and collective dissension—too late for the Crispins to save themselves.

To save face from the considerable blow to his reputation, Sing attempted to supervise the bottoming room with reduced hands, pushing those loyal Chinese to stay at their machines and work longer and faster. But they could neither keep the pace nor fill the orders, even in a market downturn, and Sampson had to send for

new Chinese from San Francisco to fill the empty berths. It must have been horrifying to Sing, who had gloried in the popular characterization of him as leader of his flock and the ever-smiling, unassuming president. To make matters worse for him, the effects of Ah Coon's defiance rippled. At the remaining men's insistence, Sing was stripped of his control over their finances. The demotion must have been a further blow to his ability to supervise—he would never really regain it—and no small indication that many among his coworkers no longer looked to him as their business and political representative, as their Chinese migrant association, as it were. Anticipating the arrival of the new recruits, the men chose another foreman.

In October, after months of difficulties among the Chinese and no clear resolution to their grievances, the men struck again, but this time they openly agitated. Sampson discharged them, but Sing could not escape the suspicion that he was the real force behind their dismissal and stood most to gain from their absence from both the bottoming room and the dormitory. The men "accused Charlie Sing of causing their discharge . . . for the purpose of carrying out some selfish design of his own," the local *Transcript* reported.[34] Despite the many attempts at delicacy, the papers could not ignore the troubles inside the factory any longer, no matter how hard Sampson tried to keep matters buttoned, because they spilled out into the streets. That month, the men threatened to kill Sing, and Ah Coon got hold of a pistol for the purpose. Sampson had him arrested. Forty shoemakers—many more than went on strike—left the factory and accompanied Ah Coon as he was being led to jail. Before he could be locked up, they stormed the building, acting "like wild men in their frantic shouting and leaping." The papers could not believe the transformation in the Chinese (the "disposition of the race quickly showed itself," they tried to explain, though the reasoning hardly convinced anyone) and, in breathless reportage, described the confrontation and ensuing violence blow-by-blow. Quickly overwhelmed by Chinese aggression, the constable called upon passersby for help. Mostly unemployed factory hands, they "fell upon the Chinamen and . . . a shocking scene of brutality and wanton cruelty ensued." Half

crazed, the crowd picked up all kinds of weapons—"clubs, stones, brass knuckles" (how brass knuckles were casually found was never addressed)—and began cracking skulls. The scene was gruesome, the melee between the groups of workers, Chinese and non-Chinese, containing violence "which seem almost incredible," the reporter for the *Transcript* declared in shock. At evening's end, two Chinese were beaten so badly they lay close to dying. "Nothing can justify the brutality," the papers declared. With so raw a display of sheer animosity, the tensions lasted for days. Charlie Sing was given an armed guard (having it did not win him any friends among the Chinese); the striking men and their bunks were moved to another part of the factory. Ah Coon was fined an amount totaling nearly a month's worth of wages. It effectively bankrupted him and forced him to leave. When fifteen new recruits arrived later that week, they were quarantined, as if they could somehow be kept away from the fester.[35]

It would be easy to suggest, as the papers did, that the unrest among the Chinese "arose entirely among themselves" and "grew from a distrust of each other," as if the tensions and violence had no roots in the conditions surrounding the men.[36] There was truth to that perception, as the many migrants never gelled into one, and the long-standing Pearl River Delta differences between them were never resolved. But the events throughout the summer and autumn of 1873 also suggest how much the men became entangled in historical developments completely characteristic of Reconstruction New England. The workers and passersby who visited violence on the striking Chinese let loose a fury born out of unemployment, the frustrations of hunger and poverty, the unfair labor practices adopted by northeast manufacturers—all these magnified by the Panic. The "wanton cruelty" identified by the papers was only the most manifest sign, an outpouring of a bottomless reservoir of anger and helplessness; and the Chinese, like so many new arrivals in the country, were the easy target of a deeper economic predicament and social loathing. The Chinese factions who aligned with Ah Coon were equally frustrated, not only with Sing but with a system of contractual obligations required of the Chinese, stemming right from the beginning of their arrival in California and

sometimes even before, that kept them in near-servitude. They lived and worked among westerners whose language they only roughly understood, whose laws and provisions they faced but had no ability to change, no matter how deleterious to their livelihoods, and whose behavior patronized and belittled them, even (or especially) when it came in the guise of English and Bible teachers trying to civilize them. It surely did not help that Sing seemed to collude in their difficulties.

The Chinese were pulled this way and that, at once being split apart by Ah Coon's challenge to Sing and Sampson and at the same time gathering together in defense of each other in the face of an angry North Adams mob. The very notion of a community of men was shot through with contradiction, fissuring from within but also sheathing in response to the pressures from without.

<center>醫</center>

During the winter of 1877, deposed and unsettled, living outside the factory but maintaining a rough relationship with the men who remained inside, Sing went to Ernest Hurd's photography studio and sat for another carte de visite (fig. 4.36). It was the same year Sing Ah Ham sat for his defiant portrait (fig. 4.14). Charlie Sing took along two of the youngest of the most recent arrivals, Ah Dock and Ah Ling. Together they made an extraordinary picture, the three shoemakers spiffed with the latest hats, smart new coats and vests, starched collars, striped pants for Sing, a gold watch and chain, and polished shoes. They had gotten new haircuts, and Sing had grown carefully groomed sideburns. They arranged themselves in such a way as to suggest a tall pyramid, accentuating their closeness and tight mass. The composition also had the advantage of disposing them in a rough hierarchy, the youngest (Ah Ling) at the bottom and the oldest (Sing) at the top, an ascending scale of age and experience. Ah Ling's expression is stoic, Ah Dock's breaking ever so slightly into a smile, Sing's lip curls into a small, wry grin. The hands form a play of flesh on cloth, light on dark, the press of Sing's fingers on Ah Dock's sloping shoulder—touches of intimacy and warmth amidst the swaths of formal dress. Most noticeable is the extraordinary scenery—the smoky, leafy

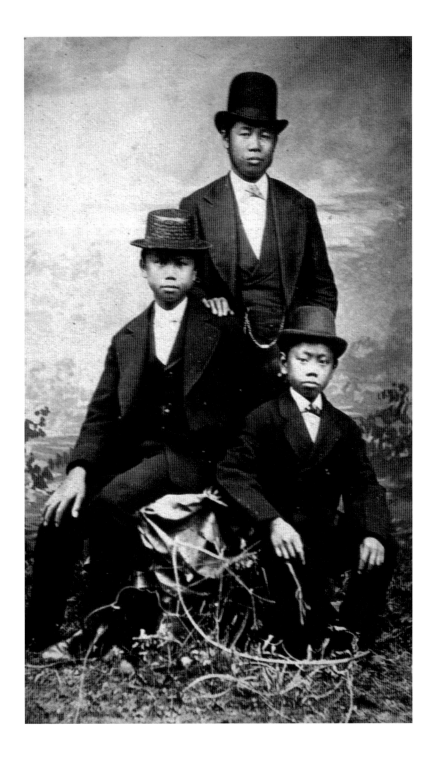

FIGURE 4.36
Ernest Hurd,
*Charlie Sing, Ah
Dock, Ah Ling*,
1877. (Private
collection.)

background and, especially, the twigs, dried leaves, and tall yellow grass in the foreground. It is an absurd stage set, the photographer and sitters agreeing to import bits and pieces of the picturesque Berkshire landscape into the downtown studio. I know of no other instance in Hurd's work where he or his sitters arranged for such an environment. As if to acknowledge his hand in helping to bring "nature" into the studio, Ah Ling presses a long twig against his knee, holding it delicately and yet insistently. Chung Ley (fig. 4.11) and Hin Quan Lay (fig. 4.12) might bring hymnals and fans; Sing Ah Ham (fig. 4.14) might bring a teapot and teacup; others might bring photo albums and books of English grammar; Sing and his young friends bring wintry North Adams and claim it for themselves. It is a knowing gesture.

It was also provocative gesture—provoking in its deliberate counter to pictures previously made of other Chinese shoemakers, salutary in its reply to Sing Ah Ham's portrait, and also valedictory to a time and place on the verge of being transformed. While the Chinese had split under the pressure of Ah Coon's challenge and the original transport of men broken up—some banished, others leaving on their own volition, and new recruits taking their places, all the coming and going dramatically changing the social life of the dormitory and bottoming room—Sing and his young comrades opted for a radically different version of themselves than heretofore tried by any of the Chinese. Whereas the Chinese had gone to the studio to sit in front of the lens as individuals, Sing and his friends went to sit together, ascribing (or perhaps conjuring) a set of social relations among themselves; it was the first time any of the Chinese had done so. Of course all the previous portraits had been made with some sense of social relations, even if these extended only to imagined viewers. But whereas the other Chinese had preferred the more conventional indoor scenery—the tables upon which they could arrange their props, the chairs that let them splay their legs, the soft rugs to touch their soft slippers—Sing and his friends chose the outdoors, as if they were now entering and occupying a new and wild terrain that required them to conceive of themselves in a wholly different manner. The many old terms of self and identity, including the meanings of the migrant son along the continuum of

family and region, no longer obtained. New ones had to be essayed, including selecting the friends with whom such inquiries had to be undertaken. Look again at the picture, and notice the odd cloth that Ah Dock sits on. It was no haphazard prop but in fact a crumpled Chinese smock, like the kind worn by nearly all the Chinese sitters in the previous cartes de visites and tintypes. The three shoemakers brought it to the studio not for the purposes of adorning themselves, as others had done, but as something to be deliberately refused—sat on, turned into makeshift upholstery, discarded like so much rumple. Along with searching for a new image of themselves, the refusal of the old had to be pictured as well.

By the late 1870s, the quandary posed by the famous early photograph of the Chinese on the south wall had materialized, the fraught relation between self and other manifested all too vividly. While that combination of singularity and unity, distinctiveness and sameness, had once produced an alienated, distorting, but also pleasurable recognition among the Chinese, proposing an image of collectivity in the face of their own keenly felt differences and, in the gap, allowing for all kinds of investigations in the photography studio, recent events had shown them how that tension was no playful fiction, no pliable fantasy in the photograph, but in fact deeply constitutive of their experiences in North Adams. However much they wished for adventure, for making some money and keeping obligations, learning a bit of English and testing new kinds of liberations, their many ambitions ran up against the facts of their dependency on each other and their fragile existence in the context of American-style industry. They courted considerable risk when they believed otherwise. It took a clean break (from each other, from the factory, from family, from sojourning) to pursue a new life. Charlie Sing knew that. He soon married a stolid woman from Virginia, settled down in North Adams and started his own family, and tried his hand at anything except shoemaking.[37]

֎

In 1876, four of the Chinese shoemakers drew up guidelines for a new Chinese republic. It was founded on democratic principles, representative government, and the one-body, one-vote logic given

to all Chinese. How they thought such a republic would actually come into being, whether in Qing China or Reconstruction America, was never addressed, but the fantasy, though patently ridiculous, penetrated the anxieties of white observers as far away as San Francisco. A caricaturist for that city's scandal rag, *The Wasp*, vented those fears in the picture called the "Fourth of the Future" (fig. 3.11). In his imagination, Independence Day would not be celebrated by proper American citizens but by a newly empowered population parading its garish new symbols of freedom. Led by a drum sergeant (a white man dressed in an outrageous Chinese military costume), the procession of musicians parades an enormous, enthroned lion—the kind seen dancing in the streets in Chinese New Year's celebrations. While a large crowd of Chinese peasants looks on, firecrackers pop, smoke fills the air, and a hybrid flag— part stars and stripes, part Chinese dragon—is swung in the distance. On the near street, white men, all jowls and beards, have donned new outfits, like the kind worn by the typical Chinese man. A man at the bottom right is even having his head shaven and his hair twisted into a queue. *The Wasp* was notorious for inflammatory pictures such as this; they helped subscriptions, and readers would not have thought the paper complete without them. And yet the image of the "Fourth of the Future" and the new republic that it suggested was neither a passing anxiety nor a bit of amusement to be laughed at over morning coffee. As the country was celebrating its centennial and Philadelphia hosting an enormous exhibition marking the event, such an image went against the grain of a widespread and intense nationalism. The push for Chinese exclusion was soon gaining an unprecedented momentum. With Reconstruction officially ended, the Southern and New England economies resurging, the question of race and slave labor increasingly pushed off to the side (and so, too, the appeal of "Christianize and citizenize"), and the Chinese presence seeming to stand in the way of political gains for both white labor and the Republican and Democratic parties, it was only a matter of time before championing the Chinese became a liability. Sampson saw the writing on the wall, and in 1880 when the last of the Chinese contracts expired, he did not renew them and sent the shoemakers packing.[38] By then, he no

longer needed them. The Crispins had been crushed (most of his competitors too), and he was by then a very rich man and settling into his role as a town patriarch. Two years later, as we know, Congress passed an act that excluded the migrant Chinese from the country altogether.

Given what eventually took place, there was unintended irony in Charlie Sing's group portrait in the twigs and tall grass. He and his young friends had chosen for their new guise the bits and pieces of the land from which they were soon officially excluded. And if there was any sense of valediction in the portrait—any proposition that it was laying to rest the many previous images of themselves, including the famous south wall photograph—that too was ironic. The picture of *any* Chinese in North Adams soon belonged to a frozen moment and receded into the distant past. After 1880, there was no Chinese community in the Berkshires to speak of. There has not been one since.

Postscript

A small photograph has taken us from North Adams to Quebec and China; from the intense emotions surrounding *la survivance* to those surrounding "self-strengthening"; from small picture galleries to large shoe factories; from boardinghouses and bunkrooms to steamships and railcars; from the gossip of journalists and tourists to the concerns of credit reports, registries of deeds, labor annuals, and government surveys; from engineering feats to Christianizing adventures; and from strikes, fisticuffs, and truculent public assemblies to quiet moments of grammar study and the precious gift of the visiting card. The forces that issued into and swirled around the making, understanding, and effect of that photograph were many and varied and have required that we track them, however briefly. In the process, something of the ambitions and experiences of the central actors—the shoe manufacturer, photographers, shoemakers, and strikebreakers—can be glimpsed, and something of their social relations with each other can be understood. Those relations were constantly in flux and changed over time, of course. But for a moment, the photograph froze those relations—condensed them, "hardened them into an image," as our earlier cryptic formulation put it, gave them a substance and a visual form that allowed us, and indeed the historical actors, a means of grasping at them. By trying to understand the photograph from the many points of view we have gained some measure of the main characters who participated in its historical place and time and of the dynamic and complicated relations between them. Of course there were other points of view that could be added, and the story could be made even thicker.[1] This book is but a primer for a means of inquiry into the many sorts of common images that fill our attics and make up our past.

By the late 1870s and early 1880s, the many energies and relations surrounding the original photograph of the Chinese had mostly dissipated or changed. Calvin Sampson was more and more traveling on extended trips to Florida, where the warmth and sunshine suited his and his wife's tastes. The manufactory ran on schedule, made astronomical amounts of money, and seemed to require less and less of his daily attention. He would return from his southern sojourns to add newer and more machines. The factory hands, still mainly Chinese, proved so efficient they simply adapted to anything given to them. In 1877, for example, the Chinese were putting out 12,500 cases of shoes per year, compared to the 4,800 they were producing in 1870 when the first group arrived. No longer pressed to take charge (or pretend to show the men how to work the machines, as he once preened for the illustrators), Sampson in 1879 incorporated the business, removed himself from the daily operation, and left the job of running the factory to his chief assistant, George Chase. The great shoe manufacturer was no longer the hulking, combative presence around the factory and in the newspapers he had been. He would eventually resign as an active partner in 1887, retire in 1891, and die in 1893. Although he was born in Vermont and spent most of his final years in Florida, he chose to be buried in the oldest cemetery of the Berkshire town he had helped to transform, at Hillside Cemetery in North Adams, the same one where several of the Chinese who died during their employ with him were so controversially buried. His grave is about a hundred yards uphill from theirs. I wonder if he knew that their bodies were never exhumed or returned to their villages in the delta.[2] In a sense the relations between the shoe manufacturer and the Chinese migrants continues to be reproduced in the cemetery. Today, the writing on their small, misshapen tombstones has been etched away by the harsh winters and acid rain; except when the sun shines brightly at the proper angle, the characters are nearly illegible. A passerby could easily miss the stones and the identities of the men beneath them. At the top of the hill, Sampson's tomb complex, all shiny red granite and gleaming white marble, the chiseled words crisply intact throughout, is still the largest on site.

Whatever happened to William Hurd, after he skipped town for Nevada in an effort to escape his debts, remains unknown. There was a rumor he joined forces with a man named John G. Brayton, formerly of Braytonville, a small village on the western edge of North Adams. Brayton had gone to Northern California to strike it rich but soon turned to a business that, while not prosperous, must have helped bring in a few dollars. He became a photographer. We might be tempted to look for signs of William Hurd's hand in a portrait done by John Brayton, in which the Chinese sitter comes complete with whacky pastoral motifs and an even zanier dandyish umbrella (fig. P.1). But there is no hard evidence to suggest that Hurd had anything to do with Brayton's studio or pictures.

Henry Ward continued his picture gallery and art repository at the same Main Street address that he and Hurd had first established in 1866. Business had its ups and downs, but he remained at that address for nearly four decades, an impossibly long tenure for a North Adams "professor" and an extraordinarily rare exception to the rule of quick failure in the early profession of photography. His relations with Hurd's son, Ernest, who had taken over his father's studio in the late 1870s, were far more congenial. Perhaps the men were too far apart in age to have developed the sibling-like rivalry that had beset, divided, and embittered William Hurd and Henry Ward; perhaps Ward had mellowed and, as a widower trying to raise two daughters, begun to think about their future rather than his past. Whatever the many reasons, the rivalry between the studios, so significant in providing the caustic and combative energy and facilitating the dialogue with the camera, completely disappeared by the end of the decade.

Ward soon developed other interests, but in these there was a hint that the memory of William Hurd still resonated, as if his old partner's obsessions were not so easily exorcised. In 1886, Ward took out a ninety-nine-year lease for a large tract of farmland—not to raise crops, as most would have guessed, but "for the purpose of digging, excavating and exploring for mineral and metal ores," as the registrar, eyebrow undoubtedly raised again, was careful to elaborate.[3] In 1888, he took out another ninety-nine-year lease—this time from Levi Randall, the same man who had sold Sampson his

Figure P.1
John G. Brayton,
untitled photograph,
ca. 1880

first shop in 1854—and worked out a newfangled agreement to
split the profits of whatever ores he could find and bring to market.
He never found any, but the failures did not seem to deter him. Fol-
lowing what he thought was a vein on Randall's land, Ward bought
the abutting land a year later in 1889, and then another in 1902,

continuing to excavate year after year with a passion that only the Hoosac's engineers or North Adams's old-time tunnelers could have appreciated.[4] It was as if, on the one hand, Ward was hankering after the quick-rich schemes that he had once pursued as a younger man. But on the other hand, it was as if he had become afflicted with the same voracious appetite to acquire property that had once bedeviled and bankrupted Hurd. Like his old partner, Ward had to take loans out to pay for his speculations, putting his precious house up as collateral.[5] He was never able to pay off the loans; and when he died in 1912, his house did not get passed to his daughters but instead went up for public auction.[6]

Whereas the manufactories in and around Boston continued to struggle with labor throughout the 1870s, Sampson's crushing of the Crispins effectively destroyed whatever organized labor movement there had been in town. Beginning in the mid-1870s and continuing for a decade, North Adams had absolutely no unions. It did not help that the French Canadians continued to be viewed as unfit for organization by the national labor movement's own officials. The fact that the people from the north continued to make up anywhere between a quarter and a third of the town's workforce in the late 1870s meant that the labor question in North Adams—the black hole of organization—became an increasingly marginal issue in statewide discussions. Indeed the great and final push to exclude the Chinese came from politicians and labor representatives who lived elsewhere and had other agendas and constituencies in mind. After the cooperatives closed, most of the known French Canadian Crispins had to find other kinds of work to survive. Of those who had worked in the shoe factory in 1870, nine out of ten worked in some other job by 1880.[7] How many of the original Crispins returned permanently, or even temporarily, to the Quebec farms is unknown. But a very sizable number of them settled in North Adams and, against the odds and the shoe manufacturer's venom, struggled to make it their home. They eventually formed an unbroken chain; the descendants of some of the original French Canadian Crispins still live in town.

In 1880 when the last of the Chinese contracts were up, Sampson simply did not renew them. The Crispins and the cooperatives

had long since disappeared; the many unemployed and unorganized craftsmen floating through town took whatever scraps of assembly work the manufacturers doled out; and with the larger political energies toward exclusion becoming harder to ignore, the Chinese were expendable. Sampson felt no need to expand or deepen the paternalistic or patriarchal sensibility he had momentarily adopted. The last reports do not say whether he honored his contract and paid for the men's return, but by then the Chinese in North Adams, as most Chinese throughout the country, were living on borrowed legislative time and had many larger concerns than whether they got their proper fare to San Francisco. In fact if they wanted to remain in the country, it would have been better to disappear for a while in Boston or New York.

Only two of the Chinese men, Charlie Sing and Lue Gim Gong, stayed in town. Always the most sensitive to American mores and speaking English the best, Sing had by then married, had children, and operated a small store. The very year the Chinese were let go, he bought a house and some land—a pastoral "orchard lot"—and tried to settle down.[8] But without any significant Chinese community to support or perhaps buffer him, he must have been singled out for abuse. Maybe he was simply neglected by the rest of the townspeople, who did not want to be reminded of the Chinese experiment. At any rate, his business went sour almost immediately. Although from the beginning he had obtained and polished a reputation for financial responsibility and shrewdness, by 1882 he couldn't pay his taxes, and by 1883 he couldn't meet his mortgage payments.[9] Later that year, he defaulted on his loan.[10] He left for New York, never to return to North Adams. Unlike Sing, Lue Gim Gong lived with but never married a white woman. Named Fannie Burlingame, she was, ironically enough, distantly related to Anson Burlingame, the U.S. minister to China who had brokered the 1868 treaty that opened Pacific ports to unlimited Chinese immigrants and migrants. Lue Gim Gong was officially Fanny Burlingame's hired help, gardener, and stable boy, but the romantic charge of their relationship was town gossip. Whatever the character of their attachment, he traveled back and forth to Florida with her, eventually settled permanently there, never returned to any kind of factory

FIGURE P.2

Thomas Nast, *Uncle Sam's Thanksgiving Dinner*, 1869

work, and as a farmer obtained a modicum of fame as a developer of a hardy species of oranges.[11]

❖

The year 1882 marks a shrill endpoint to our story. In a sense the date has hung like a ghost or death knell over the whole drama, though in the effort to understand the vibrancy and energy of North Adams's visual culture and social relations, I have tried to keep it at arm's length. That year, Congress passed the act that put a stopper to Chinese immigration and, in effect, decreed that experiments in introducing Chinese labor into post–Civil War industry, as essayed by Sampson, were outlawed. The call to Christianize and citizenize the Chinese fell on deaf ears; and besides, hardly anyone thought to make that call anymore. The act was the second such policy to renege on the promise to invite the country's most abject

FIGURE P.3
Unknown
photographer, untitled
photograph, n.d.

laborers to obtain the privileges of freedom, equality, and participatory and communal democracy, as the illustrator Thomas Nast had once fancied (fig. P.2). The first, the ending of Reconstruction in 1876, enabled the rise of Jim Crow practices in the South. A post-slavery society reformulated itself as slavery under a different guise. Both developments, the ending of Reconstruction and the exclusion act, had the overall effect of making a more explicit equation between race and class. By ridding color from the equation, they in fact "whitened" the industrial working classes, when no such strong equivalence had been made before. For the next twenty years and more, those "colored" working people rarely emerged in social and economic legislation or received any of its meager crumbs. One important effect of this racializing of labor was that it made whiteness a marker and goal that could be pursued by those hardworking immigrants who passed and sought inclusion in an American polity. The French Canadians, having no previous place in the spectrum of whiteness, would eventually follow the course and gain a foothold. The Chinese had no such option, could not even fake whiteness, and were simply excluded altogether.

Some, of course, found ways to evade exclusion and continued to live and work in the country. Sometime in the early years of the twentieth century, one of Sampson's former Chinese workers, reaching an advanced age and perhaps deciding that after a lifetime of adventure in America it was finally time to return to his family village, set sail on a steamer bound for China. I have no idea what this man did between his time in North Adams, when he was a youngster in a New England factory, and his voyage back across the Pacific, when in all probability he was making a last trip to the ancestral home. But he kept ties to the friends and acquaintances he had made in North Adams and, on the final return, sent them a photograph of himself, old and balding (fig. P.3). Of the many things he tried to convey to them in the picture, across the many miles and years, at least one was clear: he proclaimed that he did not forget his efforts as a shoemaker and, at last, saw no reason why he could not be pictured amidst the trappings of his trade.

ACKNOWLEDGMENTS

The seeds for this book began one winter day in North Adams a few years ago. Looking for some shelter from the brisk Berkshire winds, I ducked into the local historical society. Wandering through the cozy galleries, I noticed on one of the walls an old, small, crude drawing of a shoe factory, Calvin Sampson's it turned out. The drawing was not much more than a simple ground plan, showing the location of the main office, the various rooms set aside for the stock, and other key spaces in the factory. It looked like countless factory ground plans I had seen before. But something caught my eye. On one corner in small print, the illustrator had flagged the location of the Chinese bunkroom. With the exception of the caricatures in *Frank Leslie's* and *Harper's*, I had never seen *any* visual materials acknowledging that the Chinese had lived in North Adams, even modest and indirect references like a floor plan with an empty (but named) room. It got me thinking that there must be more. Maybe the society might have more plans? Perhaps, if I were lucky, an archive somewhere might have a sketch or two of the Chinese? Or maybe, if I were extremely lucky, a photograph? Surely the caricatures were not the only visual remains of the shoemakers' presence.

The search that began that day has taken me to historical societies throughout New England, Quebec, and California, to special collections from the Baker Library at Harvard to the Bancroft Library at Berkeley, and to the neighborhoods near the Petite Champlain in Old Quebec to a muddy fork in the river in Littleton, New Hampshire. I learned something of the immense distances traveled by the individuals studied in this book and also something

of the call of home. I soon learned that the "archives" I had hoped might contain an image or two turned out to be the picture albums and overstuffed photo boxes belonging to many North Adams families, each holding a treasure trove of old photographs. With graciousness and generosity, these good people invited me into their homes and allowed me to pore over their pictures, read through their papers, and ask them all sorts of odd questions. I often felt I was intruding, but if that was the case, none of them ever let that on. They met me instead with patience and kindness, often with a pint of good beer or a glass of homemade lemonade and a good story. I also wish to thank the many librarians and archivists who gave their time generously, especially Kacy Westwood at the North Adams Public Library, Sue Denault and Linda Kaufmann at the Massachusetts College of Liberal Art's Freel Library, Debbie Sprague at the North Adams Historical Society, and Andrea Still at the State Library of Massachusetts Special Collections. During my many visits, they helped me with their collections and kept finding new (that is, old) things for me to see. I thank Karen Bucky at the Clark Art Institute Library for finding and borrowing all those early and rare photography periodicals. Chapter 2 could not have been written without her. I thank D & B and the Baker Library at Harvard University for allowing me to quote from the R. G. Dun & Co. Collection. For help with obtaining reproductions, I thank Linda Callahan, Michael Croke, Betsy McGovern, Heather McNabb, Dee Psail, Barbara Taylor, Liz Workman, and especially James Gehrt, the wizard of digital imagery.

I had many opportunities to present aspects of this project in public lectures, during which I learned much from the audiences. For these opportunities and for the insightful comments and suggestions they offered, I thank Pat Berman, David Brownlee, Dennis Crockett, Alice Friedman, Randy Griffin, Pat Hills, Pat Johnston, Debbie Kao, Robin Kelsey, Evie Lincoln, Virginia Mecklenberg, Jack Tchen, and Bert Winther-Tamaki. For their many good questions and comments that sent me chasing down books and rewriting large passages, I thank Mary Coffey, Jason Francisco, Paul Marino, Jay Oles, Marni Sandweiss, Sally Stein, and, with special thanks, my old friend Michael Wilson.

During the years of traveling, researching, and writing, I was lucky enough to receive several fellowships, including a Millicent McIntosh Fellowship from the Woodrow Wilson National Fellowship Foundation, a Research Fellowship at the Sterling and Francine Clark Art Institute, and several Mount Holyoke College Faculty grants. I am grateful for all of them. During my time at the Clark, I was surrounded by friends and scholars who made the last stages of writing such a joy. I want to thank Michael Ann Holly, Mark Ledbury, and Gail Parker at the Clark; and Maggie Bickford, Alice Jarrard, Charlie Musser, Mignon Nixon, and Marty Ward, my compatriots in arms at the Clark residence. They reminded me again why we are in this business.

Several friends read through the entire manuscript: Stephanie Fay, Robin Kelsey, Karen Shepard, Shawn Michelle Smith, and Elizabeth Young. I can't thank them enough, and can't apologize enough. I tried as much as possible to respond to their suggestions. They will note that I have remained stubborn about some issues. I know this will prompt more drinks and more good conversations. Scott Wong listened to so many versions of this project and wrote so many letters on my behalf that I am sure he is glad this book is finished.

At Princeton University Press, Hanne Winarsky's great enthusiasm for the book and careful guidance of its making have been inspiring. Terri O'Prey's shepherding through production and Richard Isomaki's copyediting have been flawless.

When I was a graduate student at Berkeley—it seems like yesterday, but now it has been more than a decade—my advisor, Tim Clark, once waxed eloquent about digging where one stands, meaning a commitment to local subjects and the belief that they deserved just as much rigorous scrutiny as more glamorous, cosmopolitan ones. At the time, he was being considerate of my circumstances and tried to make them a virtue. Back then, I had neither the funds nor the wherewithal to dig anywhere else. But I took his advice to heart and at many points in my travels have tried to practice versions of it. This book is all about scratching the soil nearby and seeing what turns up. I continue to learn that such a project is neither limiting nor truly local but instead opens up to a very wide and meaningful world.

NOTES

INTRODUCTION

1. "Testimony of C. T. Sampson," *Report of the Bureau of Statistics and Labor, Embracing the Account of Its Operations and Inquiries From March 1, 1870, to March 1, 1871* (Boston: Wright and Potter, 1871), 105.

2. "Testimony of C. T. Sampson," 106.

3. As recorded in Brent Filson, "Calvin Sampson's Chinese Experiment," *Yankee* (February 1985), 133.

4. "The Chinese Reception," *Berkshire County Eagle* (June 16, 1870).

5. Washington Gladden, *Recollections* (Boston: Houghton Mifflin, 1909), 172.

6. "Testimony of C. T. Sampson," 105–6.

7. Although Chase had much to do with the Chinese arrival, his appearance at the head of the march is mentioned only in a much later report, "A Great Berkshire Industry: Pioneer Shoe Manufacturers of North Adams," *Berkshire Hills* (February 1, 1903).

8. The census count for 1870 lists 49,310 Chinese living in California, about 8.5 percent of the state's population. Most lived in San Francisco, where they made up about 25 percent of the population. There are no similarly detailed tabulations for the Chinese living east of the Rockies. The numbers probably fluctuated greatly. During the late 1860s, many Chinese lived temporarily in makeshift camps in Nevada and Utah as they worked on railroad construction; it's unclear how many traveled eastward and settled in the regions around the tracks after construction ended in 1869. See U.S. Bureau of the Census, *The Statistics of the Population of the United States, Embracing the Tables of Race, Nationality, Sex, and Selected Occupations. To Which Are Added the Statistics of School Attendance and Illiteracy, of Schools, Libraries, Newspapers and Periodicals, Churches, Paupers and Crime, and of Areas, Families, and Dwellings. Compiled from the Original Returns of the*

Ninth Census (June 1, 1870) under the Direction of the Secretary of the Interior, by Francis A. Walker, Superintendent of the Census (Washington, D.C., 1872). Hereafter, the titles for the census reports will be abbreviated.

9. A quick word about names: the city today known as "North Adams" was until 1878 part of a much larger, sprawling community and included a large town to the south. The whole of it was called "Adams." But even before the developments described in this book took place, there was a clear separation between Adams's various communities. The two main halves were often referred to as "north village" and "south village," sometimes "north Adams" and "south Adams," and often in official state documents "North Adams" and "Adams." I'll continue to refer to north village as North Adams, as it is known today, with the proviso that no such incorporated entity existed until the latter parts of the history traced here.

10. Based on the 1870 census for Adams, which includes a complete listing of the men. My compilation and tabulation are based on the microfilm copy at Freel Library, Massachusetts College of Liberal Arts.

11. The details of the men's travel can be compiled from many sources. See especially "Testimony of C. T. Sampson," 105–6. The men traveled in emigrant cars from San Francisco to Omaha, passenger cars from Omaha to Suspension Bridge at Niagara Falls, and finally emigrant cars from Niagara Falls to North Adams.

12. "Testimony of C. T. Sampson," 105.

13. "Chinese Notes," *Adams Transcript* (June 23, 1870).

14. *Frank Leslie's Illustrated Magazine* (July 9, 1870).

15. This is an enormous topic, and the relationship between the one (the appearance of the strikebreakers in North Adams) and the other (federal legislation in 1882 to exclude the Chinese) is still hotly debated. For one strong view and, especially, the debates that it spawned, see Andrew Gyory, *Closing the Gate: Race, Politics, and the Chinese Exclusion Act* (Chapel Hill: University of North Carolina Press, 1998); Stanford Lyman, "The 'Chinese Question' and American Labor Historians," *New Politics* (Winter 2000), 113–48; and Gyory, "A Reply to Stanford Lyman," *New Politics* (Summer 2000).

CHAPTER ONE: WHAT THE SHOE MANUFACTURER SAW

1. See William F. G. Shanks, "Chinese Skilled Labor," *Scribner's Monthly* (September 1871), 494–99; and "Calvin T. Sampson," *New England Manufacturers and Manufacture* (Boston: J. D. Van Slyck, 1879), 528–31. Compare

them to W. F. Speer, *History of North Adams* (North Adams: Hoosac Valley News Printing House, 1885), 83–84; and (after Sampson's death) "C. T. Sampson Manufacturing Co.," in H. G. Rowe and C. T. Fairfield, eds., *North Adams and Vicinity Illustrated* (North Adams: Transcript Publishing, 1898), 63.

2. Frederick Rudolph, "Chinamen in Yankeedom: Anti-unionism in Massachusetts in 1870," *American Historical Review* 53 (October 1947), 7.

3. "Calvin T. Sampson," 530. This reference for the following quote as well.

4. Shanks, "Chinese Skilled Labor," 495.

5. "Calvin T. Sampson," 530.

6. "A Great Berkshire Industry: Pioneer Shoe Manufacturers of North Adams," *Berkshire Hills* (February 1, 1903), 61.

7. "Calvin T. Sampson," 530.

8. There are many studies that trace developments in Lynn, but see especially Paul G. Faler, *Mechanics and Manufacturers in the Early Industrial Revolution: Lynn, Massachusetts, 1780–1860* (Albany: State University of New York Press, 1981).

9. Horace Greeley et al., "Ladies' Shoes," *The Great Industries of the United States: Being an Historical Summary of the Origin, Growth, and Perfection of the Chief Industrial Arts of this Country* (Hartford: J. B. Burr and Hyde, 1873), 1250–64.

10. Greeley et al., "Ladies Shoes," 1252.

11. "Calvin T. Sampson," 531.

12. Rowe and Fairfield, *North Adams and Vicinity*, 63.

13. Massachusetts, vol. 3, p. 40, R. G. Dun and Co. Collection, Baker Library, Harvard Business School.

14. Massachusetts, vol. 3, p. 40, R. G. Dun and Co. Collection, Baker Library, Harvard Business School.

15. Sometimes the purchase date is listed in the biographies as 1852, but the Adams Registry lists otherwise in a deed known as "Levi Randall to Calvin T. Sampson." Deed, July 24, 1854, book 79, p. 113, Northern Berkshire District Registry of Deeds. Sampson purchased the land and building for thirteen hundred dollars.

16. "Calvin T. Sampson," 531.

17. Rowe and Fairfield, *North Adams and Vicinity*, 63.

18. Elizabeth Allegret Baker, "Blackinton: A Case Study of Industrialization, 1856–1876," *Historical Journal of Massachusetts* (January 1981), 16. The major beneficiary of Union army contracts was Sanford Blackinton and his woolen mill. Sampson's wealth was listed as closer to twenty

thousand dollars by the credit reports. See Massachusetts, vol. 3, p. 40, R. G. Dun and Co. Collection, Baker Library, Harvard Business School.

19. Greeley et al., "Ladies Shoes," 1252.

20. Thomas Dublin, *Transforming Women's Work: New England Lives in the Industrial Revolution* (Ithaca, N.Y.: Cornell University Press, 1994), 124–25. Dublin's estimates are based on the output of the high-end McKay machine.

21. On the whole phenomenon of the household economy, see Christopher Clark, *The Roots of Rural Capitalism: Western Massachusetts, 1780–1860* (Ithaca, N.Y.: Cornell University Press, 1990).

22. Judith A. McGaw, *Most Wonderful Machine: Mechanization and Social Change in Berkshire Paper Making, 1801–1885* (Princeton: Princeton University Press, 1987), 234–79.

23. Baker, "Blackinton," 16–17.

24. "A Great Berkshire Industry," 62. The article erroneously lists the purchase date as 1862. I have not been able to locate the deed of sale, but in 1863, Sampson sold his earlier shop to Sarah Simons for $2,250. Deed, February 1, 1863, book 97, p. 181, Northern Berkshire District Registry of Deeds.

25. For some of the details of the early Eagle Street factory, see "Testimony of C. T. Sampson," *Report of the Bureau of Statistics and Labor, Embracing the Account of Its Operations and Inquiries From March 1, 1870, to March 1, 1871* (Boston: Wright and Potter, 1871), 98.

26. Massachusetts, vol. 3, p. 40, R. G. Dun and Co. Collection, Baker Library, Harvard Business School.

27. Built in 1866 by Allen Wilson, inventor of the Wheeler-Wilson sewing machine. At the time of the building's opening, Wilson's company paid higher dividends on its stock than any other stock in the country. Federal Writers' Project, *The Berkshire Hills* (New York: Funk and Wagnalls, 1939), 21–22.

28. The shops can be gleaned from advertisements in the *Hoosac Valley News*, the apartments from Rowe and Fairfield, *North Adams and Vicinity*, 103.

29. I tabulate from slightly later sources. In 1871, Sampson claimed he was paying 150 men $7,000 per month, about $1.50 per day. This rate was a significant raise from his previous wages. See "Testimony of C. T. Sampson," 107.

30. Estimates in Timothy Coogan, "The Forging of a New Mill Town: North and South Adams, Massachusetts, 1780–1860," Ph.D. diss., New York University, 1992, 448.

31. Nolens Volens (pseud.), *North Adams with Some Accounts of Things as They Are and Have Been* (North Adams: n.p., 1860), n.p. This reference for the following quotes as well.

32. Rowe and Fairfield, *North Adams and Vicinity*, 59.

33. The general thesis of Baker, "Blackinton," esp. 22–23.

34. "Testimony of C. T. Sampson," 99. This reference for the preceding quote as well.

35. "Testimony of C. T. Sampson," 99. This reference for the following quote as well.

36. Deed, October 2, 1869, book 119, p. 3, Northern Berkshire District Registry of Deeds. The purchase price was seventeen thousand dollars.

37. Deed, October 2, 1869, book 119, p. 3, Northern Berkshire District Registry of Deeds.

38. "A Model Shoe Factory," *Adams Transcript* (March 24, 1870). This reference for the following quotes as well.

39. William Walsh, *Curiosities of Popular Customs and of Rites, Ceremonies, Observances, and Miscellaneous Antiquities* (Philadelphia: J. B. Lippincott, 1897), 293–94.

40. Blanche Hazard, *The Organization of the Boot and Shoe Industry in Massachusetts before 1875* (Cambridge: Harvard University Press, 1921), 147.

41. Hazard, *Organization*, 147–48.

42. The pledge is worth transcribing whole: "I do solemnly and sincerely pledge myself, my word and honor as a man, before God and these witnesses present, that I will not divulge any of the secrets of this Lodge to any one who I do not know to be a member in good standing, except my spiritual adviser. I will not make known any of the signs of recognition or any matter pertaining to the good of the order. I faithfully pledge myself, that I will not learn, or cause to be learned, any new hand, any part of the boot and shoe trade, without the consent of this lodge, and I will do all I can to prevent others from doing the same. I shall consider myself bound, if any member shall violate this rule, to be his enemy, and will work against his interest in every way possible without violating the civil law. I further pledge myself that if a member gets discharged from a job of work, because he refuses to learn a new hand, that I will not take his place, except the member discharged gives his consent. I also agree to be governed by the will of the members of the order. This pledge, I agree to keep inviolate, whether I remain or not, as long as the organization stands. So help me God." *Hide and Leather Interest* (May 1869).

43. "Testimony of C. T. Sampson," 99.

44. "Testimony of C. T. Sampson," 99. This reference for the following quotes as well.

45. "Testimony of C. T. Sampson," 103.

46. In the past twenty years, historians have argued that the family-style Slater mill was the dominant model for most New England factory villages. See as an example Jonathan Prude, *The Coming of the Industrial Order: Town and Factory Life in Rural Massachusetts, 1810–1860* (New York: Cambridge University Press, 1983). See also the essays in Steven Hahn and Jonathan Prude, eds., *The Countryside in the Age of Capitalist Transformation: Essays in the Social History of Rural America* (Chapel Hill: University of North Carolina Press, 1985).

47. Orson Dalrymple, *History of the Hoosac Tunnel* (North Adams: Orson Dalrymple Publishers, 1880), 5.

48. Oliver Wendell Holmes, *The Autocrat of the Breakfast Table* (Boston: Houghton, Mifflin, 1861), 25. "Cummings" refers to either Alfred Cumming (1829–1910) or Jonathan Cummings (1785–1867). Alfred Cumming was the first territorial governor of Utah. In 1857, the same year as Holmes's poem, Cumming was appointed by James Buchanan to assert federal control over the Mormons. The "blaze" may refer to the fact that Cummings brought federal troops with him when he assumed office. Jonathan Cummings was the founder of the Adventist Christians and set the date for Christ's coming to be 1854. "Miller" most definitely refers to William Miller (1782–1849), a New England farmer and Baptist preacher who beseeched his congregation to sell their worldly possessions because the end of the world was imminent. Miller's main disciple was Jonathan Cummings.

49. J. L. Harrison, *The Great Bore* (North Adams: Advance Job Print Works, 1891), 14.

50. Harrison, *The Great Bore*, 16.

51. Dalrymple, *History of Hoosac Tunnel*, 5–6.

52. "Fatal Explosion: Prof. Mowbray's Nitro-Glycerine Works the Scene of a Catastrophe with loss of Life, but Trifling Damage to Property," unidentified clipping, George Mowbray folder, Freel Library, Massachusetts College of Liberal Arts.

53. Washington Gladden, "The Hoosac Tunnel," *Scribner's Monthly* (November 1870–April 1871), 144.

54. Henry Kemble Oliver, as quoted in Henry Bedford, ed., *Their Lives and Numbers: The Condition of Working People in Massachusetts, 1870–1900* (Ithaca, N.Y.: Cornell University Press, 1995), 4.

55. "Introduction," *Third Annual Report of the Bureau of Statistics and Labor, Embracing the Account of Its Operations and Inquiries From March 1, 1871, to March 1, 1872* (Boston: Wright and Potter, 1872), 9.

56. "Conclusions and Recommendations," *Third Annual Report*, 538–39.

57. "Testimony of Daniel Luther," *Report of the Bureau of Statistics and Labor, Embracing the Account of Its Operations and Inquiries From March 1, 1870, to March 1, 1871*, 109–12.

58. "Chinese Labor," *Third Annual Report*, 402–5.

59. "The Chinese," *Adams Transcript* (July 8, 1869).

60. "The Chinese Emigration," *Adams Transcript* (July 15, 1869).

61. *Memphis Appeal* (June 26, 1869), as quoted in Lennie Austin Cribbs, "The Memphis Chinese Labor Convention, 1869," *West Tennessee Historical Society Papers* 37 (1983), 75.

62. *Montgomery Mail* (June 23, 1869), as quoted in Sylvia H. Krebs, "John Chinaman in Reconstruction Alabama: The Debate and the Experience," *Southern Studies* 24 (Winter 1982), 376.

63. Koopmanschap's role is recounted in Andrew Gyory, *Closing the Gate: Race, Politics, and the Chinese Exclusion Act* (Chapel Hill: University of North Carolina Press, 1998), 30–37.

64. *Hide and Leather Interest and Industrial Review*, quoted in *American Workman* (June 5, 1869).

65. Frank Norton, "Our Labor-System and the Chinese," *Scribner's Monthly* (May–October 1871), 68.

66. "The Chinese of Koopmanschap and Co. are Taken to Massachusetts as Shoemakers," *New York Tribune* (June 4, 1870); and Sampson's reply in "The Chinese in New England," *Harper's Weekly* (July 23, 1870), 468.

67. "Chinese Contract and Wages," *Adams Transcript* (August 18, 1870).

68. The contract was for three years and was specific about a graduated pay scale: for the shoemakers and cooks, twenty-three dollars per month for the first year, twenty-six dollars for the following two, and twenty-eight dollars after that, if the men should stay on; for the foreman, sixty dollars per month to oversee seventy-five men. For each additional man, the foreman was to receive an extra seventy-five cents per month. "Chinese Contract and Wages."

69. The rumor that "if [the men] die, they must, it is said, be sent home to China" is found in *The Nation* (June 23, 1870), 397.

70. "Sampson's Heathen Chinee [*sic*]," unidentified clipping, North Adams Public Library.

71. See Shanks, "Chinese Skilled Labor," 496, as an example. Usually, Sampson implied that he and his top assistant Chase were the teachers. Chase was an accountant and bookkeeper.

72. "Local Intelligence," *Adams Transcript* (June 23, 1870).

73. Richard Bennett, "The Crispins, Calvin, and the Chinese," M.A. thesis, Wesleyan University, 1986, 55.

74. "Editor's Easy Chair," *Harper's New Monthly Magazine* (December 1870), 138.

75. "Editor's Easy Chair," 138.

76. "Chinese in New England," 467.

77. "Chinese in Massachusetts," *Frank Leslie's Illustrated Newspaper* (July 9, 1870), 262.

78. James L. Bowen, "The Celestials in Sunday-School," *Scribner's Monthly* (November 1870–April 1871), 559.

79. Julia Plumb, "Family History," unpublished manuscript, 1946, Massachusetts College of Liberal Arts. This copy is only a fragment of the larger manuscript, whose complete whereabouts is still unknown.

80. The Chinese man who died was Quain Tang Tuck, his death reported in "The Dead Chinese," *Adams Transcript* (September 26, 1872). For many years, the gravesites of the Chinese remained unknown, until recently when a local historian, Paul Marino, discovered them on a hillside in the cemetery on the west side of town. The headstones are intact but the engraved texts have all but worn away.

81. The second Chinese man to die was Chain Kow, reported in the *Adams Transcript* (February 20, 1873), and also in *Greenfield Courier and Gazette* (February 17, 1873). At the city clerk's office, however, Chain Kow is not listed in the Index to the Book of Deaths.

82. "Landlord Doolittle had a gay party," *Greenfield Courier and Gazette* (June 30, 1873).

83. Charles W. Slack, "Interesting Local Comments by the Editor of the Boston Commonwealth," *Adams Transcript* (June 26, 1873).

84. "Testimony of C. T. Sampson," 107.

85. Of Hawthorne's specific entries on North Adams, see his "July 27th, 1838," *The American Notebooks*, ed. Claude M. Simpson (Columbus: Ohio State University Press, 1972), especially 82–88.

86. Ward often mixed and matched his images freely, marketing them under different titles on different lists, as the discussion in chapter 2 makes clear. Although figure 1.36 is from the same session as figure 1.35, Ward sometimes sold it as "No. 794 *North Adams and Vicinity*," with no accompanying descriptive caption.

1. The land speculation is noted in mortgage papers, dated October 18, 1864, book 102, p. 148, Northern Berkshire District Registry of Deeds. Hurd bought a small farming tract from Shepherd Thayer for nine hundred dollars, putting the whole parcel up as collateral. He does not seem to have provided any down payment.

2. *Humphrey's Journal* (February 1, 1862).

3. Massachusetts, vol. 5, p. 27, R. G. Dun and Co. Collection, Baker Library, Harvard Business School.

4. Lease, April 4, 1866, book 101, p. 311, Northern Berkshire District Registry of Deeds.

5. *Humphrey's Journal* (May 15, 1860), 18.

6. Oliver Wendell Holmes, "Doings of the Sunbeam," *Atlantic Monthly* (July 1863), 7.

7. H. J. Rodgers, *Twenty-three Years Under a Sky-light, or the Life and Experiences of a Photographer* (Hartford: H. J. Rodgers, 1872), 28.

8. Massachusetts, vol. 3, p. 82, R. G. Dun and Co. Collection, Baker Library, Harvard Business School.

9. The sitters are named: "Jane E. Leonard and son Mason."

10. Oliver Wendell Holmes, "The Stereoscope and the Stereograph," *Atlantic Monthly* (June 1859), 742.

11. Oliver Wendell Holmes, "Sun-Painting and Sun-Sculpture," *Atlantic Monthly* (July 1861), 17. This reference for the following quote as well.

12. Holmes, "Stereoscope and Stereograph," 747.

13. Roland Barthes, *Camera Lucida: Reflections on Photography*, trans. Richard Howard (New York: Noonday Press, 1981), 85.

14. George Rookwood was in fact a noted Civil War photographer who by the war's end had settled into a thriving business in New York City. How or when he traveled to North Adams is unknown.

15. A brief biography of the two brothers is included in T. K. Treadwell, *The Photographic Images Issued by the Kilburn Company*, 6th ed., Monograph Series no. 5 (Bryan, Tex.: Institute for Photographic Research, 2002), n.p. (but 2, by my count).

16. Holmes, "Doings of the Sunbeam," 2.

17. On the Kilburns' relationship with Soule, see T. K. Treadwell, *The Stereoviews of John Soule*, 3rd ed., Monograph Series no. 4 (Bryan, Tex.: Institute for Photographic Research, 1998,), n.p. (but 1, by my count).

18. This is not to suggest that Wheeler and O'Sullivan were above economic forces or saw their photographs as purely scientific. See Robin

Kelsey, "Viewing the Archive: Timothy O'Sullivan's Photographs for the Wheeler Survey, 1871–1874," *Art Bulletin* 85, no. 4 (2003), 702–23.

19. The examples of a sensibility-based history are usually monographic. See James D. Horan, *Timothy O'Sullivan: America's Forgotten Photographer* (New York: Bonanza Books, 1966); and D. Mark Katz, *Witness to an Era: The Life and Photographs of Alexander Gardner* (Nashville: Rutledge Hill Press, 1991).

20. For an example of a technologically based history, see William Wellig, *Photography in America: The Formative Years, 1839–1900* (New York: Thomas Crowell, 1978).

21. J. L. Harrison, *The Great Bore* (North Adams: Advance Job Print Works, 1891), 31. The details of the disaster vary. See also Washington Gladden, "The Hoosac Tunnel," *Scribner's Monthly* (November 1870–April 1871), esp. 158; and Orson Dalrymple, *History of the Hoosac Tunnel* (North Adams: Dalrymple Publishers, 1880), 10–11.

22. Harrison, *The Great Bore*, 32.

23. Gladden, "The Hoosac Tunnel," 158. This reference for the following quote as well.

24. Deed, April 9, 1867, book 110, p. 373, Northern Berkshire District Registry of Deeds; Deed, April 17, 1867, book 109, p. 571, Northern Berkshire District Registry of Deeds; and Deed, July 15, 1867, book 110, p. 345, Northern Berkshire District Registry of Deeds.

25. Mortgage, April 9, 1867, book 109, p. 539, Northern Berkshire District Registry of Deeds; Mortgage, April 17, 1867, book 109, p. 573, Northern Berkshire District Registry of Deeds; Mortgage, April 17, 1867, book 109, p. 575, Northern Berkshire District Registry of Deeds.

26. Mortgage, April 15, 1868, book 113, p. 147, Northern Berkshire District Registry of Deeds.

27. Massachusetts, vol. 3, p. 82, R. G. Dun and Co. Collection, Baker Library, Harvard Business School.

28. An important exception is Elizabeth Anne McCauley, *Industrial Madness: Commercial Photography in Paris, 1848–1871* (New Haven: Yale University Press, 1994).

29. Elizabeth Anne McCauley, *A. A. E. Disdéri and the Carte de Visite Portrait Photograph* (New Haven: Yale University Press, 1985), 112–16.

30. The advice spilled into two issues: L. M. Dornbach, "Applied Photography—Grouping and Artistic Expression," part 1, *Humphrey's Journal* (January 1, 1861), 257–58, and part 2 (January 15, 1861), 274–75. This second reference for the following quote as well.

31. Dornbach, "Applied Photography," part 1, 258.

32. Rodgers, *Twenty-three Years*, 174.

33. Rodgers, *Twenty-three Years*, 89.

34. Rodgers, *Twenty-three Years*, 90.

35. William Kent, "Taking Views," *Humphrey's Journal* (January 15, 1861), 273–74.

36. Court Order, April 7, 1869, book 112, p. 197, Northern Berkshire District Registry of Deeds; and Mortgage, April 10, 1869, book 122, p. 521, Northern Berkshire District Registry of Deeds.

37. The "picture gallery" also included gilt frames, diaries, albums, valentines, and "all kinds of Fancy Carved Work, such as Brackets, Work Boxes, Segar [*sic*] Boxes, Card Receivers, Rustic Frames, Pen Racks." *Hoosac Valley News* (January 22, 1868).

38. What I call the registration of engineering feats Robin Kelsey has called in another context an "archive style." See his "Viewing the Archive."

39. "Hoosac Tunnel," *Adams Transcript* (June 23, 1870).

40. "The Hoosac Tunnel," *Scribner's Monthly* (November 1870–April 1871), 143. The writer is also chastising his readers for not knowing anything of geography.

41. The omission of the Shanlys persists. See Robert M. Vogel, "Tunnel Engineering—a Museum Treatment," *United States National Museum Bulletin 240: Contributions from the Museum of History and Technology* (Washington, D.C.: Smithsonian Institution, 1964), 215–16.

42. Deed, April 13, 1869, book 128, p. 389, Northern Berkshire District Registry of Deeds.

43. Mortgage, April 10, 1869, book 122, p. 521, Northern Berkshire District Registry of Deeds.

44. "Look at this Picture!" *Hoosac Valley News* (August 10, 1870). This reference for the following quote as well.

45. "H. D. Ward," *Hoosac Valley News* (December 21, 1870). See also "H. D. Ward's Art Repository and Photographic Gallery," *Hoosac Valley News* (August 10, 1870).

46. "W. P. Hurd," *Hoosac Valley News* (August 24, 1870). This reference for the following quote as well.

47. "Hurd and Sons," *Hoosac Valley News* (December 21, 1870). Emphases added.

48. "Ward's Picture Frame Establishment," *Hoosac Valley News* (November 8, 1871).

49. Deed, December 11, 1869, book 116, p. 515, Northern Berkshire District Registry of Deeds.

50. Mortgage, December 29, 1870, book 121, p. 251, Northern Berkshire District Registry of Deeds.

51. Mortgage, November 17, 1870, book 124, p. 303, Northern Berkshire District Registry of Deeds.

52. Mortgage, June 1, 1871, book 124, p. 305; and Mortgage, June 1, 1871, book 124, p. 295, Northern Berkshire District Registry of Deeds.

53. Massachusetts, vol. 5, p. 31, R. G. Dun and Co. Collection, Baker Library, Harvard Business School.

54. Mortgage, April 1, 1870, book 120, p. 99, Northern Berkshire District Registry of Deeds. The interest rate was 12 percent. The norm was 7.75 percent. Ward refinanced it several times. See Mortgage, April 18, 1871, book 112, p. 571; and Mortgage, April 17, 1872, book 127, p. 119, Northern Berkshire District Registry of Deeds.

55. William Cullen Bryant, *Picturesque America: Or, The Land We Live In,* vol. 2 (New York: D. Appleton, 1874), 299.

56. Bryant, *Picturesque America,* 304. This reference for the following quote as well.

57. Bryant, *Picturesque America,* 316–17.

58. Washington Gladden, *From the Hub to the Hudson: With Sketches of Nature, History, and Industry* (Greenfield, Mass.: E. D. Merriam, 1870), iv.

59. The phrase is part of the subtitle for Bryant's book.

60. G. P. Putnam, *The Home Book of the Picturesque: Or, American Scenery, Art, and Literature* (Gainesville, Fla.: Scholars' Facsimiles, 1967, orig. published 1852), 90. The author of the passage in Putnam's book was Susan Cooper, daughter of James Fenimore Cooper.

61. J. Eliot Cabot, "On the Relation of Art to Nature," *Atlantic Monthly* (March 1864), 326–27.

62. Bryant, *Picturesque America,* 317. He refers specifically to Mount Greylock (he calls it "Graylock"), which overlooks North Adams. The "life and labor" and the "turmoil and trouble" are never precisely detailed by Bryant—that vagueness is the benefit of the picturesque—but it somehow concerns the tunneling of the Hoosac.

63. Gladden, *From Hub to Hudson,* iii.

64. Cabot, "On the Relation," 319.

65. Cabot, "On the Relation," 322.

66. Deed, August 13, 1872, book 129, p. 169, Northern Berkshire District Registry of Deeds. See also Hurd's mortgage for the property, Mortgage, August 13, 1872, book 132, p. 405.

67. Ward called the new style the "Rembrants" [*sic*]. "Ward's Picture Frame Establishment."

68. Heinz Henisch and Bridget Henisch, *The Photographic Experience, 1839–1914* (University Park: Pennsylvania State University Press, 1994), 208.

69. Dornbach, "Applied Photography," part 1, 257–58, and part 2, 274–75.

70. On the many statistics for the tunnel, see Harrison, *The Great Bore*, 34. Some of the statistics vary from account to account, the most notable and surprising being the date of completion. Most accounts list it as 1875, when the first trains passed through; some list it as 1876. See, for example, Dalrymple, *History of Hoosac Tunnel*, 3.

71. Massachusetts, vol. 5, p. 31, R. G. Dun and Co. Collection, Baker Library, Harvard Business School.

72. Mortgage, April 10, 1875, book 135, p. 313; and Mortgage, April 10, 1875, book 140, p. 111, Northern Berkshire District Registry of Deeds.

73. Massachusetts, vol. 5, p. 31, R. G. Dun and Co. Collection, Baker Library, Harvard Business School.

CHAPTER THREE: WHAT THE CRISPINS SAW

1. The whole topic of the Quebec rebellions is huge. I have found especially useful Stanley Ryerson, *Unequal Union: Confederation and the Roots of Conflict in the Canadas, 1815–1873* (Toronto: Progress Books, 1968). For a shorter assessment, see Allan Greer, "Rebels and Prisoners: The Canadian Insurrections of 1837–1838," *Acadiensis* 14 (Autumn 1984), 137–45.

2. Joseph-Charles Taché, as transcribed in Paul-André Linteau et al., eds., *Quebec: A History, 1867–1929* (Toronto: James Lorimer, 1983), 98–99.

3. Robert Darnton, *The Great Cat Massacre and Other Episodes in French Cultural History* (New York: Vintage, 1985), 26.

4. These numbers are middle-of-the-road. Estimates vary wildly. For examples, see Yolande Lavoie, "Les mouvements migratoires des Canadiens entre leur pays et les Etats-Unis au XIXe et au XXe siècles," in Hubert Charbonneau, comp., *La population de Québec: Études rétrospectives* (Montreal: Boréal Express, 1973), 78; and Dyke Hendrickson, *Quiet Presence* (Portland, Maine: Guy Gannett Publishing, 1980), 51.

5. The "great haemorrhage" is by Raoul Blanchard. Both this quote and "the graveyard of the race" by Antoine Labelle are offered in Linteau et al., *Québec*, 28. This reference for the following quote as well.

6. "Where are you going?—To the States.—You are headed for poverty. Turn around, don't go there!" As transcribed in Donald Deschènes, "The

Dream of a Better Life in the Songs of Departure for the United States," in Claire Quintal, ed., *Steeples and Smokestacks: A Collection of Essays on the Franco-American Experience in New England* (Worcester, Mass.: Assumption College, 1996), 438.

7. Though not as plentiful as studies devoted to other immigrant groups, studies of how French Canadians settled in New England factory towns are growing. For typical examples, see Frances Early, "French-American Beginnings in an American Community: Lowell, Massachusetts, 1868–1886," Ph.D. dissertation, Concordia University, 1979; and Tamara Hareven and Randolph Langenbach, *Amoskeag: Life and Work in an American Factory* (New York: Cambridge University Press, 1982). A good example of a comparative study (in this case, between Irish and French Canadian immigrants) is the early and venerable Daniel J. Walkowitz, *Worker City, Company Town: Iron and Cotton-Worker Protest in Troy and Cohoes, New York, 1855–1884* (Urbana: University of Illinois Press, 1978).

8. The 1860 census for North Adams is helpful in making these assessments. It lists categories for age, employment, and place of origin for each person. The common profile of the French Canadian immigrant was a man in his twenties who worked as a "day laborer."

9. Pierre Anctil, "The Franco-Americans of New England," in Dean R. Louder and Eric Waddell, eds., *French America: Mobility, Identity, and Minority Experience across the Continent* (Baton Rouge: Louisiana State University Press, 1983), 43.

10. Christopher Benfey, "American Jeremiad," *New York Review of Books* (September 22, 2005), 65.

11. Longfellow's understanding of the Acadian history is recounted in Charles C. Calhoun, *Longfellow: A Rediscovered Life* (Boston: Beacon Press, 2004), 179–93.

12. The details of Acadian expulsion are recounted in John Mack Faragher, *A Great and Noble Scheme: The Tragic Story of the Expulsion of the French Acadians from Their American Homeland* (New York: Norton, 2005).

13. Henry Wadsworth Longfellow, *Evangeline: A Tale of Acadie*, in *Poems and Other Writings* (New York: Library of America, 2000), 114.

14. As quoted in Calhoun, *Longfellow*, 190.

15. As quoted in Manning Hawthorne and Henry Wadsworth Longfellow, *The Origin and Development of Longfellow's "Evangeline"* (Portland, Maine: Anthoensen Press, 1947), 39.

16. On the poem's various afterlives, see Naomi Griffiths, "Longfellow's Evangeline: The Birth and Acceptance of a Legend," *Acadiensis* 11 (1982), 28–41; and Carl Brasseux, *In Search of Evangeline: Birth and Evolution of the*

Evangeline Myth (Thibodaux, La.: Blue Heron Press, 1988). The fascination with the myth persists in French Canada; I observed an exhibition devoted to Evangeline at the Musée de l'Amérique Française in Quebec City in summer 2005.

17. Faragher, *Great and Noble Scheme*, 452.

18. George Munro Grant, *French Canadian Life and Character, With Historical and Descriptive Sketches of the Scenery and Life in Quebec, Montreal, Ottawa, and Surrounding Country* (Chicago: Alexander Belford, 1899), 12–13.

19. Anctil, "Franco-Americans," 35.

20. Sir Adams George Archibald, "The Expulsion of the Acadians," *Nova Scotia Historical Society Collections* 8 (1895), 86. On Massachusetts's refusal, see Robert G. Leblanc, "The Acadian Migrations," in Louder and Waddell, *French America*, 169.

21. Faragher, *Great and Noble Scheme*, 460. See also Barbara Leblanc, "Evangeline as Identity Myth," *Canadian Folklore / Folklore Canadien* 15 (1993), 139–53.

22. H. A. Dubuque, as quoted in *Thirteenth Annual Report of the Bureau of Statistics and Labor, Embracing the Account of Its Operations and Inquiries From March 1, 1881, to March 1, 1882* (Boston: Wright and Potter, 1882), 12.

23. Timothy Coogan, "The Forging of a New Mill Town: North and South Adams, Massachusetts, 1780–1860," Ph.D. diss., New York University, 1992, 448–50.

24. In North Adams, such charges usually accompanied temperance campaigns. See, for example, articles in the *Adams Transcript* for January 27, 1870, and November 19, 1874; and in the *Hoosac Valley News* for September 7, 1870, April 26, 1871, and July 5, 1871.

25. Anctil, "Franco-Americans," 44.

26. It is a claim often repeated by historians in otherwise sympathetic accounts and is the basis for the related claim that French Canadians did not organize into unions as enthusiastically as other groups. See for example Hugh Mason Wade, *The French Canadians, 1760–1945*, vol. 1 (Toronto: Macmillan of Canada, 1968), 337–43.

27. Dubuque, as quoted in *Thirteenth Annual Report*, 12.

28. The literary association and Cohoes paper are noted in Walkowitz, *Worker City, Company Town*, 161 and 172. The Burlington paper is noted in Hendrickson, *Quiet Presence*, 47. The early and valuable study by Edmond Hamon details the many schools, parishes, and newspapers that had cropped up. See his *Les Canadiens-Français de la Nouvelle-Angleterre* (Quebec City, 1891).

29. "The priests in the States, they lead us better than that. They hold parties for us where we can dance." As transcribed in Deschênes, "Dream of Better Life," 442.

30. Blanche Hazard, *The Organization of the Boot and Shoe Industry in Massachusetts before 1875* (Cambridge: Harvard University Press, 1921), 170.

31. Don Lescohier, *The Knights of St. Crispin, 1867–1874: A Study in the Industrial Causes of Trade Unionism*, University of Wisconsin Economics and Political Science Series (Madison, 1910), 17.

32. Andrew Gyory, *Closing the Gate: Race, Politics, and the Chinese Exclusion Act* (Chapel Hill: University of North Carolina Press, 1998), 41.

33. *New York Times* (July 9, 1870), 2.

34. *The Nation* (June 23, 1870), 397.

35. The rally was widely covered. See *New York Herald* (June 26, 1870); *Springfield Republican* (June 25, 1870); and *Albany Journal* (June 23, 1870).

36. "Chinese Notes," *Adams Transcript* (June 23, 1870). This reference for the following quote as well.

37. Lescohier, *Knights of St. Crispin*, 32.

38. Lescohier, *Knights of St. Crispin*, 33.

39. As quoted in Lescohier, *Knights of St. Crispin*, 34.

40. "A Labor Reform Meeting," *Adams Transcript* (June 23, 1870).

41. This is a huge point of contention among scholars of labor and the Exclusion Act. Most proclaim the anti-Chinese sentiment among eastern labor. Gyory proclaims otherwise; see his *Closing the Gate*, especially 42–47 for his assessment of labor's attitudes in the many rallies during the summer of 1870. My own claim is not an either-or proposition. There is plenty of evidence to support both labor's demand for exclusion and its plea for accommodation, suggesting that workers were quite split on their attitudes toward the Chinese and exclusion.

42. John R. Commons et al., *History of Labor in the United States*, vol. 2 (New York: Macmillan, 1918), 148–51.

43. Frederick Rudolph reports the Crispins wanted the Chinese to agitate for a pay raise to two dollars a day, more than twice what they had contracted for. See his "Chinamen in Yankeedom: Anti-unionism in Massachusetts in 1870," *American Historical Review* (October 1947), 23.

44. *The Nation* (June 30, 1870), 412.

45. Understanding "diaspora" is a scholarly industry in its own right, but for a useful introduction, see Safran's full essay, from which my quote is taken, "Diasporas in Modern Society: Myths of Homeland and Return," *Diaspora* 1 (1991), 83–99. I have also benefited enormously by wrestling with James Clifford, "Diasporas," *Cultural Anthropology* 9 (1994), 302–38.

46. "That's where I was born. It is there that I always lived. We'll buy a farm that will be perfectly beautiful." As transcribed in Deschênes, "Dream of Better Life," 443.

47. The details of the company and its shareholders are described in "The North Adams Cooperative Shoe Company," *Adams Transcript* (October 6, 1870). An interesting aspect of this October 6 essay is that it was written by a journalist from the *New York Tribune* and picked up by the *Transcript*. The local paper had not bothered to cover the cooperative on its own.

48. *The Nation* (July 14, 1870), 18.

49. As recorded in Lescohier, *Knights of St. Crispin*, 49.

50. Lescohier, *Knights of St. Crispin*, 49–55.

51. "New Shoe Manufacturing Company," *Adams Transcript* (September 15, 1870).

52. Comparisons between the town's factories are offered in "The Shoe Manufacturing Business of North Adams," *Adams Transcript* (October 6, 1870). Although the town had many more shoe manufactories, the *Transcript* compared data for only five.

53. "Cooperative Shoe Company."

54. "Cooperative Shoe Company."

55. Massachusetts, vol. 5, p. 37, R. G. Dun and Co. Collection, Baker Library, Harvard Business School.

56. Based on the 1870 census for Adams, which includes a complete listing of men, women, and children by age and birthplace. My compilation and tabulation were based on the microfilm copy at Freel Library, Massachusetts College of Liberal Arts.

57. Dubuque, as quoted in *Thirteenth Annual Report*, 12.

58. Gagnon, as quoted by Armand Chartier, "The Spiritual and Intellectual Foundations of the Schooling of Franco-Americans," in Quintal, *Steeples and Smokestacks*, 240.

59. *Adams Transcript* (November 24, 1870).

60. *Hoosac Valley News* (April 5, 1871), 2.

61. *New York Times* (December 31, 1870), 2.

62. Massachusetts, vol. 5, p. 37, R. G. Dun and Co. Collection, Baker Library, Harvard Business School.

63. *Adams Transcript* (March 13, 1873).

64. *Adams Transcript* (May 15, 1873), 2.

65. Alexander Saxton, *The Indispensable Enemy: Labor and the Anti-Chinese Movement in California* (Berkeley and Los Angeles: University of California Press, 1971). See also David Roediger, *The Wages of Whiteness: Race and the Making of the American Working Class* (New York: Verso, 1991);

and my *Picturing Chinatown: Art and Orientalism in San Francisco* (Berkeley and Los Angeles: University of California Press, 2001), 59–99.

66. Readers will hear echoes of Noel Ignatiev's argument, which I wish gratefully to acknowledge. See his *How the Irish Became White* (New York: Routledge, 1996).

67. From the Order's by-laws, as quoted in Matthew Frye Jacobson, *Whiteness of a Different Color: European Immigrants and the Alchemy of Race* (Cambridge: Harvard University Press, 1998), 160. My reference to the "alchemy" of race and class is indebted to Jacobson.

68. See the several articles in *Harper's Weekly* for January 1877 and March 1877 and *Harper's New Monthly Magazine* for June 1877 and October 1877.

69. The literature on blackface is large and growing. I have learned especially from Eric Lott, *Love and Theft: Blackface Minstrelsy and the American Working Class* (New York: Oxford University Press, 1993); and Michael Rogin, *Blackface, White Noise: Jewish Immigrants in the Hollywood Melting Pot* (Berkeley and Los Angeles: University of California Press, 1996). I also benefited from discussions with a Visual Studies faculty group at Mount Holyoke College on Spike Lee's *Bamboozled*.

70. *New York Herald* (June 18, 1870), 6.

CHAPTER FOUR: WHAT THE CHINESE SAW

1. My sense of the migrant societies has been sharpened by Adam McKeown, *Chinese Migrant Networks and Cultural Change: Peru, Chicago, Hawaii, 1900–1936* (Chicago: University of Chicago Press, 2001).

2. On these destinations, see Walton Look Lai, *Indentured Labor, Caribbean Sugar: Chinese and Indian Migrants to the British West Indies, 1838–1918* (Baltimore: Johns Hopkins University Press, 1993); and Humberto Rodríguez Pastor, *Hijos del Celeste Imperio en el Perú* (Lima: Instituto de Apoyo Agrario, 1989).

3. The relation between the Opium Wars and the transformed global economy, including the impetus for Guangdong peasants to travel in search of work (and enter that economy), is a huge topic. I have learned especially from Yen-p'ing Hao, *The Commercial Revolution in Nineteenth Century China: The Rise of Sino-Western Mercantile Capitalism* (Berkeley and Los Angeles: University of California Press, 1986); and Carl Trocki, *Opium, Empire, and the Global Political Economy* (London: Routedge, 1999). See also the brief but important essay by Jonathan Spence, "Opium," in his *Chinese*

Roundabout: Essays in History and Culture (New York: Norton, 1992), 228–56.

4. Sow-Theng Low, *Migration and Ethnicity in Chinese History: Hakkas, Pengmin and Their Neighbors* (Stanford: Stanford University Press, 1997). See also Myron Cohen, "The Hakka or 'Guest People': Dialect as Socio-cultural Variable in Southeast China," in Nicole Constable, ed., *Guest People: Hakka Identity in China and Abroad* (Seattle: University of Washington Press, 1996), 36–79.

5. McKeown, *Chinese Migrant Networks*, 63–64.

6. Unknown passenger, whose poem is translated and transcribed in Him Mark Lai, Genny Lim, and Judy Yung, *Island: Poetry and History of Chinese Immigrants on Angel Island, 1910–1940* (Seattle: University of Washington Press, 1980), 38.

7. Stanford Lyman, William Willmott, and Berching Ho, "Rules of a Chinese Secret Society in British Columbia," in Lyman, *The Asians in North America* (Santa Barbara: ABC Clio, 1977), 97–98.

8. On the experiences of the Chinese in Monterey, see Sandy Lydon, *Chinese Gold: The Chinese in the Monterey Bay Region* (Capitola, Calif.: Capitola Book Company, 1985).

9. See, among many studies, William H. Goetzmann and William N. Goetzmann, *The West of the Imagination* (New York, 1986); William Truettner, ed., *The West as America: Reinterpreting Images of the Frontier, 1820–1920* (Washington, D.C.: Published for the National Museum of American Art by the Smithsonian Institution Press, 1991); and Jules Prown et al., *Discovered Lands, Invented Pasts: Transforming Visions of the American West* (New Haven: Yale University Press, 1992).

10. For a related discussion of the technological transformations in the 1870s and their effects, see Rebecca Solnit, *River of Shadows: Eadweard Muybridge and the Technological Wild West* (New York: Viking, 2003).

11. McKeown, *Chinese Migrant Networks*, 80.

12. There is some uncertainty about Sing's birthdate. An obituary lists his birth as December 11, 1849. See "National Character Expires in this City," *Los Angeles Examiner* (April 12, 1904). During an interview with im-migration officers, Sing claimed he was born in 1858 or 1859, unlikely dates since that would have made him eleven or twelve when he arrived in North Adams. See the interview with the U.S. Department of Labor Im-migration Service, April 11, 1923, collected by J. F. Dutton, hereafter cited as Dutton. I base my date on a listing provided by a genealogy archive, available at freepages.geneaology.rootsweb.com/~lantman/d419.htm. I know of no corroborating evidence for any of these dates. My many

thanks to Karen Shepard for providing me copies of her correspondences with the Sing family and of the Immigration Service interview.

13. The names of Charlie Sing's parents are recorded in his marriage certificate to Ida Wilburn, Commonwealth of Virginia, July 23, 1878. His early life, including the fiction of his royalty, is recounted by one of his descendents, Erica Mae Peterson, email correspondence with Karen Shepard, February 3, 2005. The approximate dates of his arrival and chronology of his early travels in California are recounted by Sing in Dutton.

14. Dutton.

15. McKeown, *Chinese Migrant Networks*, 102. See also Frederic Wakeman, *Strangers at the Gate: Social Disorder in South China, 1839–1861* (Berkeley and Los Angeles: University of California Press, 1966).

16. The recipients are listed in "Christmas Presents From Chas. Sing," *Adams Transcript* (December 26, 1872).

17. James Bowen, "The Celestials in Sunday School," *Scribner's Monthly* (November 1870–April 1871), 558.

18. The *Boston Advertiser*'s account is recorded in "Charles Sing," *Adams Transcript* (October 27, 1870).

19. *Adams Transcript* (June 19, 1873).

20. The death of Quain Tung Tuck on August 27, 1872, is noted in "The Dead Chinese," *Adams Transcript* (August 29, 1872).

21. Quoted in Richard Smith, "Ritual in Ch'ing Culture," in Kwang-ching Liu, ed., *Orthodoxy in Late Imperial China* (Berkeley and Los Angeles: University of California Press, 1990), 288. In this specific passage, the *Book of Rites* is referring to governance, though these claims were characteristic of the book's understanding of ritual generally. This reference for the following quote as well.

22. McKeown, *Chinese Migrant Networks*, 119.

23. The October 9, 1872, deed for the lot can be found in book 1, p. 408, of the North Adams City Clerk's office. The lot cost a princely thirty dollars.

24. "The Dead Chinese."

25. Chain Kow's death is noted in *Adams Transcript* (February 20, 1873); and Hing Wing Shing's in *Adams Transcript* (July 23, 1874).

26. *Hoosac Valley News* (January 20, 1876).

27. *Adams Transcript* (May 10, 1877).

28. For a discussion of photography's mimicking painted funeral portraiture, see Sandra Matthews, "Chinese Photography: Notes toward a

Cross-Cultural Analysis of a Western Medium," *Afterimage* (January 1982), esp. 4–5.

29. "Burned Out," *Hoosac Valley News* (November 8, 1871).

30. Bowen, "Celestials in Sunday School," 558. This reference for the following quote as well.

31. I am butchering Althusser's meaning. He intends such gestures as signs of the overwhelming presence of ideology, the interpellations into it, and the impossibility of escape from it. See his "Ideology and Ideological State Apparatuses: Notes toward an Investigation" in *Lenin and Philosophy*, trans. Ben Brewster (London: New Left Books, 1971), 127–86.

32. "The Chinese—How to Treat Them," *Adams Transcript* (June 19, 1873).

33. *New York Times* (August 18, 1873), 1. This reference for the following quote as well.

34. "The Chinese Trouble," *Adams Transcript* (October 30, 1873). This reference for the following quotes as well.

35. Ah Coon's fines totaled $24.95, as reported in "The Chinese Trouble." The fifteen new recruits are reported in *Hoosac Valley News* (October 29, 1873).

36. "The Chinese Trouble."

37. Charlie Sing was not the only Chinese shoemaker to leave the factory. In each case, the man who left risked being ostracized by the more conservative Chinese. A notable example is the case of Chung Tick Way, who in 1879 married a "Miss Gardner" and moved with her to a house on Brooklyn Street, near Sampson's shoe manufactory. He married her against the advice and wishes of his Chinese coworkers. During their brief marriage, two sympathetic shoemakers moved in with Chung and Gardner but soon returned to the factory ("Me live there eleven day," one of them is reported to have said, "Me lose eleven pound. Bimeby me get so d——n poor me blow away"). Within months of their marriage, Gardner left town with another man, and Chung, by then ostracized by the Chinese ("renounced by his fellow countrymen in a strange land," the papers reported), was not welcomed back to the dormitory. His story is recounted in "The Deserted Husband," *Adams Transcript* (September 4, 1879). Shunned and unemployed, Chung eventually left North Adams altogether ("He couldn't stand his life in this town any longer"), as described in *Adams Transcript* (September 11, 1879).

38. The departure of the last Chinese is noted in "Departure of the Chinese," *Adams Transcript* (September 16, 1880).

1. Readers may hear in the word "thicker" a reference to Clifford Geertz, which I gratefully wish to acknowledge. See his magisterial "Thick Description: Toward an Interpretive Theory of Culture," in his *The Interpretation of Cultures: Selected Essays* (New York: Basic Books, 1973), 3–30.

2. Only two of the graves have been identified. The whereabouts of the others remains unknown, though a local historian, Paul Marino, believes they are located somewhere in the town's other and newer cemetery.

3. Lease, August 9, 1886, book 169, p. 330, Northern Berkshire District Registry of Deeds.

4. Deed, October 3, 1889, book 194, 337; and Mortgage, October 23, 1902, book 265, p. 244, Northern Berkshire District Registry of Deeds.

5. Mortgage, October 5, 1897, book 224, p. 433; Mortgage, October 5, 1899, book 241, p. 193, Northern Berkshire District Registry of Deeds.

6. Notice, March 4, 1912, book 286, p. 368, Northern Berkshire District Registry of Deeds.

7. Matthew Bryson, "The North Adams Shoe Manufacturers: How They Created a Successful Industry Only to Abandon It," honor's thesis, Williams College, 1999, 151.

8. Deed, January 31, 1880, book 157, p. 205; Mortgage, January 31, 1880, book 145, p. 411, Northern Berkshire District Registry of Deeds.

9. Notice, January 26, 1882, book 158, p. 527; Notice, March 27, 1883, book 169, p. 14, Northern Berkshire District Registry of Deeds.

10. Notice, November 15, 1883, book 169, p. 51–53, Northern Berkshire District Registry of Deeds.

11. Lue Gim Gong traveled back to North Adams frequently, at least until 1903, when Fanny Burlingame died. He is listed in the town directories as holding residences on the Blackinton Block in 1883–85 and boarding at the Burlingame residence in 1896–1903. He has easily been the most studied of the North Adams Chinese. See especially Ruthanne Lum McCunn, "Lue Gim Gong: A Life Reclaimed," in Marlon Hom et al., *Chinese America: History and Perspectives 1989* (San Francisco: Chinese Historical Society, 1989), 117–35. McCunn's essay includes transcriptions of two wills written by him. In them, he claimed North Adams as his home, though at the time of writing both, in 1904 and 1911, he was living in DeLand, Florida.

INDEX

Page numbers in boldface refer to photographs

McLaughlin, William, 173
Memphis Appeal, on Chinese labor, 52
Millard, E. R. and N. L., 172
Millard, George, 15, 18, 23, 38, 81, 181
Millard and Whitman, 172–73
Moniteur Acadien, Le, 156
Montgomery Mail, on Chinese labor, 52
Moore, George, 123
Morse, Samuel, 93
Moulton, John, **41**, **44**, 112–13, 123
Muybridge, Eadweard, 45

Nast, Thomas, 4, **5**, **186**, **270**, 272
Nation, The, 10, 181
National Labor Union, 48
New York Globe, 10
New York Herald, 10, 195
New York Tribune, 10, 54
Newhall, M., **21**
North Adams, MA, **25**, **26**, **79**, **120**,
 136, **137**, 278n9
Norton, Frank, 53
Notman, William, 150, **151**, **157**, **159**,
 160
Notre Dame du Sacré Coeur, 189

Obermüller and Son, **65**
Opium Wars, 200
Order of the Caucasians, 193
O'Sullivan, Timothy, 92, 211

Papineau, Louis-Joseph, 145–46
Parker Brothers, 172–73
Patrie Nouvelle, La, 166
Patriote, Le, 166
Philadelphia Photographer, 80
Phillips, Wendell, 48
photo albums, 61–65, **64**
photography, advice on, 103–6
Picturesque America, 127–30

Ping H., **237**, 238
Plessy, Homer, 196
Prang, Louis, 108, 121
Prince Hongming, **230**
Punchinello, 171, 175; on Crispins,
 173

Quain Tung Tuck, 227, 228, 284n80
Quartre-Vingt-Douze Résolutions, Les,
 145
Quebec, 145–46; farming in, 146–49,
 148, 152–53, 157–61; life in,
 152–53, 156–58

Randall, Levi, 266–67
Rodgers, H. J., 105–6
Rogers, W. A., **216**
Rookwood, George, 88, 285n14
Root, Marcus, 93

Sampson, Calvin T., 8, 10, 25–26,
 28–29, 36–37, 81, 124, 172, 177,
 181–83, 191–92, 265, 280n24,
 280n29; biography of, 13–20; and
 Chinese, 2–5, 7, 54–61, 65–69,
 69–73, 218–19, 226, 254–56,
 262–63; competition with Lynn,
 MA, shoemakers, 19–20; and
 Crispins, 34–36, 50–51, 268; facto-
 ries of, 24, 30–33, **32**, **67**, **69**, **71**,
 73; and French Canadians, 150;
 illustrations of, 12–13, **13**, 28,
 55–56, **56**
Sampson, Henry, 14
Scribner's Monthly, 10, 40, 53, 100, 226,
 234; on Chinese, 60; on Hoosac
 Tunnel, 109
Shanghai, **206**
Shanly, Walter, 117–18, **118**, 143
Shays's Rebellion, 14, 15